# PHOTOSHOP® CS
# FOR DIGITAL
# PHOTOGRAPHERS

# Photoshop® CS for Digital Photographers

## Colin Smith

**CHARLES RIVER MEDIA, INC.**

Hingham, Massachusetts

Publisher: Jenifer Niles
Production: Publishers' Design and Production Services, Inc.
Cover Design: The Printed Image
Cover Image: Colin Smith

CHARLES RIVER MEDIA, INC.
10 Downer Avenue
Hingham, Massachusetts 02043
781-740-0400
781-740-8816 (FAX)
info@charlesriver.com
www.charlesriver.com

This book is printed on acid-free paper.

Colin Smith. *Photoshop CS for Digital Photographers.*
ISBN: 1-58450-321-1

Unless otherwise indicated, photos courtesy Colin Smith.
All AbleStock images © 2004 Colin Smith and its licensors. All rights reserved.

Library of Congress Cataloging-in-Publication Data
Smith, Colin, 1966-
    Photoshop CS for digital photographers / Colin Smith.— 1st ed.
        p.   cm.
    ISBN 1-58450-321-1 (pbk. with CD-ROM : alk. paper)
    1. Photography—Digital techniques. 2. Image processing—Digital techniques.
    3. Adobe Photoshop. I. Title.
    TR267.S63 2004
    775—dc22

2004001985

Printed in the United States of America
04 7 6 5 4 3 2 First Edition

# CONTENTS

## 5  COLOR CORRECTION 133

## 6  SHARPENING AND NOISE REDUCTION 167

# ACKNOWLEDGMENTS

I would like to acknowledge the people who have made this book possible.

First of all Jenifer Niles, for the vision and patience to make this project a reality.

Thanks to Ablestock for allowing me to use so many of your great images in this book. Thanks to Susannah Garcia and Mauriahh Beezley for being willing models and allowing me to stick my lens in your faces. Tim Cooper, for tech editing, your valuable advice, and the long conversations on the phone. Nina Indsct Anderson, thanks for your friendship and contributing your great photos.

Thanks to my friends in the industry: Al Ward, who has co-authored books with me in the past, and I'm sure more in the future. To my buddies at NAPP: Scott Kelby, Jeff Kelby, Chris Main, Dave Cross, Stacy Behan, and Felix Nelson. All the crew at PhotoshopCAFE, the staff and loyal visitors and supporters, thanks for coming along on the journey.

To my parents, especially my Mum, who always encouraged me to follow my heart. To my pastors and good friends George and Hazel Hill, who always encourage me to keep pressing forward and dreaming bigger each year. Thanks to God for giving me the talent and the strength to do what I do.

# INTRODUCTION

It is a pleasure to write this book at such a critical and pivotal time in the history of photography. Right now, there is a revolution under way—the explosion of digital photography. Every day people say, "I'm taking the plunge, I'm going digital." In this mass exodus from film to digital, there is one tool right in the center—Adobe® Photoshop® has become the darkroom for the future. Some advantages of this new darkroom are that the results are instant, the possibilities have been greatly expanded, and it smells much nicer without all the messy chemicals involved in traditional development! In addition, this new darkroom is more accessible than before; not only professionals have access, but now, it is also within the reach of all photographers.

Adobe has acknowledged this revolution with the release of Photoshop 8, dubbed Photoshop CS. This new release of the world's most powerful image-editing program is jam packed with new features designed especially with you—the photographer—in mind. Everything is streamlined, from importing your images and organizing them, to new correction tools and better ways of enhancing images, to enhanced 16-bit support, to built-in Camera Raw functionality and much more. No stone is left unturned in this book; we examine all the new features in Photoshop CS and the best way you can use them to make your images look better.

## INTENDED AUDIENCE

This book is written with two groups of people in mind.

The first group is the mass of photographers who have made the transition from film to digital. The new darkroom is now sitting on your desktop with Photoshop running—there are so many options and dialog boxes, where do you start? This book shows you how to process your images and produce professional results. New challenges abound with digital—this book is your guide to how to overcome these obstacles and how to produce the results you want. Professional-level techniques help you

develop an efficient workflow. In many cases, several different methods are presented for each challenge. This allows you to choose the method that works best for your needs and to develop your own workflow.

The second group is amateur photographers and hobbyists. Perhaps you have been using a personal computer for years and are already somewhat familiar with Adobe Photoshop. This book reveals the secrets to producing clearer, sharper, and more professional-looking images. Photoshop is a vast program that can perform many tasks. It can be very intimidating, and only the "pros" know the techniques to perform the tasks that you need to bring out the best in your images. The mysteries are revealed in this book, bringing within your reach the results you have always dreamed of.

We also go beyond just cleaning up your images. You learn how to manipulate images digitally and do things that were impossible with film. You learn how to apply special effects and even how to get the best results while printing.

This is not a book for those people who want to learn how to take photographs. Many books on the market can help you choose cameras and shoot better pictures. A few tips are mentioned in Chapter 1, "Before You Begin," to make your images more friendly for use in Photoshop. When you have finished clicking the shutter and uploading your images to a computer, you are ready for this book. This book is about Photoshop and what happens to your images after they are on your computer.

## Topics Covered

Chapter 1, "Before You Begin," explores file formats, resolution, and pixels. You then learn about the importance of 16-bit images and Camera Raw functionality.

Chapter 2, "Organizing, Automation, and Output," explores the File Browser. This is an application in itself and is designed to make everyone's life easier. This tool provides a way to organize, label, and view your images in one place. You can attach information to images that can be searched and categorized. To top it off, you will be able to automate many tasks and save many hours of work by letting Photoshop do the hard work for you. You can then present your images on the printed page and over the Internet.

Chapter 3, "Cropping and Sizing," walks you through cropping and resizing your images. You learn how to crop for better emphasis and how to straighten images and correct perspective. You learn how to resize your images without destroying their appearance. You learn the strate-

gies for successful enlargement and reduction of images, and interpolation is demystified.

Chapter 4, "Image Correction," takes you to the core of the digital darkroom. This is where you learn about histograms and use them as a visual cue as you correct your images. Are the images too dark, too bright, or lacking in contrast? You learn the techniques to tame overexposed images, open up the shadows, and bring back brightness to dull images. You may be surprised at just how much detail Photoshop can bring back to a bad image.

Chapter 5, "Color Correction," takes a look at strategies to bring out the best color in images. We look at color correction, such as removing color casts and warming and cooling the appearance of photos. We can even take faded images and inject new life into them using the methods taught in this chapter.

Chapter 6, "Sharpening and Noise Reduction," empowers you to sharpen your images to bring out the detail. On the other end of the spectrum, we take grainy images and reduce the grain to produce smoother-looking results.

Chapter 7, "Image Retouching," takes you on a journey as we retouch images. This is where we perform digital cosmetic surgery. We reduce wrinkles; remove redeye, tattoos, freckles, acne, and birthmarks; shrink noses and waistlines; and generally flatter the people we take pictures of.

Chapter 8, "Frame and Color Effects," kicks off some of the more creative content in the book. We look at the best ways to convert color images to grayscale as well as sepia tone effects. We change the depth of field on an image using the advanced features of the exciting new filter, lens blur. We also frame our photos with different kinds of borders and edges.

Chapter 9, "Special Effects," is a lot of fun. We explore special effects such as turning photos into hand-drawn images and paintings. We create trendy effects and even turn day into night.

Chapters 10 and 11, "Working with Multiple Images" and "Collaging Techniques," respectively, wrap it all up by combining our images in different ways. From producing panoramic images to creating collages and animations, you discover that the journey doesn't have to end with a single photograph. Photoshop has given you the power to do amazing things with your images, and this book puts that power into your hands.

# BASICS

# BEFORE YOU BEGIN

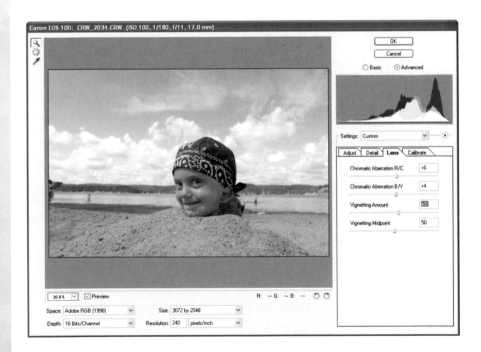

The focus of this book is on the post-capture phase of photography. Plenty of good books are available on the art of photography that will help you to capture wonderful images. This book shows you how to organize, enhance, and repair images; how to do creative things with those images; and how to output them. You should be aware of a few considerations before shooting that affect your output and ability to work with your images.

## CONSIDERATIONS BEFORE SHOOTING

This section will provide an introduction to such issues as resolution and image formats. We will take a look at the kinds of settings recommended to get the best possible images from your camera. This is just a brief introduction; we will get into more detail throughout the book.

### Resolution

Resolution is one of the biggest factors in enabling you to output nice, sharp images. The most obvious resolution consideration is that the more pixels in the image, the larger you can print the final image. If the resolution is insufficient, the print will suffer from pixelization. In extreme cases, pixelization looks like LEGO® structures. Photoshop does, however, have some very impressive interpolation technology that enables you to enlarge your images substantially and still have an acceptable quality print. Still, printing a sharp, clean 8 × 10 image from a 2-megapixel capture is a little ambitious.

Another resolution consideration is cropping. If an image is taken with a higher resolution than is needed, there is plenty of overhead, or reserve pixels to work with. This overhead is very useful while cropping away precious pixels.

The bottom line is this: If you want flexibility with your images, always shoot with the maximum resolution available on your camera. You can decrease the image resolution, but once it is shot, you can't increase it. After all, why buy a 5-megapixel camera capable of shooting 2560 × 1920 pixels and shoot only at 640 × 480 pixels? Of course, there are always exceptions, such as limited storage space and instances in which images are not needed in a high resolution (when e-mailing a snapshot, for instance). Keep this in mind for now, and we will discuss resolution and resizing in more detail in Chapter 3, "Cropping and Sizing."

## File Formats

Cameras offer different types of image formats. The types of file formats used by cameras and the best times to use them are discussed briefly in the following sections.

### JPEG

The Joint Photographic Experts Group format (JPEG or JPG) is standard on all cameras. Pronounced "jay-peg," this is the most common type of compression used on photographic images today. There are different levels of compression used; a high amount of compression produces a very small file size, but the image will suffer from artifacts, blurring, and damage to the color. This is usually the kind of result you can expect from the low-quality setting on a camera and is not recommended. The high quality setting will use a low amount of compression, and the file size will be a little larger but still substantially smaller than an uncompressed image. The quality of the high quality JPG is very good. When using compression or compressed format types such as JPEG, you should shoot with the highest quality JPEG setting on the camera and fit an acceptable number of images on your card without too much quality loss. The quality of JPEGs on newer cameras is surprisingly good, and you would be hard-pressed to notice the effects of compression.

### TIFF

For a higher-quality image, use the TIFF (Tagged Image Format) mode. TIFF is one of the most common uncompressed file formats used for images. TIFF images do not suffer from the results of image compression. A disadvantage of using TIFF, however, is very slow captures, with long rendering times on the camera. Because there is a much bigger file to write to the card, this causes a long delay between pictures. In addition, the memory card fills up quickly. Experiment for yourself by shooting some images in TIFF and JPEG; examine them carefully to decide which format works best for you. In reality, you will probably alternate between the two settings. The slow rendering time of TIFF could cause you to lose too many shooting opportunities of live action or fast-paced activities such as sporting events. On the other hand, if you are shooting still objects in a studio, there is no reason not to use TIFF.

### RAW

A third format worth mentioning is the RAW format, which is offered by higher-quality and more expensive cameras. The RAW format retains the

pixel information directly from the camera's CCD or CMOS sensor (a digital camera's version of film) and saves it unprocessed by the camera. The image is tagged with the camera's settings, but these settings are not embedded. This enables you to process the images on a computer at a later time and adjust the settings while importing the image. Another advantage of shooting in the RAW format is that images can be captured in 16-bit. We examine RAW and 16-bit later in this chapter. If you are lucky enough to possess a camera that supports RAW, this is the best setting to use for the majority of shooting.

### Digital Zoom

To be honest, I never use the digital zoom on my camera—I always use the optical zoom. The digital zoom basically crops and interpolates the image to make it appear closer. This can be performed with better quality in Photoshop at a later date when you are not dealing with camera shake.

### Flash/Lighting/Exposure

Lighting configuration and flash versus nonflash shooting is a whole subject in itself. Two good books in the actual photography phase of image capturing are *Complete Digital Photography* by Ben Long (Charles River Media) and *Shooting Digital* by Mikkel Aaland (Sybex). The important thing is using the correct exposure, making sure that there is sufficient lighting, and using the correct shutter speed for the scene you want to shoot. The use of natural light, studio lighting, and reflectors that bounce light to fill the darker areas is very common with photographers. Even a large piece of white sponge board can be used effectively to bounce extra lighting into a scene. When a flash is used, it's a good idea to diffuse it with a gel or tissue paper to avoid overexposing the highlights. Taping some tissue paper over the flash softens the light that comes from the flash and produces more pleasant overall lighting on the subject. Also, if you are using a flash, make sure that you are close enough to the subject for the flash to be effective, and check the manual's specifications for recommended shooting distance for the camera or external flash. An external flash can be used effectively to lighten a shadowed portion of the scene. This is called *fill flash*. A well-exposed image contains image detail in both the highlights and the shadows. The exceptions are for creative purposes. Most good quality digital cameras have white balance settings that compensate for different kinds of lighting. Most cameras use icons that represent different lighting situations such as sunlight, overcast, and

tungsten and fluorescent lighting. If you are unsure of the correct setting, the Auto setting will produce good results most of the time. Choosing the correct camera settings when shooting reduces the need for color correction later. Keep in mind that it's easier to repair a slightly underexposed image than it is an overexposed one.

### Take Lots of Pictures

The more images you take, the better photographer you will become. With digital photography, the expense of developing pictures is eliminated, which can be very liberating. When traveling (especially abroad or to exotic locations), many people suffer from having to pay to develop 10, 20, or more rolls of film. While traveling, the expense of developing can weigh heavily on the decision of whether to shoot an image. Now, however, this is a concern of the past. Not only can your memory cards store images, but new devices such as the Apple® iPod™ can be used as well. At the time of this writing, the iPod can hold up to 40 gigabytes of data. That's a lot of images. The more images you take, the more you have to choose from. When in doubt, go ahead and click!

## 16-BIT IMAGES

Photoshop CS has been heralded as the digital photographer's upgrade. There is certainly a lot for photographers in this release of Photoshop—not the least of which is the expanded support for 16-bit images. An 8-bit image contains 256 shades of gray in each channel, whereas Photoshop's 16-bit image contains approximately 32,768 shades in each channel. The reason it's 32,000 and not 65,000 is that technically Photoshop uses only 15-bit color, but for the sake of clarity, we will call it 16-bit from here on. The result of more shades of gray in each channel is smoother gradations in the images, which results in reduced posterization and banding (a harsh, unnatural transition in color) in viewed and, even more noticeably, in printed images.

To take advantage of the denser 16-bit features, the images must be captured in 16-bit color. Taking an 8-bit image and choosing Image > Mode > 16 bits/Channel does not magically convert an 8-bit image to 16-bit. Photoshop cannot add color information that was not captured. Cameras that support the RAW format are capable of shooting images in 16-bit—which is excellent for making adjustments and corrections to the images. The extra data helps the image maintain integrity while adjusting it. An 8-bit image can become posterized very quickly, whereas a 16-bit image is much more robust as a result of the extra image data.

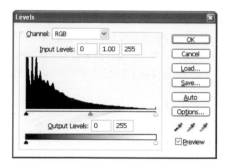    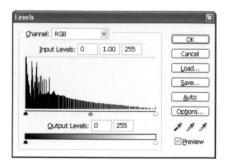

**FIGURE 1.1**   Adjustment with 16-bit.          **FIGURE 1.2**   Adjustment with 8-bit.

Figure 1.1 shows a histogram of a 16-bit image with a radical adjustment applied to it.

Figure 1.2 shows a histogram of the same image and adjustment. Notice the gaps in the histogram? These gaps indicate that there is no image data available. The result would be posterization or a very harsh transition of color gradient in the image. Histograms and image correction are covered in more detail in Chapter 4, "Image Correction."

The disadvantage of a 16-bit image is file size. A 16-bit image's file size is double that of an 8-bit image. After you begin to modify the image and add layers, the file size can grow very quickly. If you have a fast computer with a lot of RAM and plenty of storage, you can keep the images in 16-bit. If you are working with limited computing resources, a good practice is to perform the image corrections, such as tonal adjustments and color correction, and then convert to 8-bit (Image > Mode > 8 Bits/Channel).

## CAMERA RAW

Photoshop supports a growing number of different camera RAW formats and offers processing for these images through a special plug-in called Camera RAW 2. The first Camera Raw plug-in is available for previous versions of Photoshop, and Camera RAW 2 is built into Photoshop CS.

When a supported RAW image is opened, a dialog box appears. This is where you can set the processing options to ensure that the best possible image is opened in Photoshop.

*You cannot access these controls unless you are using a RAW image. A RAW image saved from a Canon 10-D,* CRW_2043.CRW *(the file extension used by Canon for RAW images), is provided on the accompanying CD-ROM for your learning pleasure.*

ON THE CD

Figure 1.3 shows the Camera Raw dialog box and an unprocessed image as shot by my friend Nina Indset Andersen. You can either choose the Camera Default setting and open the image as it was shot or make some corrections using Photoshop's Camera Raw filter.

## Adjusting Image Tone

The first and most important task to be performed in the Camera Raw dialog box is to adjust the image's tonal values. We want to brighten the image and optimize the contrast without losing any pixel data. When we lose data, we call it *clipping* an image. Clipping occurs when some of the highlights or shadows are lost by overcorrecting the exposure or shadows. You can see the image information displayed as a histogram in the top right of the dialog box shown in Figure 1.3 (see Chapter 4 for more

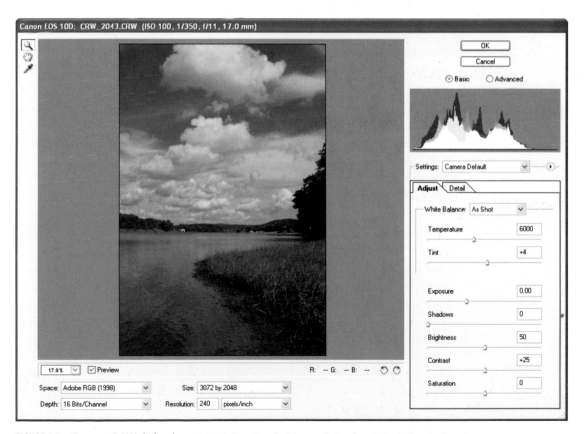

**FIGURE 1.3**   Camera RAW dialog box. © 2003. Reprinted with permission from Nina Indset Andersen.

**FIGURE 1.4** Setting the exposure. © 2003. Reprinted with permission from Nina Indset Andersen.

information on histograms). The goal is to remove the empty areas to the left and right and have the histogram displayed in the window without losing any of the ends (clipping). The two settings that really concern us are the exposure and shadows.

1. Hold down the Alt key (Option key on a Macintosh®) and slide the Exposure slider. Holding down the Alt/Option key shows image clipping. You want to move the slider right on the threshold where clipping just begins, as shown in Figure 1.4. The spots that are revealed are the very brightest points of the image.
2. Now do exactly the same thing with the Shadows slider. You should see the darkest points of the image displayed as colored speckles, as shown in Figure 1.5.

As you can see, the luminosity of the image is now adjusted. The highlights and shadows are now correct, and the image has much more contrast.

**FIGURE 1.5**   Setting the Shadows values. © 2003. Reprinted with permission from Nina Indset Andersen.

### Color Correction

The next step is to adjust the overall color of the image.

1. Choose the White Balance option that most closely resembles the shooting conditions, such as cloudy, shade, incandescent light, and so on. If this setting looks like the color balance on your camera, it is no accident. That is exactly what you are doing. This setting adjusts the image for different lighting conditions and removes the color casts that may be present. In the example in Figure 1.6, the Daylight setting is chosen. This is the best setting for photos taken outdoors with plenty of sun.

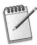

*The White Balance settings change the Color Temperature and Tint. It's a good idea to choose the setting that looks best and then make small changes manually.*

**FIGURE 1.6**    Choosing White Balance options. © 2003. Reprinted with permission from Nina Indset Andersen.

2. Use the Temperature slider to fine-tune the color settings. If the slider is moved to the left, the image becomes cooler with more blue; if the slider is moved to the right, it becomes warmer with more yellow.
3. Adjust the Tint slider if any further color correction is required. Move it left for more green or right for more magenta. See Figure 1.7.
4. Note that you might have to readjust the Exposure and Shadows settings after color correction because things may have shifted a little.

*If you hold down the Alt key (Option key in a Mac), the OK and Cancel buttons will change to Update and Reset. Update will update the RAW file with the entered settings, and Reset will restore all the sliders to the initial value when you first opened the image in the Camera RAW window. This is like the panic button when you have really messed things up and need to start again.*

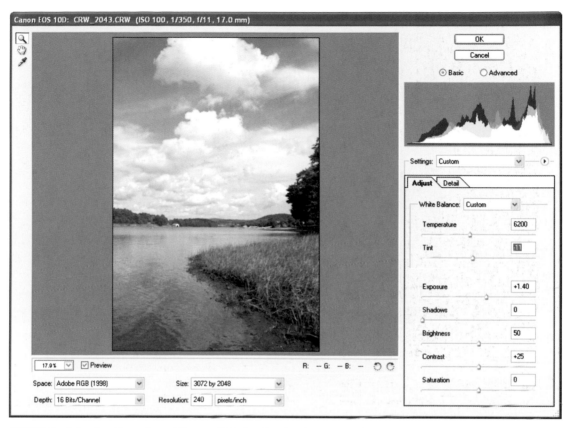

FIGURE 1.7    Adjusting the color settings. © 2003. Reprinted with permission from Nina Indset Andersen.

5. Click the Detail tab. This is where sharpening and noise reduction can be performed. It is usually best to perform sharpening in Photoshop after all the other corrections are complete. Use the Noise Reduction sliders to minimize grain that may be evident in the image. Look at the darker portions of the image to spot the grain. Always zoom to 100% when working on grain and sharpening images so that you can see the true result of the adjustments.

 *If you require resizing of the image, it's a good idea to do it in the Camera RAW dialog box now so that the image will be processed and imported to Photoshop at the desired size.*

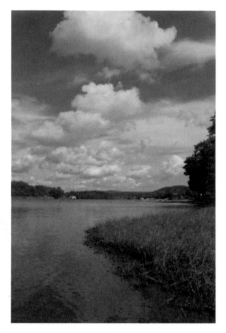

**FIGURE 1.8A**    RAW data. © 2003. Reprinted with permission from Nina Indset Andersen.

**FIGURE 1.8B**    The same data after processing using the Camera RAW dialog box. © 2003. Reprinted with permission from Nina Indset Andersen.

6. When you are satisfied with the settings, click OK to process the image and open it in Photoshop.

Figures 1.8A and 1.8B show the image before and after processing.

## Advanced Settings

If you are fussy about the tiny details and are pretty comfortable with image correction, take a peek at the Advanced settings.

Click the Advanced radio button. Two more options become available:

**Calibrate:** Adjusts the hue and saturation of each color channel separately; use this only if you are an advanced user.

**Lens:** Allows for compensation of the chromatic aberration and lens vignetting amount.

**FIGURE 1.9**   Aberration on the edge pixels. © 2003. Reprinted with permission from Nina Indset Andersen.

**FIGURE 1.10**   Aberration corrected. © 2003. Reprinted with permission from Nina Indset Andersen.

### Chromatic Aberration

If you zoom into an image very closely, chromatic aberration can sometimes be seen. This effect causes a slight, colored halo around the edges. In Figure 1.9, notice the color where the red meets the blue. This may not be a problem or even noticeable in a print. However, if you plan to remove the image from its background and paste it onto a white background, then the colored edges may be noticeable, depending on the resolution and how bad the aberration is.

Figure 1.10 shows the same image after a few tweaks on the Aberration sliders.

### Lens Vignetting

Sometimes a lens does not distribute light evenly across the image. Because of the curvature of a lens, the edges of the image sometimes appear darker than the center. This is called a *lens vignette*. Figure 1.11 shows an image with vignetting around the edges (the effect has been exaggerated here for learning purposes).

By adjusting the Vignetting Amount and Vignetting Midpoint sliders, we have compensated and now have an even distribution of light across the image, as shown in Figure 1.12.

**FIGURE 1.11** Lens vignetting. © 2003. Reprinted with permission from Nina Indset Andersen.

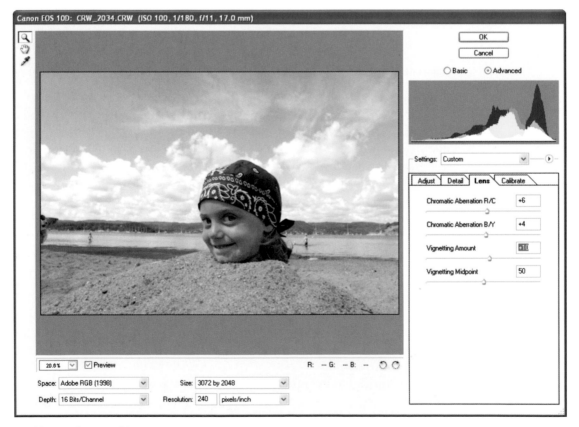

**FIGURE 1.12** Corrected image. © 2003. Reprinted with permission from Nina Indset Andersen.

## SUMMARY

Most of the information in the latter part of this chapter applies only if you are shooting in the RAW format. You learned about the advantages of shooting in the RAW format and how to produce better-looking images from your initial captures. There are a couple of disadvantages of RAW to keep in mind. The biggest is that you still have to process the images on your computer before they can be used. The other big drawback is that it's not quite as easy to share the images with someone else until you have processed them. Once you get comfortable with the process, you will find that the extra effort is well worth the advantages of working in RAW. If your camera does not support RAW, don't worry—this book shows you how to perform color and image correction tasks that achieve very good image results. If, after reading this chapter, you are a little confused with some of the terminology or principles, don't worry. These principles are broken down and explained in much more detail in the following chapters.

# ORGANIZING, AUTOMATION, AND OUTPUT

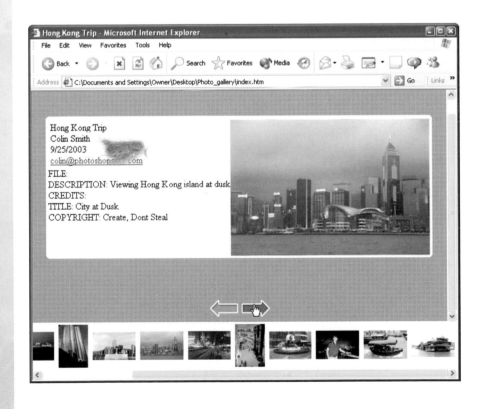

## Using the File Browser

Since Photoshop 7, a new feature has been introduced in Photoshop called the *File Browser*. This allows us to organize our images and provides a visual way to open them. The File Browser is so effective that many users have changed their workflow and hardly ever use the Open menu. The drawback of the File Browser is that it is pretty unstable with larger images (resulting in crashes) and slow. The good news is that in Photoshop CS, the File Browser has been transformed into a hulk and beefed up. The File Browser is laden with more features, and is faster and more stable. We are going to explore the File Browser and its plethora of new features in this chapter.

### Launching the File Browser

The most obvious change to the File Browser is the addition of the Toggle File Browser button on the option bar. This button, as shown in Figure 2.1, resides to the left of the palette well and remains as a permanent feature on the option bar.

**FIGURE 2.1** The Toggle File Browser button.

To launch the File Browser, click the Toggle File Browser button. Click it again to close the File Browser. You can also launch the File Browser by using:

- File > Browse
- Window > File Browser
- The shortcut keys Ctrl-Shift-O (Cmd-Shift-O in Mac)

The File Browser is no longer available as a palette from the Dock.

The File Browser is divided into three main regions, as shown in Figure 2.2. They are

**Navigation:** This is how you locate your images and folders on your computer and external drives.
**Preview:** This is where you preview the images in the folders.
**Information:** This is where you will find all your image and camera information.

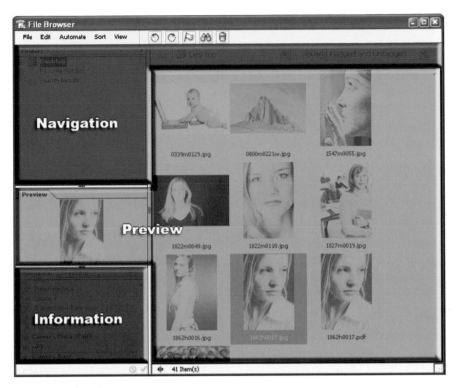

**FIGURE 2.2**    The File Browser.

### Navigating the File Browser

The File Browser functions very much as a visual navigation tool. You will notice that the Folders window looks and acts a lot like the File Explorer in Windows or like the Finder on the Mac. You can navigate to any folder using the Folders window; click on a folder to display its contents. When you are in a folder, its contents will be displayed in the main File Browser window as thumbnails, as seen in Figure 2.3.

Navigation can also be performed from the drop-down menu in the File Browser menu bar as shown in Figure 2.4. Notice that it displays the full path as well as the Favorite folder and the Recent folder. This is a great timesaver, as it saves hunting around for your images.

We love the File Browser for looking at Photo CDs. This feature saves hunting around for catalogs to locate images.

### Customizing the File Browser Windows

You can totally customize the File Browser windows.

If you double-click the window names such as Folders, Preview, and Metadata, the windows will collapse or expand. This allows more screen

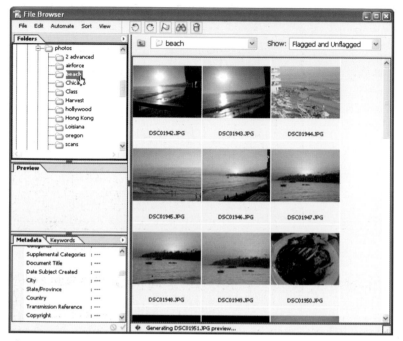

**FIGURE 2.3**  Navigating the Folders window.

**FIGURE 2.4**  Navigating from the drop-down menu.

real estate for the things that are important to you. Figure 2.5A shows the Folders window collapsed.

You can also resize panes by clicking and dragging the middle of the dividers. This is handy for browsing images with a bit more detail as we have done in Figure 2.5B. The preview will expand to fill the preview window and will scale to the window size. This is a great configuration for viewing large previews of all the images in a folder.

Another option is to hide all the windows except for the thumbnails. You will see a double-sided arrow in the bottom left of the thumbnail pane. Click this arrow to toggle the expanded view of the thumbnails, as shown in Figure 2.6. Press the button again to return to Normal view.

### Rotating Images

When you shoot with the camera held sideways, you create images with a portrait orientation as opposed to the usual landscape orientation. There is no way for Photoshop to know that you rotated the camera, so all the images are displayed in landscape by default. Of course, you will

**FIGURE 2.5A**   Collapsing windows.

**FIGURE 2.5B**   Drag the windows to resize them.

**FIGURE 2.6**   Expanded thumbnail view.

get a sore neck tilting your head all the time to view these images. The obvious solution is to rotate the images in the File Browser.

To rotate the images:

1. Click on the thumbnail (for multiple thumbnails, Ctrl-click or Cmd-click in a Mac).
2. Click on the rotation buttons on the menu bar in File Browser, as shown in Figure 2.7.
3. The image(s) will be rotated 90 degrees.

When the image has been rotated in File Browser, there will be a rotated arrow icon to indicate that the image has been marked for rotation,

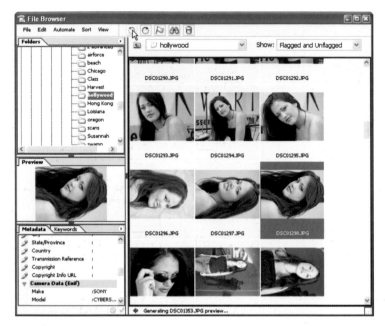

**FIGURE 2.7**    Rotating images.

**FIGURE 2.8**    A rotated thumbnail.

as shown in Figure 2.8. The actual image will be unchanged at this point. The thumbnails and preview will appear rotated, and when you open the image in Photoshop, it also will open in the previewed orientation.

If you save the image in Photoshop, the new orientation will be applied permanently, but otherwise it will remain simply marked in the File Browser.

To apply the rotation to the source image in File Browser, right-click on the thumbnail and choose Apply Rotation. This will not work on some RAW image files.

### Changing the Thumbnail Preview Sizes

By default, the thumbnails will display as Large. Depending on your screen resolution, this display will work best for most situations, offering a fairly large preview while still allowing approximately 24 thumbnails to be displayed on a monitor with 1024 × 768 resolution.

You can choose medium or small thumbnails from the View menu. Figure 2.9A shows us changing the thumbnail display. You can also choose Details, which shows a thumbnail and its associated information in a List view as shown in Figure 2.9B.

**FIGURE 2.9A**   Changing the thumbnail sizes.

**FIGURE 2.9B**   List view.

### Custom Thumbnail Sizes

As well as the preset thumbnail sizes, you can specify your own custom sizes. See Figure 2.10.

1. Choose Edit > Preferences.
2. You will see the File Browser Preferences window.
3. Enter a setting under Custom Thumbnail Size.
4. In this example we chose 500 pixels. You can set only the width; the height will be adjusted automatically.
5. Press OK.

Choose View > Custom Thumbnail Size from the menu in the File Browser.

Figure 2.11 shows the File Browser with a 500-pixel custom preview.

## Opening Images with the File Browser

There are several ways to open images in Photoshop from the File Browser. To open a file:

1. Double-click on the thumbnail or preview.
2. Choose File > Open.
3. Right-click and choose Open.

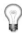 *By default the File Browser will stay open after you have opened an image. To open an image and close the File Browser at the same time, hold down the Alt key (Option in Mac) and double-click a thumbnail.*

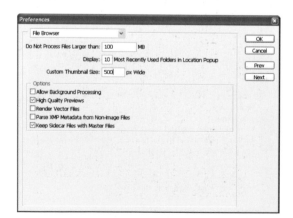

**FIGURE 2.10**    File Browser preferences.

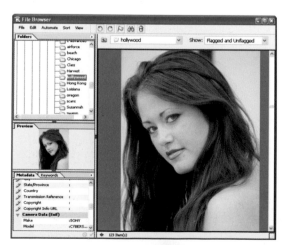

**FIGURE 2.11**    Custom thumbnail view.

You can also open an image in ImageReady if you prefer, by right-clicking the thumbnail and choosing Edit in ImageReady.

You are not limited to opening a single image at a time, because multiple images can be opened at the same time. This is really useful for opening a series of images. You can browse the thumbnails and select them by holding down the Ctrl key (Cmd in Mac) and clicking a thumbnail. When you click the thumbnail it will be highlighted, as shown in Figure 2.12, and added to the selected thumbnails.

When you have finished selecting all the desired thumbnails, double-click any one of the highlighted thumbnails to open all the selected images as a series of images, as shown in Figure 2.13.

### Organizing Contents of Folders

The File Browser provides a drag-and-drop environment for organizing your images. To move an image to a new folder, simply click and hold the mouse button on a thumbnail. It can then be moved to a folder by dragging to either a folder in the Folders window or to a folder in the Thumbnail window. See Figure 2.14. Release the mouse button to complete the move. To copy an item instead of moving it, hold down the Ctrl key (Cmd in Mac) while dragging. You will see a small plus sign to indicate you are copying an image to a new location.

**FIGURE 2.12**   Selecting multiple thumbnails.

**FIGURE 2.13**   Opening multiple images.

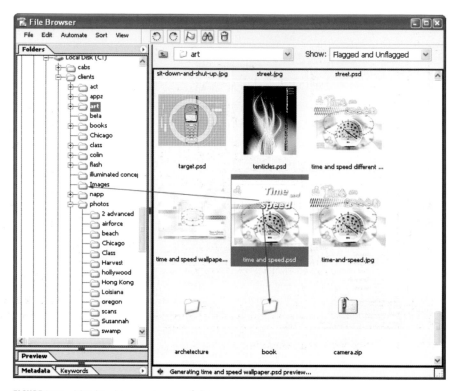

**FIGURE 2.14** Moving images to new folders.

## Using Favorites

A new time-saving feature in CS that has been borrowed from the Web browser world is the addition of a Favorites option. This saves a lot of digging around and repeated searching for folders on your computer. Once you mark a folder as a favorite, you can quickly select it from the menu.

To mark a folder as a favorite, first navigate to the folder. When the folder is selected, right-click on its name in the Folders window and choose Add Folder to Favorites (see Figure 2.15.) The folder will now be added to the Favorites list, as in Figure 2.16.

To open the folder from the Favorites list, click on the Folders drop-down menu from the menu bar in the File Browser. When the drop-down menu appears, choose your folder from the list in the Favorite Folders list. The thumbnails will now appear in the File Browser.

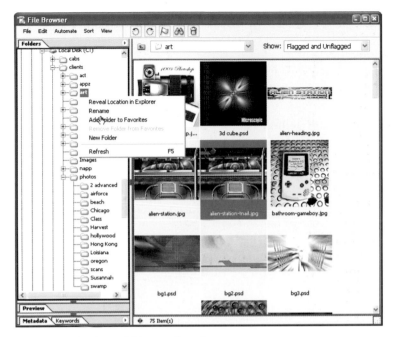

**FIGURE 2.15**    Setting a folder as a favorite.

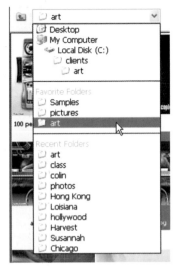

**FIGURE 2.16**    The folder added to the Favorites list.

## Metadata

Photoshop CS has really boosted the amount of information that you can store with your image. This information is called metadata. Photoshop uses the standard used by newspapers and other publishers called XMP (eXtensible Metadata Platform). This information is very important when transmitting images electronically and is becoming more important as standards are being set for professionals. This is also very useful for organizing and searching your images. Metadata includes captions, copyright information, keywords, descriptions, credits, and origin. This information will travel with the images saved in PSD, PSB, TIFF, JPEG, EPS, and PDF formats.

### Exif

If you shot your image with a digital camera, all the camera information will be stored with the image. This is called the Camera Data or Exif. When you view this information, it will tell you all the camera settings that were used for the picture. Can you imagine how valuable this is? For

example, if you have a photo that didn't come out quite right, you can look at the Exif data and see where you went wrong. This will help you learn and avoid the same problems in the future. On the reverse side of the coin, if you have a shot that is just perfect, you can take note of the settings and reproduce them in the future. Can you imagine how this information is going to help boost the level of photography? A scenario could involve a student giving an image to their teacher for review. The teacher then critiques the image based on the results and Exif data and offers suggestions for improvement.

### Viewing the Data

All the metadata will be displayed in the Metadata window when you select a thumbnail. Click on the arrows next to each category to expand/collapse the sub-levels and view the information. Figure 2.17 shows this information for a selected thumbnail.

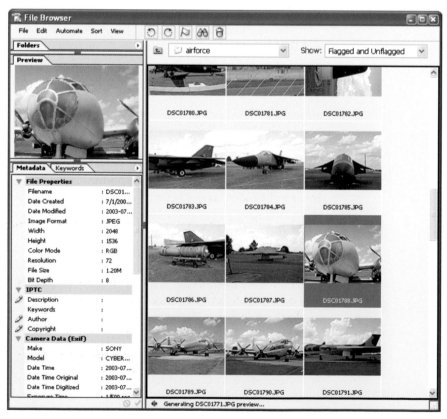

**FIGURE 2.17** The metadata information can be viewed from the File Browser.

There are several categories of data:

**File Properties:** The file information for the image will be displayed here.

**IPTC:** This is where you can add your own personalized information.

**Camera Data (EXIF):** All the settings used on the camera at the time of firing.

**GPS:** Some cameras come equipped with a GPS (global positioning system). The location will be saved in this category.

**Camera Raw:** Displays all the Camera Raw details.

**Edit History:** A log of all the image modifications will be saved in this category.

### Adding Information to the Metadata

All this metadata would not be really useful if you couldn't edit and add to the information yourself. All the camera information is saved automatically with the image file, but the rest of the information has to be added manually.

#### Adding the Information Directly

The quickest way to add the information is to add it directly into the Info field in the Metadata window in the File Browser.

1. Click on the Pencil icon to the left of any editable field. (Note: If there is no icon, that field is not editable.)
2. You will see a box appear with a cursor in it.
3. Type in your information as shown in Figure 2.18.
4. Click the check mark on the bottom right of the window to apply the information to the image.

The information will now be saved with the image.

#### Adding Data Using the File Info

You can also add or edit information using the File Info dialog box. This can be accessed by choosing File > File Info from either the File Browser or Photoshop itself. You can also access this dialog box by right-clicking on the thumbnail and choosing File Info.

The default category is the Description window. Enter the desired information into these fields as shown in Figure 2.19.

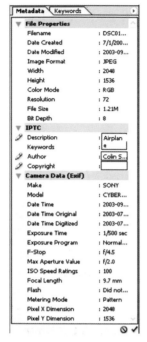

**FIGURE 2.18**   Adding data information to the Metadata.

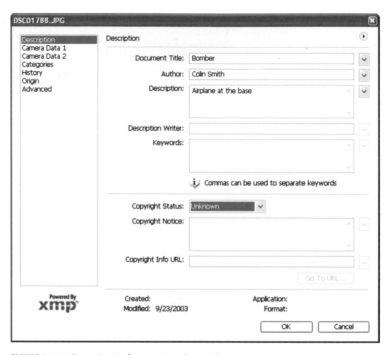

**FIGURE 2.19**   Entering information about the image.

### Copyright

For the copyright information, choose Copyrighted from the drop-down menu. (A copyright symbol will now be added to the image name.) Enter the desired copyright notice to be displayed.

When you have entered all the desired information, click OK to apply the data to the image. Figure 2.21 shows all the information viewable for the Metadata window in the File Browser.

### Saving a Metadata Template

You may find it becomes tedious to enter all the same information into every field of every image. To save some time, you can save your information as templates that will automatically populate the fields of the file info.

To save a template:

1. Open the File Info Palette from any image or thumbnail by right-clicking on the thumbnail. If the image already contains information, you can choose to replace the data with new information or use the existing data.

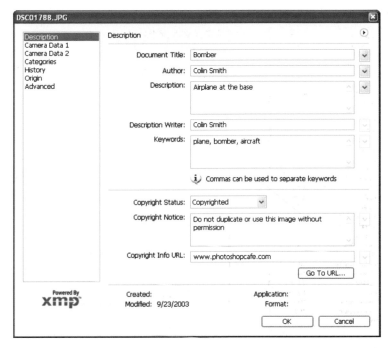

**FIGURE 2.20**    Adding copyright info.

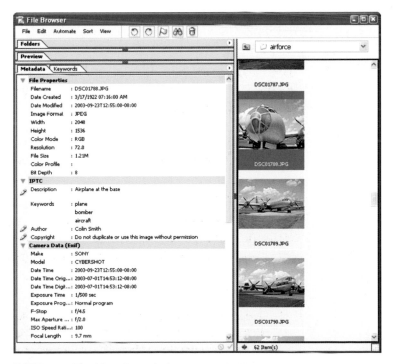

**FIGURE 2.21**    The Metadata window.

**FIGURE 2.22** Saving a template.

2. When you have appended the file information, click the top right arrow to open the drop-down menu.
3. Choose Save Metadata Template.
4. Enter a name for the template from the dialog box that opens, as shown in Figure 2.22.
5. Click Save.

To use a template:

1. Choose the image that you want to apply the data to.
2. Open the File Info Palette.
3. Click on the top-right arrow.
4. Choose your template from the list, as shown in Figure 2.23.

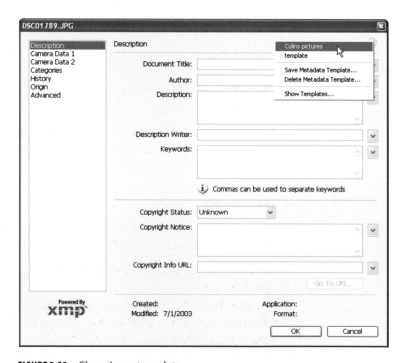

**FIGURE 2.23** Choosing a template.

**FIGURE 2.24**   The template applied.

5. The fields will now be filled out with the saved information, as shown in Figure 2.24.
6. Make any changes you desire.
7. Click OK.

Please note that when you apply a template, it will not overwrite any Exif information. The description, categories, and origin will be replaced by the template's information.

### Searching Your Images

Once you have entered all the metadata, you can use it to locate images based on different search criteria.

1. Click on the binocular icon in the File Browser's toolbar to open the search window.
2. Choose the folder to search in (under Source).
3. Choose a criterion. In the case of Figure 2.25, we have chosen to search for the key word "bomber."
4. Click the Search button.

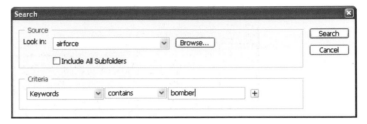

**FIGURE 2.25**   Preparing a search.

The File Browser will display thumbnails of all the images that match the search criteria, as shown in Figure 2.26.

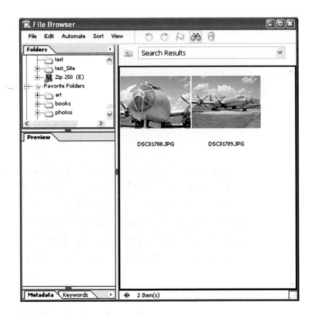

**FIGURE 2.26**   Search results.

## Batch Renaming

You have probably noticed by now that your digital camera assigns cryptic names to the images, which doesn't help you much when trying to locate images. For example, my Sony DSC-717 assigns an incremental number prefixed by the letters DSC. In Figure 2.27 you can see a shining example of these almost meaningless names. The good news is that the File Browser has a feature called Batch Rename that allows you to rename an entire folder of images.

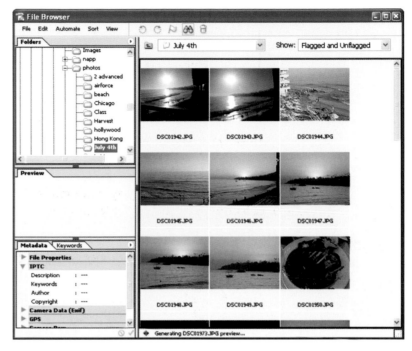

**FIGURE 2.27**    Digital camera's default names.

1. Choose a folder you want to rename. In Figure 2.27 we have chosen a folder of images shot on the Fourth of July at a dinner and fireworks display at the beach.
2. Choose Automate > Batch Rename.
3. A dialog box will pop up like the one in Figure 2.28. You have a choice to rename in the same folder (overwrites the existing image

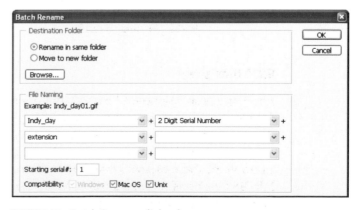

**FIGURE 2.28**    Batch Rename dialog box.

name) or move the images to a new folder (useful for organizing images). In this case we have chosen to use the same folder.

4. In the first field, enter the desired filename. We chose Indy_day, and then a two-digit serial number followed by the file extension. This way, all the images will be named Indy_day01.jpg, Indy_day02.jpg, and so on.

5. Enter the starting serial number and press OK to rename all the images in the folder.

Figure 2.29 shows all the images in the folder sporting their new names—much more interesting than the previous serial numbers.

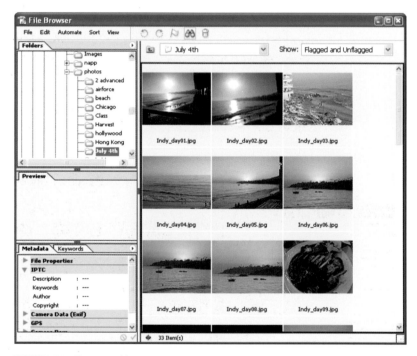

**FIGURE 2.29** Renamed images.

## Exporting the Images to a CD

Why include a section on burning images to a CD, you may ask? Don't you just copy the images to a CD and burn it? Yes you do, but the reason this section is here is to inform you of the image cache. When you make any alterations in the File Browser, such as rotating images and generating thumbnails, all the information is saved to a small file called a *cache file*. If you copy the images without the cache to another location, all the changes will be lost. It's very easy to copy the cache.

Select the folder that you are going to copy to a CD or other location. Choose File > Export Cache, as shown in Figure 2.30. The cache files will now be created in the folder.

Figure 2.31 shows that three files have been created in the image folder. When you copy the images, you should also copy the cache files. When the folder is opened in the File Browser, it will detect the cache and display the thumbnails correctly.

## Automation

Photoshop has an impressive array of automated tasks. These features will save you hours of time and will make molehills out of mountains by performing all the difficult and repetitive tasks for you automatically. You simply choose a few parameters and let Photoshop do the rest. In this section, we will discuss a few of these tasks that pertain to photographers.

Traditionally, all of the automated tasks were accessed from the File > Automate menu. They are still available from this menu, but they are also available directly from the File Browser in CS. You will notice that there is a dedicated Automate menu. This makes a lot of sense because

**FIGURE 2.30**  Exporting the cache.

**FIGURE 2.31**  Cache files.

you can now perform all these tasks from within the File Browser and see the images that are being affected. The File Browser in Photoshop CS has really graduated to a mini-application all its own!

### Contact Sheet II

A contact sheet is a page with all the thumbnails printed out with their filenames. This is very useful as an overview of your images and invaluable as a catalog tool. For example, you could create contact sheets of all your images and keep them in a binder. Then when you (or a client) need a specific type of image, you could quickly flip through the catalog of thumbnails, rather than browsing through each image. Another use for the contact sheet would be to produce a liner for your CD with all the thumbnails clearly displayed. Let's create a contact sheet, and you will see how easy and useful this feature is.

1. Browse to the folder that contains the images you want to add to the contact sheet.
2. You can create a contact sheet from either an entire folder or just selected images.
   a. If you want to use selected images, click on the first thumbnail and then hold down the Ctrl key (Cmd in Mac). Click on each thumbnail you want added to the selection, and they will be highlighted as you select them.
   b. If you want to use the entire folder, do nothing at this point.
3. Choose Automate > Contact Sheet II.
4. You will now see the dialog box shown in Figure 2.32.
5. Select your source images.
   a. For selected thumbnails, choose Selected Images from File Browser, as shown in Figure 2.32.
   b. To select the whole folder, choose Folder and then click on the Browse button and choose a folder.
6. Under Document, choose the desired size: 8 × 10 is the default and is the standard size for a photographic contact sheet. You can change this to anything you want, including 4.75 × 4.75 for a CD liner or 4.75 × 9.5 if you want a fold on the label.
7. Select the number of thumbnails you want to appear on each page, and the sizes will be adjusted automatically to fit your criteria.
8. Click OK.

Photoshop will now begin opening the images, resizing them, and arranging them into a contact sheet. If there are too many thumbnails to fit on one page, Photoshop will create multiple pages until all the thumb-

**FIGURE 2.32**    Setting up the contact sheet.

**FIGURE 2.33**    The finished contact sheet.

nails are arranged into contact sheets. Figure 2.33 shows a completed contact sheet.

### Picture Package

Picture Package is also a very useful tool. It enables us to save paper and time by squeezing as many copies of an image as possible on a sheet of paper while minimizing wasted space. This way you can print out, for example, two 4 × 5 images suitable for framing, with four wallet size prints taking up the rest of the page. Picture Package is used for a single image at a time and does not support multiple images. Picture packages are commonly used by portrait photographers. (Use the contact sheet for multiple images.)

1. Launch Picture Package by clicking either File > Automate > Picture Package or Automate > Picture Package from the File Browser.
2. Select the source image either by using a currently selected or open image, or by browsing to the desired image.

3. Choose your page size and layout. There are many different layouts to choose from.

4. If you can't find exactly what you are looking for in the presets (very unlikely), choose the closest and click Customize. Make any alterations and then click OK to return to the main dialog box.

5. If you want to add a label to the sheet, choose a label option from the Label section of the dialog box. If you want a higher-quality print for the contact sheet, change the default resolution to 180 or 240. The default of 72 will work if you just require a rough guide and you don't want to use a lot of ink.

6. Check the layout preview to make sure everything looks as you want, as shown in Figure 2.34.

7. Click OK.

After Photoshop has performed its magic, you will see the results displayed as a document (see Figure 2.35). You can now print and trim the photos.

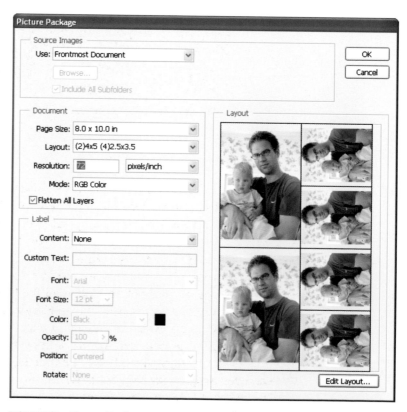

**FIGURE 2.34** Picture Package options.

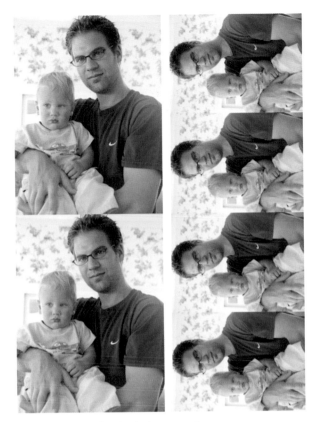

**FIGURE 2.35**    The finished picture package.

### PDF Presentation

PDF (Portable Document Format) is really coming to the forefront of publishing technology, and Adobe has built in a lot of PDF functionality to its Creative Suite of products. Photoshop can natively create and open PDF files. These files can be read by anyone who has the free viewer. New computers ship with the Adobe® Reader (formally know as the Acrobat® Reader). Otherwise, it can be downloaded for free at *www.adobe.com*. It is beyond the scope of this book to look at all the features of PDF, but there are several features that are invaluable to photographers. You can create a PDF image that compresses very well and enables the viewer to zoom in and out of the image and, perhaps most important, you can set security preferences that prevent people from extracting or printing the images. You can even assign a password that will be required to view the image.

Photoshop CS has incorporated a very welcome feature that now makes PDF a feasible option for photographers. This new feature allows

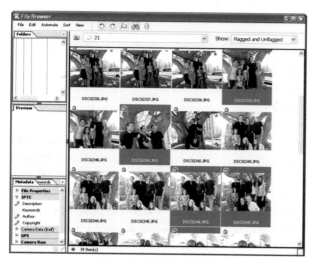

**FIGURE 2.36** Selecting thumbnails.

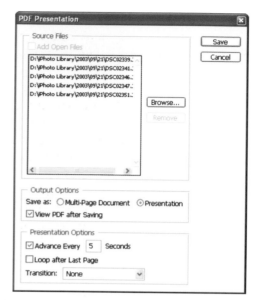

**FIGURE 2.37** PDF Presentation dialog box.

you to create a multipage PDF document, so that you can now create your portfolio as a PDF and control the way the viewer sees your images.

1. Select the thumbnails that you want to add to the presentation. Ctrl-click (Cmd in Mac) to add to the selection, as show in Figure 2.36.
2. Choose Automate > PDF Presentation, and the dialog box shown in Figure 2.37 will open.

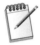

*All images in the RAW format will have to be imported to Photoshop and converted before they can be batch processed.*

3. If you have selected thumbnails, they will appear in the Source Files window; otherwise, click Browse and add the images you want in the presentation.
4. Choose between a multipage document (standard PDF document) or a presentation. The presentation will be a self-running slide show that will run full screen on any computer equipped with Adobe Reader.
5. If you want to preview the PDF as soon as it is created, check the View PDF after Saving button.
6. If you choose Presentation, choose your options. You can set the delay time between images and decide if the presentation will run once or as an endless loop.

7. Choose a transition effect, which determines how the images will look as they change from image to image. There are quite a few interesting options. Figure 2.38 shows us choosing a random transition effect.

8. When you have set the options, click Save.

9. You will now see a new dialog box, as shown in Figure 2.39. This is the PDF Options dialog box.

10. You have a choice between Zip and JPEG compression.

    a. Zip is a lossless format and will produce the best result, but it will also produce the largest file size. We suggest using this option if you are going to run the presentation from a computer's hard disk or CD/DVD.

    b. JPEG offers the maximum compression, but at lower settings it can cause some image degradation. This is the best option for Web use. Choose a quality ranging from 1–12. Usually 5 or 6 is a good all-purpose setting. You may want to experiment with this until you get a result that suits your needs the best.

11. Choose Image Interpolation if the viewer is going to zoom in or out of the images; this will produce a sharper result.

12. We will discuss the security settings at the end of this section.

13. If the image contains any text or vector layer shapes, in Photoshop you can choose Include Vector Data for a sharper result.

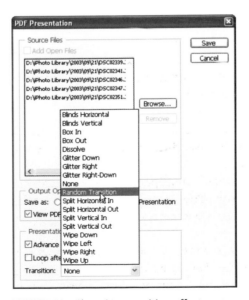

**FIGURE 2.38** Choosing transition effects.

**FIGURE 2.39** Choosing compression options.

14. Click OK to create your PDF, and you will be prompted to choose a location to save the PDF.
15. If you checked the View PDF after Saving button, the PDF will launch when it is created. You can now view the slide show or the multipage document, as shown in Figure 2.40. (The presentation will take up the full screen, and no interface will be visible until you press the Esc key.)

### PDF Security

Because this is such a valuable tool for photographers, we will dedicate this section just to PDF security options. These options are available from two places:

- Choose Automate > PDF Presentation; after you press Save, the Save Options dialog box will open with a button for PDF Security.
- Choose File > Save As. Choose PDF, and the dialog box will open with the PDF security option.

The first field enables you to enter a password to protect the document. The password will be required to open the document. This is great for confidential and sensitive documents.

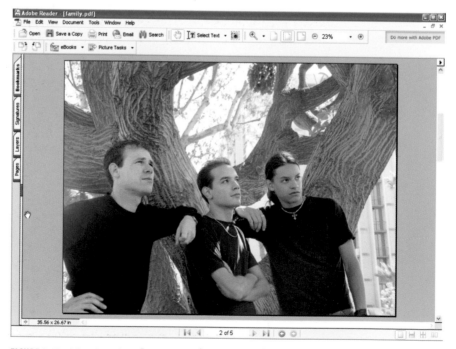

**FIGURE 2.40**    Viewing the presentation in Adobe Reader.

The second field protects the permissions and must be enabled before you can use any of the other security features. Once this is enabled, you can control the other options:

**No Printing:** Prevents anyone from printing the document.

**No Changing the Document:** Locks the document and prevents any changes to the document.

**No Content Copying or Extraction:** Prevents saving copies of the document and locks the images so they cannot be extracted in Photoshop or any other program.

**No Adding or Changing Comments and Form Fields:** Prevents anyone from changing the comments or editing the forms.

Figure 2.41 shows the PDF Security dialog box with the default 40-bit encryption selected.

There are three different types of security settings:

**40-bit RC4 (default):** Acrobat 3 and 4

**128-bit RC4:** Acrobat 5

**128-bit RC4:** Acrobat 6 (Adobe Reader)

If you choose the 128-bit encryption, the document will be more secure, and the way the options are arranged will be a bit different, as shown in Figure 2.42. You will have more control over the editing permissions as well as the capability to allow low-resolution printing as a third option, as opposed to just printing or not printing.

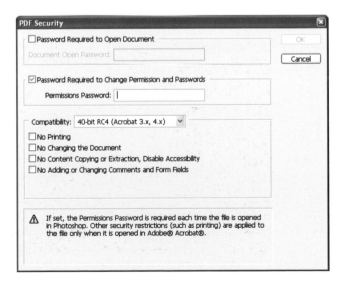

**FIGURE 2.41**   PDF Security Palette.

The only difference between the Acrobat 5 and 6 output is the addition of metadata support. You can now choose whether or not to encrypt the metadata.

## Web Gallery

Ever wanted to put your images up on a Web site, but lack the HTML skills? The Web Photo Gallery makes it a snap. Photoshop will create small thumbnails and place them on a page. When you click on the thumbnails, they will launch a larger version of the image. Photoshop re-sizes all the images and creates all the Web pages necessary for smooth navigation. What is more, the metadata can be used for captions, page titles, and more. You can point the gallery at a folder of images, go get a cup of coffee, and before you return, your Web page is finished and ready for uploading to the Web. Let's see how it works.

1. Choose File > Automate > Web Photo Gallery or choose Web Photo Gallery from the Automate menu in the File Browser.
2. You will now see the dialog box shown in Figure 2.43.
3. Choose a style of page from the first option. You can see a graphical preview to the right of the dialog box.
4. Enter your e-mail in the e-mail field. This will create a link that people can click on to contact you while browsing your page.

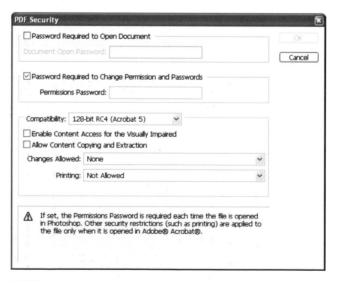

**FIGURE 2.42**    128-bit encryption options.

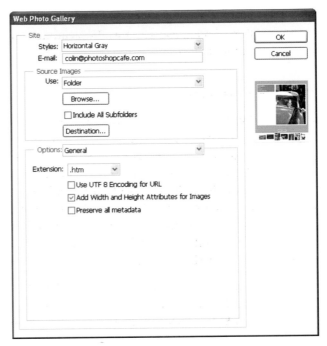

**FIGURE 2.43**    Web Photo Gallery.

5. Choose your source images. Either use selected images in the File Browser or choose a folder of images. In Figure 2.44, we have selected a folder of images to use.

6. Choose the destination where the gallery will be placed when it's built. In Figure 2.45 we have created a new folder for the gallery,

**FIGURE 2.44**    Choosing a source folder.

**FIGURE 2.45**    Choosing a destination folder.

which is a good idea because all the files will be kept together in one place.

Time to set the options:

1. Choose Banner. This is the title that will appear on the top of the Web page.
2. Fill out the Banner options as shown in Figure 2.46.
3. Choose Large Images. This is where you decide how large the images will appear on the Web page.
4. Select an image size, or enter your own custom size.
5. Choose a level of image compression. Five is a good setting for a Web page. If you were to put the gallery on a CD, you would choose a higher setting because download speed is not an issue on a CD.

If you want, you can make two copies of the gallery: one with low-quality JPEG for dial-up connections and another with high-quality for broadband.

Choose the options for titles as shown in Figure 2.47. This information will be pulled from the metadata.

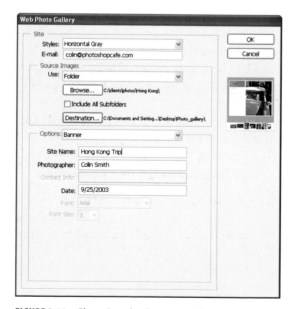

**FIGURE 2.46**   Choosing the Banner options.

**FIGURE 2.47**   Choosing the image options.

**FIGURE 2.48**   Setting the thumbnail options.

1. Choose the thumbnail options as shown in Figure 2.48.
2. Select a size for the thumbnails. These are the small images that will load quickly and provide a way for visitors to click through to the larger images.
3. Fill out the other options if they are available. If they are grayed out, it means that they are not available for the chosen galley style.
4. Click OK to run the Web Photo Gallery. You will see some activity as Photoshop goes to work, resizing images and creating HTML pages.

When you are done, the Web page will launch in your default browser as shown in Figure 2.49.

All your files are in the Destination folder. Upload the folder to a Web server to display them to the world.

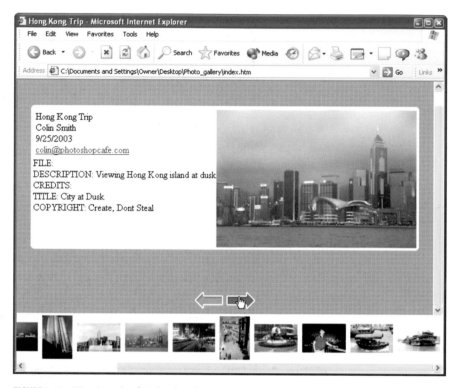

**FIGURE 2.49** Viewing the finished Web page.

## Watermarking Your Images Automatically

While creating your Web galleries, you can choose to have all your images watermarked. This will prevent anyone from using your images without your permission. This is also a great feature for sending out "comping" images; if the client decides to purchase the photo, you can supply a high-resolution copy without the watermark.

1. Choose the Security option from the Options as shown in Figure 2.50.
2. Choose the Custom Text option.
3. Enter anything you want in the Custom Text field. In this case we have added the copyright symbol.
4. Choose a size and color for the watermark. Also choose an Opacity setting such as we did in Figure 2.50.
5. Create the Web gallery just like we did in the previous exercise.

When the Web page is complete, you will see the watermark on all your images, as shown in Figure 2.51.

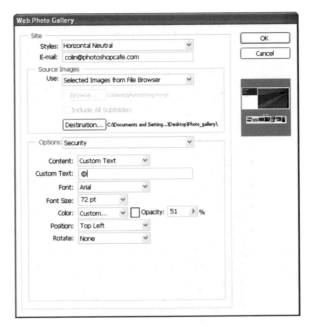

**FIGURE 2.50**  Choosing the Security options.

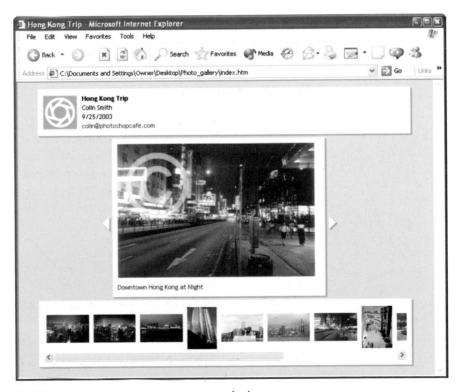

**FIGURE 2.51**  Your images are now watermarked.

Please find this Web gallery on the CD under `Photo_gallery`. Double-click on the `index.htm` file to launch the gallery.

## Printing

Photoshop has a few interesting features when it comes to printing. The most important thing to note before printing is resolution. If the resolution of the image isn't sufficient for the size of the print, pixelization will occur. Pixelization occurs when there is an insufficient number of pixels present in the image for the desired output size. The result is that the pixels become so large that they are visible as small squares. This problem is also known as the "jaggies," where everything looks like it is made out of Lego® blocks. The solution is to print the image at a smaller size by scaling it down.

The recommended resolutions are:

**Online Graphics:** 72 ppi
**Inkjet Printer:** 150 ppi
**Photo Printer:** 360 ppi is the native resolution of an Epson printer. Choose 360, 240, or 180 ppi for Epson. For a Canon printer, choose 300 ppi. Please also note that these printers will interpolate the images to match their native resolution. There is no advantage in trying to print at a higher resolution as the prints will still be downsized. Don't be fooled into thinking that because the printer has a higher dpi rating, a higher pixel resolution will produce a better print (dpi refers to dots of ink on a page, and ppi refers to pixels in an image).
**Commercial Printing Press:** 300 ppi

Let's look at some of the resizing options in Photoshop.

1. Choose File > Print with Preview.
2. Click Page Setup to choose the page size and orientation.
3. You will see a preview of the image and how it fits on the page. Choose Scale to Fit Media to enlarge/reduce the image to fit the page and allow for the extra space on the sides that the printer feeder uses.

Figure 2.52 shows an image that is scaled to the page size. (Please note that resizing the image in the print preview will cause a slight drop in quality of the print. For the best results, resize the image in Photoshop at the printer's native resolution.)

You can scale your image by entering a percent of dimensions into the Scaled Print Size fields.

**FIGURE 2.52**    Image scaled to fit the page.

If you check the Show Bounding Boxes option, you can click and drag a corner of the preview with your mouse and scale the image manually, as shown in Figure 2.53.

By default, the image will always print in the center of the page. If you turn off the Center Image checkbox, you can position the image manually. Click and drag the image to position it on the page, as shown in Figure 2.54.

When you have finished positioning and scaling the image, click Print to send it to the printer.

### Creating a Test Print

It's a good idea to print a small portion of the image to see how it will look before committing the time, ink, and the expensive sheet of paper that it takes to print a full page.

To do this, take a smaller portion of the image, print it, and then check it for color and tone accuracy. You could also take a few sheets of photo paper and cut them into smaller pieces to print on, thus reducing

**FIGURE 2.53**    Scaling an image manually.

**FIGURE 2.54**    Positioning an image on the page.

waste. Here is a strategy for creating a test print (courtesy of professional photographer Tim Cooper):

1. Open the image you want to print.
2. Choose the rectangular marquee tool and make a selection around the portion of the image you wish to print.
3. Choose Edit > Print with Preview.
4. Check the Print Selected Area box.
5. The selected area will be printed in the center of the page.

### Choosing Paper

When you want the best quality print from your printer, you will need to use the best paper. The two main manufacturers of quality photo printers are Epson and Canon, and both manufacturers make their own paper. These papers are specially formulated to produce the best results from the chemical composition of the specialty inks used. Therefore, if you are using a Canon printer, Canon photo paper will yield the best results, whereas Epson paper will produce the best images from an Epson printer.

## SUMMARY

We covered a lot of ground in this chapter. As you learned, the File Browser in Photoshop CS can now do a lot more than just organize images. You also learned how to customize the settings to suit your workflow, and how to use metadata to tag, organize, and search for your images. You will definitely find these features useful in the future. We also looked at different tasks that can be automated from within the File Browser, including putting your images onto a Web page. These automated tasks can shave hours off your work schedule. Also, you learned about printing and how to produce the best possible print from your photos.

In the next chapter you will learn about resolution and the best way to resize and crop your images.

# 3

# CROPPING AND SIZING

I n this chapter we are going to have a quick primer on resolution and resizing. We will look at a little theory in the first section and then branch out from there and have some fun with the resizing and cropping tools in Photoshop CS. At this point you probably have no idea how much fun you can have with a cropping tool and its versatility.

## RESIZING THINGS

We are going to jump into a little light theory before we start having all the fun. If you are not comfortable with resolution and resizing algorithms, this small section will help you a lot. If you are already familiar with the concept, you should still skim through this material because Photoshop CS offers some new options.

### Resolution

Whatever the reason for resizing your images, there are a few things that you should know. The first thing you should understand is resolution. Resolution is how many pixels there are in an image. We measure resolution in pixels per inch (ppi), which is the measure of the number of pixels displayed in an image. A digital image is composed of samples that your screen displays in pixels. The ppi is the display resolution, not the printed resolution. Adobe Photoshop uses ppi for image resolution, but you may hear it called dots per inch (dpi) as well. Dpi, however, is the measure of the resolution of a printer. It properly refers to the dots of ink or toner used by an imagesetter, laser printer, or other printing device to print your text and graphics. In general, the more dots, the better and sharper the image. Dpi is printer resolution. When we refer to resolution, we will be referring to ppi.

There are three main targets for Photoshop files:

**Offset printing:** The best resolution for the professional offset press printing world is 300 ppi.

**Inkjet printers:** Use 360 ppi for Epson printers and 300 ppi for Canon. For more detailed information and printing tips, refer to Chapter 2, "Organizing, Automation, and Output."

**Online:** The standard resolution for Web and multimedia use is 72 ppi; this is also known as *screen resolution*.

If you try to use an image with insufficient resolution, there are not enough pixels to provide a sharp display and, as a consequence, pixelization occurs, also known as "the jaggies."

Figure 3.1A shows an image at the correct resolution, and Figure 3.1B shows an image suffering from the jaggies.

**FIGURES 3.1A and 3.1B**    Having insufficient pixels causes jaggies.

To estimate how large an image will print, you can use this formula:

Image size in pixels ÷ Target resolution = Output size in inches

For example, if an image is 500 pixels wide, and we want to output at 300 ppi, then 500 ÷ 300 = 1.667, so the maximum size we can output this image at 300 ppi will be 1.667 inches. The same image would be 6.9 inches at 72 ppi (500 ÷ 72 = 6.9). Both sizes contain exactly the same number of pixels, because the image itself has not been altered. When we change only the target resolution, the process is called resizing.

Anytime you change the number of pixels in an image, you will lose some quality. Sometimes it is noticeable, and sometimes not. What you are doing is called *resampling*. Resampling is when you alter all the pixels in an image. When you change the physical size of a document, pixels have to be added or discarded and the image re-rendered. When you increase the size of an image (upsampling), the photo doesn't have the pixels to fill the new size, so pixelization occurs. When you are reducing the size of an image (downsampling), all the pixels are mashed together, and Photoshop has to throw away some pixels. Because of this, it's best to help Photoshop by choosing a size that is easy to calculate. If you size in increments of one-tenth (10%), you will find that the overall quality is better. This makes it possible for Photoshop to add or remove pixels in an even way.

As a rule of thumb, Photoshop does a good job of downsizing your image. With upsampling you need to be more careful. The old adage was that you shouldn't up-size more than double the file size.

There are methods you can use if you need to go larger, which are discussed later in this chapter.

### Image Interpolation

By now, you may be asking what is the point in resizing an image if you are going to lose quality. The studious team of engineers at Adobe realized that you may want to change the size of your images at some point, so they incorporated a technology into Photoshop called *image interpolation*.

Interpolation is a popular term in the scanning world. Chances are that your digital camera also has a form of interpolation—definitely if it uses digital zoom (a feature that should be avoided most of the time; refer to Chapter 1, "Before You Begin," for more info). Digital zoom analyzes a picture and, based on the pixel information, interpolates, or calculates, what pixels should be created to fill in all the gaps. The interpolation en-

gine will then kick in and draw the missing pixels just like magic. Depending on what type of image you are resizing, you can choose a different interpolation method. (Adobe calls these *resizing algorithms*.) There used to be only three methods, but two new methods have been introduced in Photoshop CS (Bicubic Smoother and Bicubic Sharper). The methods and their uses are as follows; Figure 3.2a shows the original images, and Figures 3.2 b–f illustrate the effects of the different interpolation methods.

**Nearest Neighbor** (see Figure 3.2b): This method bases decisions on the adjacent pixels and is the lowest quality setting. It is best for line art type images.

**Bilinear** (see Figure 3.2c): This is a medium quality, good for solid color and text. It looks at the four pixels on the two sides, the top, and the bottom of each existing pixel.

**Bicubic** (see Figure 3.2d): This is high quality; it uses the eight surrounding pixels and is the default setting for most images. It's a good "Jack of all trades."

**Bicubic Softer** (see Figure 3.2e): This is the best setting for upsampling images.

**Bicubic Sharper** (see Figure 3.2f): This is the best setting for downsampling images, according to the Adobe engineers. Be careful, though, because it can sometimes add unwanted sharpening to your images. Try it first to see if it is appropriate for your image.

At first appearances, the only time you have access to different interpolation modes is when you choose the Image Resize dialog box. However, whenever you use the Free Transform tool, interpolation is applied to the transformation. The transform tool uses the settings in Preferences. You can set the method in the Preferences panel, shown in Figure 3.3. The default is Bicubic, which is a good general-purpose setting. This preference will be applied to all transformations and scaling.

 *When you change the resampling method setting in Preferences, the new setting will be applied right away, and you will not have to restart Photoshop as with some of the other settings.*

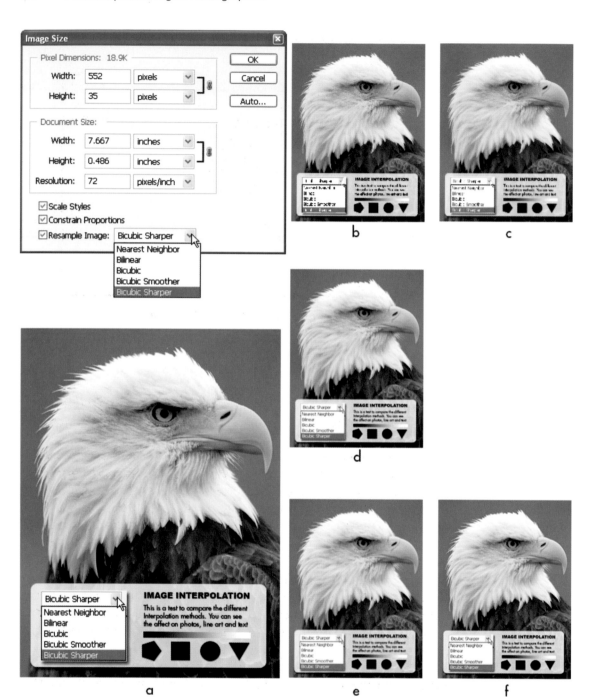

**FIGURE 3.2** The different interpolation methods in Photoshop.

**FIGURE 3.3**  Setting default interpolation in Preferences.

## Image Size

You have taken the plunge; now you are going to resize your image. We are going to look at three ways to do this. The first method is the most direct way.

From the menu bar, select Image > Image Size. You will now see the dialog box shown in Figure 3.4. The dialog box will display the current image size and resolution of your picture (b, c, and d).

To resample the image, make sure you check the box (g). If you don't check the box, the resolution will change to match the new size you input, but the pixels will not change, resulting in no change to your output image.

The Checkbox (e) is a welcome new feature in Photoshop CS. This will make the layer styles resize with the image. Without this button, any layer styles will look like a child wearing his parent's clothes, or an adult wearing a kid's clothes. We will use some layer styles in Chapter 9, "Special Effects."

When the box (f) is checked, your image will stay in proportion. For example, if you enter a new height, the width will automatically adjust to match.

Choose your resampling method (i).

Enter either the target size in inches (c) or pixels (b) or enter the target resolution (d). Press OK and the image will be resampled.

a Unit of measure
b Image size in Pixels
c Image size
d Resolution in ppi
e Scale Layer effects
f Maintain aspect
g Allows resampling
Auto resize h
Interpolation Method i

**FIGURE 3.4**   The Image Size dialog box.

As an alternative, you could click the Auto button in the Resize dialog box. This is the auto resolution feature. A new dialog box will pop up, as seen in Figure 3.5. You just enter your target line screen (line screen is a term used for commercial printing; as a rule of thumb, line screen will be half the resolution) and the quality, and Photoshop will then enter the recommended settings for you.

The third way to resize your images and the easiest way for someone who is not too familiar with resolution is to use the Resize Wizard. From the menu bar, select Help > Resize Image. Use this method only if you are totally confused with resizing and are printing to either an offset printer or uploading to a Web site.

Figure 3.6 shows the first screen for the Resize Wizard. You have two initial choices: Web or Print. If you choose Web, you will be asked what

**FIGURE 3.5**   Auto resolution.

**FIGURE 3.6**    The Resize Wizard.

size you want the image changed to, and Photoshop will resize the image at 72 ppi.

If you choose Print, you will have to complete a short interview. You will be asked the following:

**Desired size:** Enter the desired new size of the image.

**Line screen (lpi):** There are hints for the purpose of your image. Line Screen is used in offset printing. Usually the line screen will be half the resolution. So if you want 300 ppi, choose 150 lpi.

**Quality:** Here you will choose how high you want the quality of the image. Remember that if you are increasing the size of an image, you will still lose some quality no matter what setting you use. If you are going to final print, choose the highest setting. If you are just printing a comp, then choose one of the lower settings.

Press OK, and Photoshop will resize your image. A short summary will be displayed also with any warnings and further recommendations.

## Increasing the Image Size Beyond 200%

As mentioned earlier in this chapter, it's not a good thing to go beyond double the original file size. There are ways to break this rule.

One is called Stair Step Interpolation. This technique is credited to photographer Fred Miranda.

If you resize an image in increments of 10%, the loss is minimized. Pretty large images can be accomplished by using this method.

It can take a while to keep enlarging an image many times, so this is a great time to create an action. I have included a simple action on the CD-ROM, under the filename `PSDP-Colin_Smith.atn`. There are two actions in this set. The first is a 110% enlargement in a single step. The second is the same enlargement five times, which will save a bit of time.

To load an action:

1. Open the Actions palette.
2. Choose the drop-down menu at the top right of the palette.
3. Choose Load Actions.
4. Navigate to the action on the CD.
5. Click OK.

You are now ready to run the action.

When you are running an action, you will no longer be viewing the Image Size dialog box. How will you know when you have reached your target size? Click on the arrow on the bottom left of the Document window (the status bar). Choose Document Dimensions for the preferences.

There are also third-party products available for resizing images. Three of them are

- Extensis™ pxl Smart Scale at *www.extensis.com*. Extensis claims that an image can be enlarged 1600% with no visible loss of quality.
- Genuine Fractals™ at *http://www.lizardtech.com/solutions/gf/*.
- Fred Miranda's Stair Interpolation Action (*http://www.fredmiranda. com*).

## Canvas Size

In contrast to the Resize option, the canvas size leaves the image's pixels intact. The canvas size changes the size of the overall area of the image, just like a painting canvas. When we increase the canvas size, solid colored, filled pixels are added to the edges of the image. If we reduce the canvas size, we are performing the same function as cropping the image.

Using the Canvas Size tool is pretty straightforward. Enter the desired canvas size into the New Size fields as seen in Figure 3.7A. Choose the anchor by clicking any one of the nine boxes. Arrows will appear to indicate where the new pixels will be added. For example, if you want to extend the canvas to the bottom right, you would choose the top left anchor point as shown in Figure 3.7B.

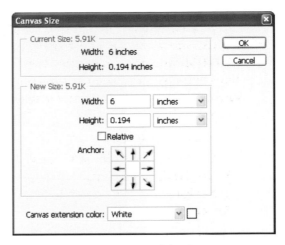

**FIGURE 3.7A**   The Canvas Size dialog box.

**FIGURE 3.7B**   Changing the anchor.

Over the last couple of releases of Photoshop, the canvas resize has become quite developed. In Photoshop 7 the Relative option was added, and in CS the Background Color Chooser has been added.

Let's explore these options now.

1. Open an image; we are using `City night.jpg` from Ablestock Images.
2. Select Image > Canvas Size.

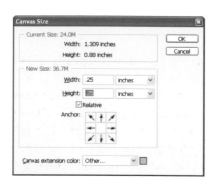

**FIGURE 3.8A**   Choosing the Relative option.

**FIGURE 3.8B**   Useful for adding frames around images.

3. Check the Relative box. The fields will now display 0. This is because the Relative option ignores the existing size and wants to know only what you want to add to the image. This is a great option and saves a lot of math.

4. Set .25 inches for the width and the height. Keep the anchor centered. This will add one-quarter inch to the canvas all the way around the image.

5. Choose the canvas extension color. Choose Foreground, Background, White, and Black or click the color swatch to choose a color for a color picker. We have chosen an orange color in Figure 3.8A. This is a very welcome option in the CS release.

6. Click OK, and your frame will be added as in Figure 3.8B.

A more practical use for the Relative option is to add bleeds to an image. Because a printer can't print all the way to the edges, a bleed is a little extra on the edges of a picture that go over the image size, so that when it's trimmed, there will be no white paper showing on the edges.

### Creative Cropping

Sometimes, the best way to trim your images is to crop rather than resize, so that we can focus on the main subject and remove distractions. It's also

a great way to bring our images down to the desired size without resampling.

### Changing Composition and Emphasis

When we crop an image, essentially we are taking out our digital scissors and cutting away the unwanted parts of an image until we are left with the perfect composition. This is a great way to draw attention to a certain part of an image and create a mood. For example, the picture in Figure 3.9 shows an image that I took in Chicago. It looks very much like a snapshot. Is the photo supposed to be of the buildings, the road, or the train line? There is so much going on that no one knows for sure. Once we have cropped the image in Figure 3.10, there is an emphasis on the ground level of the city. You now notice the brake lights of the cars and how they match the traffic signals.

To crop an image:

1. Choose the Crop tool from the toolbar.
2. Drag over the image as you would with the Marquee tool.
3. When you choose the Crop tool, you have a few options that you can set from the top menu bar, starting with Cropped Area, Delete or Hide? See Figure 3.11.

**FIGURE 3.9**   The uncropped image: the subject of the picture is unclear.

**FIGURE 3.10**   The same image cropped. The subject is now emphasized.

**FIGURE 3.11**   The cropping tool options.

    a. If you choose Delete, your image will be cropped and all the "trimmed fat" will be tossed away. This is a great option if you want to save space, you have a slower machine, and you're certain that you will never need the image data again. Of course, you could always save a copy.

    b. If you choose Hide, the image will be cropped, but no image information will be lost. The image will still be there, and only the canvas will be reduced. You can get back the detail again by increasing the canvas size. (This is the best option if you are "comping" a layout and may want to change things later.)

  4. The next set of options are the shield options, also shown in Figure 3.11.

    a. When you check the Shield option, a colored area will dim the area to be cropped away.

    b. The color box works like a standard color picker for you to choose your shield color.

    c. The Opacity slider determines how transparent the shield will be. Adjust this to suit your tastes.

When you are happy with your composition and settings, apply the crop. You can do so by clicking the check mark on the right side of the

toolbar, pressing the Enter key (Return in Mac), or double-clicking anywhere inside the cropping area.

### Cropping Out Unwanted Detail

Pictures of people often beg to be cropped. This is especially true if you are putting your images online and want to keep them as small as possible, or when you have limited space in a print piece. You see a lot of pictures that have unneeded detail and extreme headroom, as in Figure 3.12, that take up valuable space and force the faces to be so small you cannot recognize who the people are. If you are smiling right now, you have probably faced this same frustration I have. Let's emphasize the facial expression, which will communicate more through your work than needless background elements.

Of course there are times for a more creative shot with lots of interesting background detail, but this is not one of those times. Don't be afraid to be bold and ruthless. There is no law that says that you cannot crop the subject as we did in Figure 3.13. Notice how it draws us more into the picture and causes us to feel closer to the subject; the viewer is more involved and not just a casual observer.

**FIGURE 3.12**  The image uncropped—nice picture, but a bit distant. Royalty Free Image from Hemera™

**FIGURE 3.13**  Cropped for emphasis, the picture draws the viewer into the picture.

### Cropping for Perception

In the old movie westerns, the prop builders built the doors smaller to make the men appear large and intimidating. In contrast, the doorways the women used were made larger so the women would appear daintier. This is all about perception.

Another reason to crop an image is to change the perception. A classic example is the tall building. Figure 3.14 shows a typical snapshot of a tall building. By trimming out the sides and making the canvas narrower, we are putting more emphasis on the vertical aspect of the image. We are adding emphasis to the fact that the building is tall and exaggerating that aspect of the picture. Notice that the picture looks more natural in Figure 3.15.

**FIGURE 3.14**   A tall building in a typical snapshot.

**FIGURE 3.15**   The same building with an emphasis on the vertical aspect, just by cropping the image.

### Practical Cropping

In addition to creative cropping purposes, there are also some practical reasons to crop images and some really useful things you can do with the Crop tool.

 *When you have a lot of active layers in your image, the file size begins to get very large and causes your computer to slow down. Even if parts of an image are off the screen, they still count toward image size. By selecting your entire image and cropping, you can sometimes greatly reduce the file size.*

### Straightening

There are plenty of times when a photo wasn't taken quite straight and is a bit tilted. This happens all the time while scanning. Put a super-smooth picture onto a super-smooth glass plate and add a bit of warmth from the bulb to create a dry environment, and you have a recipe for a super-slippery top. Trying to keep the image perfectly straight while carefully closing the lid will qualify you to perform in a circus.

**FIGURE 3.16**   A crooked picture.

Having said that, you will be well familiar with a crooked picture such as that in Figure 3.16.

Let's straighten things up a bit:

1. Draw a rough marquee with the Crop tool. Grab the resizing handles and fill most of the image area with the bounding box.
2. Move the mouse to an outside corner. You will notice that the pointer has turned into a curved arrow, which indicates that you are about to rotate the image. Begin to rotate the selection until it is at the desired angle.

 *Move the selection edge until it lines up with a vertical edge that can be used as a visual guide as we did with the center line of the pole in Figure 3.17.*

3. Once you have everything lined up, click and drag the side handle and stretch the crop selection to the edge of the image as we did in Figure 3.18. Make sure the selection border doesn't run off the image.

**FIGURE 3.17** Use vertical objects as guides and rotate the crop selection.

**FIGURE 3.18** The crop ready to be applied.

4. Now that everything is ready to go, choose the Crop or Hide option. Apply the selection by double-clicking with the mouse anywhere within the selection area.

5. You will now have a nicely straightened image, as shown in Figure 3.19.

**FIGURE 3.19**   The straightened image.

There is also another way to straighten images that is a bit quicker:

1. Choose the Measure tool from the Tool Palette (it's hiding under the Eyedropper).

2. Click and drag along one of the sides of the image. You are selecting your desired horizon in this step.

3. Choose Image > Rotate Canvas > Arbitrary.

4. The Rotate Canvas box will open with the correct digits in it. Choose either clockwise (CW) or counterclockwise (CCW).

5. Click OK and your image will be straightened.

### Auto Cropping (Crop and Straighten Photos)

To save time while scanning multiple images, several images are placed on the scanner surface at once and then scanned together (see Figure 3.20). When you want to use these images later, you have to copy each image to a new document, straighten, and crop them individually. All this can become very time consuming—remembering my magazine days, I say VERY time consuming, not to mention tedious and boring!

If you have been a "scanner monkey," I have some exciting news for you. The latest release of Photoshop is now equipped with a one-click crop and straighten photos command. The software looks at an image similar to Figure 3.20 and can detect the white space around the photos. It approximates the picture edges, and straightens them, and lifts them off the document and places each picture into its own document. Sounds like science fiction? Try it, it really works.

It's as simple as opening a picture and clicking File > Automate > Crop and Straighten Photos, as seen in Figure 3.21.

Now just sit back and relax, or go grab a cup of coffee. In a few moments your images will all be processed automatically, as seen in Figure

**FIGURE 3.20**   Multiple images scanned at once.

Batch...
PDF Presentation...
Create Droplet...

Conditional Mode Change...
Contact Sheet II...
Crop and Straighten Photos
Fit Image...
Multi-Page PDF to PSD...
Picture Package...
Web Photo Gallery...

Photomerge...

**FIGURE 3.21**   Launching the Crop and Straighten Photos feature.

**FIGURE 3.22**   The images all processed automatically.

3.22. You have to get excited about this feature because it's so easy and saves so much time. What's more, the original is left intact.

## Perspective

Perspective is quite literally the way we see things. When an object moves away from us, it appears to shrink in size. We all know that the size does not really change, it just appears that way. For instance, look at a long fence: As it winds off into the distance, the posts appear not only to grow smaller but also to come closer together. When you look up at a tall building, you notice perspective as the top seems to get narrower. Perspective is essential to making an image appear realistic.

### Removing Perspective

The problem is that a camera lens can exaggerate perspective, causing objects to look out of proportion. We can fix that problem easily in Photoshop.

**FIGURE 3.23**  The image with perspective.

ON THE CD

1. Open the Notre Dame image, seen in Figure 3.23.

    Notice that the image has perspective on the building. The top is smaller than the bottom. This is because of two reasons: the image was shot from a low angle, and a fairly wide-angle lens was used to compose the original shot.

2. Choose the Crop tool and check the Perspective button on the top toolbar, as shown in Figure 3.24. This option enables us to transform the corners freely.

3. Drag the corners toward the center to compensate for the perspective. Figure 3.25 shows the perspective crop in place. Don't overdo it; you will want to leave some perspective or the image will look like

**FIGURE 3.24**  The Perspective button.

**FIGURE 3.25**  The Perspective Crop option in use.

**FIGURE 3.26**  The final corrected image.

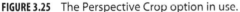

the top is larger than the bottom. Remember that perspective is natural.

4. Apply the transformation (Crop) and the image changes to the shape of the cropped area. Notice in Figure 3.25 that the picture still looks natural, but the perspective is a lot more realistic.

*You also can straighten and creatively crop the image at the same time.*

### Adding Perspective

We can also use this same tool to add perspective. This is a really useful technique to add the perception of more distance and can even make it appear as if the viewer has changed viewing positions. In this example it will look like we have moved closer to the subject and crouched lower to the ground. Figure 3.27 shows the original image with no perspective.

**FIGURE 3.27**   The original image. Royalty
Free Image from Hemera™

**FIGURE 3.28**   The image ready to have the
perspective applied.

Choose the Crop tool and make a selection on the image.

Choose the Perspective tool. You will have to think a little bit in reverse to apply the perspective crop. When we drag the handles into the middle to narrow the selection, the result will be the selection growing to fill the screen and the narrow selection being stretched.

Figure 3.28 shows the perspective selection ready to be applied to the image.

Apply the selection and notice how it changes the image. (You may need to scale the entire image horizontally if the image looks distorted and too wide.) See how much more depth appears to be in the image in Figure 3.29.

### Increasing the Canvas Size with the Crop Tool

Let's wrap up this chapter with one of the weirdest but very useful features of the Crop tool. Have you ever heard of a crop tool that makes the image bigger? The Crop tool in Photoshop will crop to whatever it has selected, and that includes off the canvas!

1. Open an image and apply the Crop tool to fill the entire document.

**FIGURE 3.29**    The final image with added perspective.

2. Zoom out a bit so that you can see some of the canvas area around the image.
3. Drag the Crop tool past the image and onto the canvas, as seen in Figure 3.30.

**FIGURE 3.30**    Dragging the Crop tool into the canvas. Royalty Free Image from Hemera™

**FIGURE 3.31** The final cropped image.

Apply the transformation, and the canvas is extended to fit the crop size. This is just the thing we need to add a bit of space and make a ticket out of our picture. I added just a bit of text to the final image to show an example of how you can use this effect in the real world.

## SUMMARY

This wraps up this chapter on resizing and cropping. You learned a lot about resolution and resizing images. We covered some pretty technical stuff, such as interpolation methods, but you also had the opportunity to take some of the tools out to play and have a bit of fun. You also discovered that the Crop tool has a number of hidden uses and is a lot more than just a way to trim images.

PART

# ENHANCEMENT

# 4

# IMAGE CORRECTION

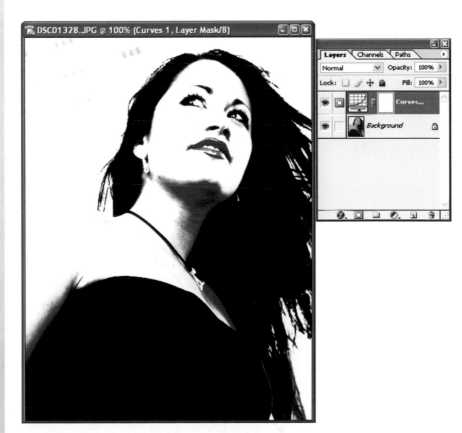

We live in the real world, and no matter how hard we try, all of our shots are not perfect. Sometimes unexpected results creep into our images, or we see ways they could be improved.

This chapter deals with understanding what is going on behind the scenes with our image and fixing images that are too dark, too light, or lacking contrast. You might have a great shot but want to emphasize the detail in a different section of the image. This chapter will show you how to bring out the hidden detail in almost any image. You will also learn how to adjust good pictures and make them even better.

## THE ANATOMY OF A COLOR PICTURE

Once upon a time there was just black and white photography. Then a revolution called color appeared on the scene. It seems so long ago now, as we shoot high-resolution digital photos and think nothing of it. There are two basic parts to a color photograph:

- The grayscale tones (black and white)
- The color information

Figure 4.1 shows a color photo broken apart. On the left we see the color information in the picture, and in the middle we have the grayscale image—combine the two and we have a color image.

ON THE CD

It's hard to believe that the faded, flat color information is the colors that are used to create the vibrant blues in the lake seen in the photo. But it's true, and you can see for yourself by opening the layered image `color-tone.psd` from the chapter four folder on the CD-ROM and dragging the color over the grayscale, as seen in Figure 4.2.

What this teaches us is the importance of the tones in the grayscale portion of the image. You can see that all the contrast and details come from the grayscale portion of the image and that the color offers none of this detail at all. We will be dealing with the color portion in Chapter 5, "Color Correction," but in this chapter, we will be enhancing the image tones or grayscale information to improve the appearance of our pictures.

**FIGURE 4.1**   The color information and grayscale information make a color image.

**FIGURE 4.2**   Combining the color and grayscale.

## HISTOGRAMS

Histograms are the little mountain-shaped graphs that represent the tonal properties in an image. When we say tonal properties we mean the 256 levels of grayscale that give the image its contrast and sharpness. Some digital cameras have histograms in their displays. Histograms are not new or unique to imaging. Scientists have used histogram charts since 1891 for various purposes.

Figure 4.3A and Figure 4.3B show the histogram you are probably most familiar with, from the Levels Adjustment dialog box. This dialog box is reached from the menu by selecting Image > Adjust > Levels.

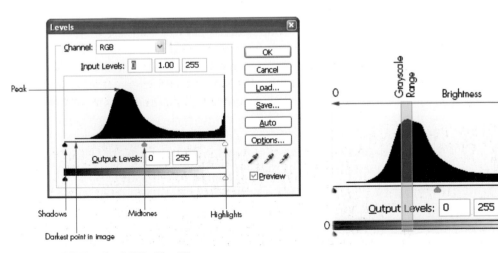

**FIGURES 4.3A and 4.3B**   The Histogram.

We divide the tonal range of an image into three main sections:

**Highlights:** Whites (255 or 100% brightness)
**Midtones:** Grays
**Shadows:** Blacks (0 brightness)

 *The histogram is broken into 256 levels of brightness. A setting of 0 means no light at all is present and will be reflected as black. A setting of 255 indicates that this is the highest level of light and will be shown as white. This 256-level scale is used throughout Photoshop. It stops at 255 and not 256 because the counting begins at zero and not one.*

The histogram shows a visual graph of our image. The shadows are on the left and the highlights on the right. The horizontal measurement is in brightness from 0–255. The gray bar underneath indicates what part of the grayscale we are looking at, as seen in Figure 4.3B.

The mountain shape represents image data. The top of the mountain is the peak. The peaks show the way pixels are dispersed in the image. Where pixels are present, the peak will be higher. If there are no pixels at a particular level of gray of the image, then a gap will appear in the histogram, indicating no data in that tonal range.

Where the "mountain" part of the graph begins and ends indicates where the pixels lie. In our example in Figure 4.3, you can see that there is a gap at the left of the histogram (marked as the darkest point in the image). This means that there is no image data in that area. This translates to the image lacking any pure blacks.

Also notice that the highlights are climbing on the right. This is called *clipping*. Clipping is when some of the detail gets cut off on an image. In this case, some highlight detail is being clipped off the image. Have you ever seen an image where the flash is too bright and everyone's face is burned out with white? That is clipping in the highlights.

In a nutshell, the graph in a well-balanced image will be low on the two ends. The well-balanced histogram will be just touching the left and right edges. There is no such thing as a perfect graph in the middle of the histogram, as all images will show a different graph. A solid shape is more desirable than a broken shape, though. A choppy-looking histogram with gaps and thin lines indicates abrupt transitions in color tones, known as *posterization* or, in extreme cases, *banding*.

We will now explore some different histograms. Notice the images in Figures 4.4 to 4.8. These images are exaggerated for the sake of illustration. Studying these images will help you to understand how a histogram maps out an image.

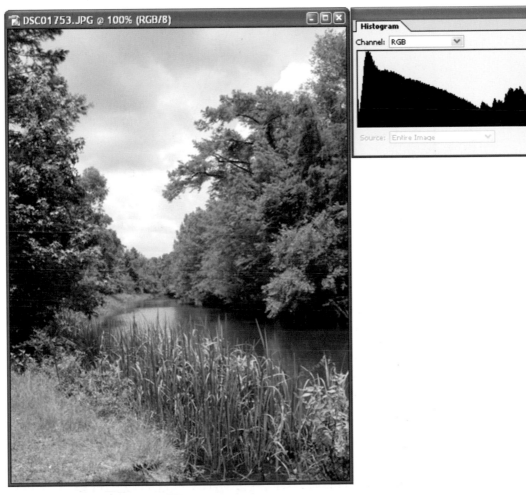

**FIGURE 4.4**    A well-balanced image.

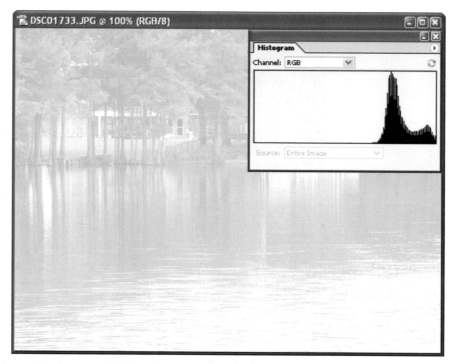

**FIGURE 4.5** A washed out image, lacking shadows.

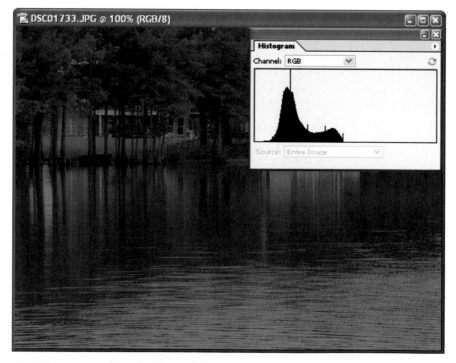

**FIGURE 4.6** A dark image, lacking highlights.

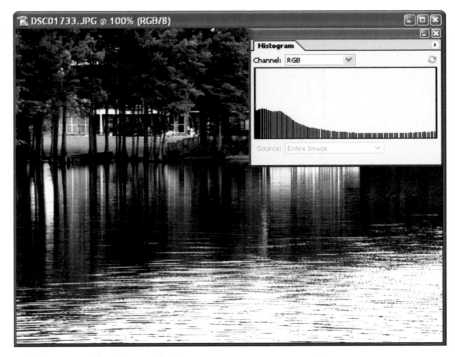

**FIGURE 4.7**   Too much contrast, (image beginning to posterize); notice that the histogram is showing gaps.

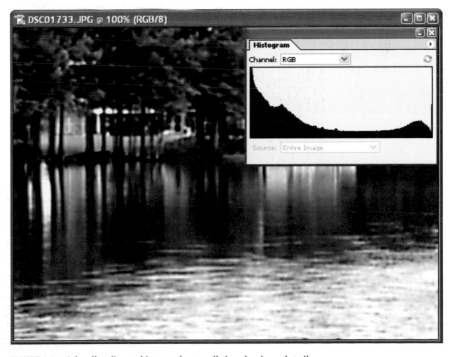

**FIGURE 4.8**   A badly clipped image loses all the shadow detail.

## The Histogram Palette

In Photoshop CS there is a new feature called the *Histogram Palette*. This allows us to keep a histogram displayed on the desktop at all times. This is a very handy feature because we can see what effect the adjustments are having on images.

To display the Histogram Palette, select Window > Histogram.

### Palette Options

There are several ways you can view the Histogram Palette. To access the options, click on the arrow at the top right of the palette and choose your desired options from the drop-down menu. Figure 4.9 shows the drop-down menu.

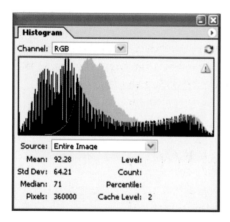

**FIGURE 4.9**   Histograms for each channel.

**FIGURE 4.10**   The Histogram Palette in expanded view.

The Compact view will nest with all the other palettes in Photoshop and stay out of your way while you are working. This offers a visual view of your image with minimum information.

The Expanded view is shown in Figure 4.10. This offers more options than the Compact view and is ideal for most situations.

The third type of view is the Channels view. This will show you a separate histogram for each channel in the image. If you choose Show Channels in Color, each histogram will be displayed in the host channel's color.

### Reading the Histogram's Statistics

If you choose the Show Statistics option from the drop-down menu, you will see eight sets of figures in the Histogram Palette, as seen in Figure 4.11.

The four figures on the left show the overall statistics of the image. You may be familiar with some of the terms because they are math terms.

**Mean:** Remember that there are 256 levels of gray in an image. This shows the average brightness from 0–255 (not 256, because we begin counting from 0 and not 1). An all-black image would show as 0, and a white image would show as 255.

**Std Dev:** Standard Deviation, which measures how the pixel ranges are dispersed in the image.

**Median:** Often defined as the vertical line that divides the histogram of a frequency distribution into two parts having equal area. We can call it the middle point of the image's grayscale value.

**Pixels:** The number of pixels present in the image.

**FIGURE 4.11**  Sampling the stats.

The stats on the right hand side are a bit easier to understand. These are the stats you get by sampling the histogram.

**Level:** This displays the grayscale level you are currently sampling, from 0–255. It can also show a range if you are sampling more than one level at a time.

**Count:** How many actual pixels fall into the selected range.

**Percentile:** The percentage of pixels in the selected range as compared to the entire image.

**Cache Level:** How recently your histogram has been refreshed. A cache level of 1 means that your histogram is current. (More on this subject later in this chapter.)

To sample the histogram, click inside the window with the mouse and you will see a line, as shown in Figure 4.11. This line is the brightness range you are currently sampling, from 0–255. You can also sample a range of tones by clicking and dragging with the mouse as shown in Figure 4.12.

### Getting an Accurate Histogram Readout

Because the histogram is ever present in our image window, we need to have more options than just the overall image. For example, we may want to make some adjustments to a single layer in Photoshop. By clicking the Source option, you can choose an individual layer. This is important because for the first time you can have accurate image information for each layer in an image. This allows for unparalleled accuracy in image correction.

**FIGURE 4.12**  Viewing stats on a range of tones.

**FIGURE 4.13**  Choose a layer or the entire image.

Photoshop will cache (pronounced *cash*) the histogram display in memory. This means that Photoshop remembers the latest settings in memory rather than displaying them in real time. The reason for this is speed. If the histogram wasn't cached, performance could be affected and slow down your computer. On a larger image, more caching will take place, whereas a small image may not be cached at all.

You will need to keep an eye on the cache level. When you see a little triangular warning icon in the histogram, this indicates that the view is cached and not current. To update, simply click on the warning icon or the Refresh button if you are in Expanded view, as seen in Figure 4.14.

When you are adjusting your image, you will see the histogram change to reflect your adjustments. The original histogram graph will be ghosted (Figure 4.15), so you can compare the adjustments to the original before committing to an adjustment. When you apply your changes, the ghosted histogram will vanish.

### A Word of Warning

In my band days, we were always told that musicians make the best sound people, not the actual sound engineers. Why is that? Because the sound engineers might rely on their readings and instruments too much and forget that music is about actual sound and not just readings and recorded levels. Musicians rely on their ears for the best sound possible and then check the readings to make sure everything is functioning correctly and make a few tweaks if needed. It is the same in the area of imaging; don't be so glued to the histogram that you make all your decisions based on your readings. Use these tools to help; they are incredibly use-

**FIGURE 4.14**  Refreshing the cache.

**FIGURE 4.15**  Original setting is ghosted.

ful, but still you should trust your eye. After all, others will be viewing the images with their eyes and not through histograms.

Enough of all the histogram theory. Let's jump in and enhance some images now!

We will be looking at four tools for adjusting the image tones, in order of the simplest to the most complex and accurate: Brightness/Contrast, Shadows/Highlights, Levels, and Curves.

## BRIGHTNESS/CONTRAST

This is the simplest of the four tools that we use to adjust the tones of images. Brightness/Contrast is one of those tools that is really quick and easy to use. It is designed to brighten up photos quickly and doesn't do as good a job as Levels or Curves. When we make the adjustments, they are

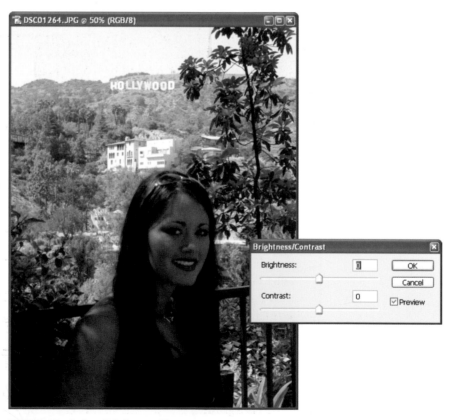

**FIGURE 4.16** Before Brightness/Contrast.

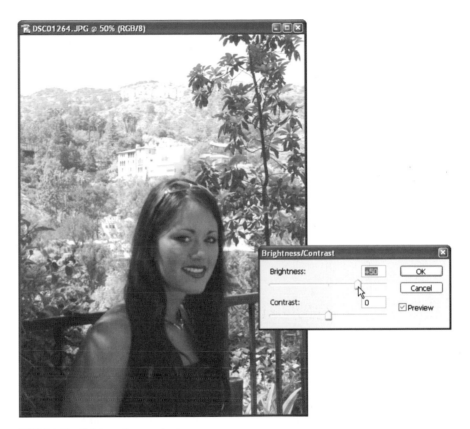

**FIGURE 4.17**    Brightening up the image.

across the board. There are no separate controls for highs, shadows, or mids.

1. Select Image > Adjust > Brightness/Contrast. Figure 4.16 shows the image with the dialog box.
2. Drag the brightness to the left to darken or to the right to brighten. In Figure 4.17 we have brightened up the image. You will notice that the image is starting to look washed out and lacking contrast. That is because the shadows have also been lightened. This loss of contrast is the reason for the second setting in the dialog box.
3. Adjust the contrast to compensate for the brightening.

You will see that Figure 4.18 is a vast improvement over the original. You can see a lot more detail in the person. The drawback is that the detail in the background is lost. This tool is good for a quick fix, but not as good as the Levels controls for accuracy.

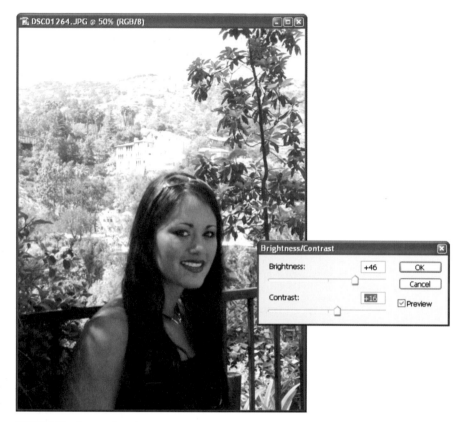

**FIGURE 4.18**   Increasing the contrast.

## SHADOW/HIGHLIGHT

This filter is the newest of the Photoshop tonal tools. Photoshop CS has had a pretty big overhaul to accommodate the boom in digital photography. This filter has been designed to allow you to lighten the shadows and darken the highlights. This allows you to bring back detail that has been lost by underexposure or overexposure. For example, suppose you have a picture that has been overexposed. There is an area that is almost all white, and most of the detail has been lost in this bright area. You can now pinpoint just that tonal area and bring back highlight detail without affecting the rest of the image. The opposite is also true for an image that is too dark and loses all the detail in the shadows.

When you make the changes, you can adjust the range of shadows/highlights you want to modify. For example you can adjust all the shadows or just the very darkest shadows. Think of this tool as the graphic equalizer of image tone. (If you have a sound background, it's

more like a parametric EQ.) A great thing about this tool is that you can target the shadows and brighten them up without changing the rest of the image. A great example is when you have taken a picture of a person against a brighter background and the person ends up very dark. Using the Shadow Highlight filter, you can lighten up the person without changing the background.

Select Image > Adjust > Shadow/Highlight. Click on the Show More Options box, and the dialog box will open to show all the options.

You will see three regions of adjustments: Shadows, Highlights, and Adjustments. The main areas that concern us right now are Shadows and Highlights. Each has three sliders:

**Amount:** This determines the strength of the adjustment. Zero has no effect, and 100 is full effect. Adjust this slider to suit your desired results, like the volume knob on your radio.

**Tonal Width:** This sets the range of tones to be adjusted. A lower setting will affect just the darkest shadows and brightest highlights. A higher setting will affect more tones and begin to affect

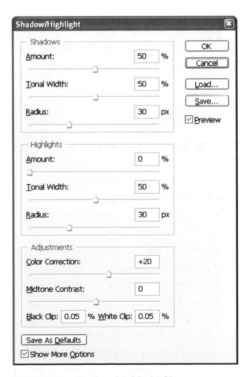

**FIGURE 4.19**  Shadow highlight filter.

the midtones. Experiment with this slider to encompass just the depth of shadow/highlight you want to adjust.

**Radius:** This tool does its magic by trying to determine individual objects in the image. By adjusting the radius, you set the distance on the image that Photoshop will affect. The filter averages out adjustments based on the target tones compared to the brightness of surrounding pixels. The radius determines how many surrounding pixels will be taken into account for the adjustment. A lower setting will keep the adjustments more localized, and a larger setting will spread out the contrast more evenly.

The third area has two controls:

**Color correction:** Adjusts the saturation of colors.

**Midtone contrast:** Allows the contrast of the midtones to be reduced or increased. Change this subtly, if at all.

Figure 4.20 shows an image that is too dark in the foreground, and the detail is lost.

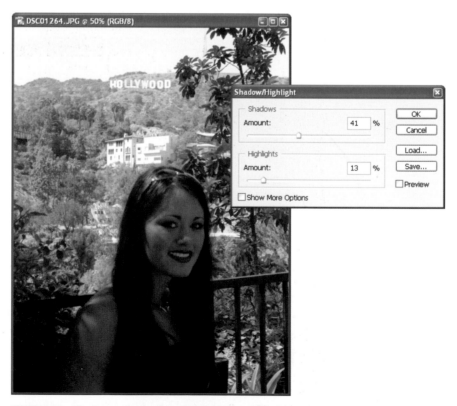

**FIGURE 4.20**   The image in the foreground is too dark.

Select Image > Adjust > Shadow/Highlight. You can see that the dialog box is open in Simple mode. Click on the Show More Options box, and the dialog box will open to show all the options.

Begin with the shadows:

1. Adjust the Tonal Width slider; slide until you have selected only the range of shadows you want to affect. (Slide the Amount setting up to exaggerate the adjustment so that you can see the range better.)
2. Adjust the Amount slider until you have brightened up the shadows sufficiently.
3. Do some fine-tuning with the radius until you are happy with the shadow contrast.

Repeat each step for the highlights. If the image appears oversaturated or undersaturated, make some adjustments with the Color correction. If the midtones look like they need some help with contrast (turning gray because of the radius setting), adjust the midtone contrast.

You now have a corrected image (see Figure 4.21). The woman has been brightened, but the Hollywood sign has been unaffected (unlike

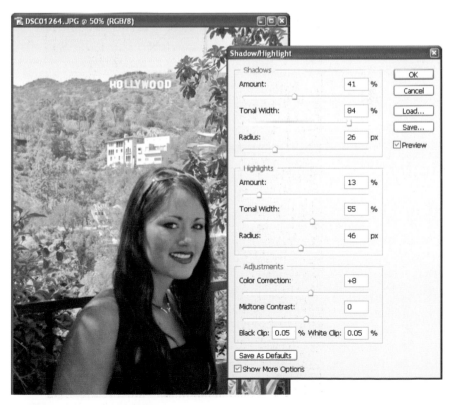

**FIGURE 4.21**    The adjusted image.

with Brightness/Contrast). If you need to make changes in the midtones, consider using Shadow/Highlight first and then using Levels or Curves for more control over the midtones.

## LEVELS

Since we have learned about histograms, let's use them to make some adjustments. The most hands-on place for using histograms is the Levels Palette. The Levels Palette is really an adjustable histogram. You will notice that there are three triangles under the histogram:

**Black Point Input Slider (Shadows):** The left triangle is the Black Point Input slider; when we slide this to the right it darkens the shadows. This is where we set the black point of the image. All pixels to the left of the slider will be turned black.

**White Point Input Slider (Highlights):** The right triangle is the White Point Input slider. By moving this slider to the left, you will lighten the highlights. This sets the white point. The pixels will be turned pure white above this slider, and no pixels will be displayed to the right of it. They will be clipped (turned pure white).

**Midtones:** The center slider is the midtones. When you slide this to the left, the grays will brighten, and when you slide it to the right, they will be darkened.

Also, refer to Chapter 5 for more on levels, where we set the white, black, and gray points.

### Quick Corrections with Levels

Hang on to your hats—this section is going to move very quickly. We are going to fix the most common problems with images: underexposure and overexposure.

#### Fixing Underexposure

The image in Figure 4.22 looks too dark because it is underexposed. When the image was taken, there was not enough light present. Click Image > Adjust > Levels. In the Levels Palette, you will notice that there is no pixel information in the highlight area.

Click and drag the White Point Input slider to the left until you are just inside the pixel area, as shown in Figure 4.23. You will notice that the image brightens up. If you see no change, turn on the Preview checkbox.

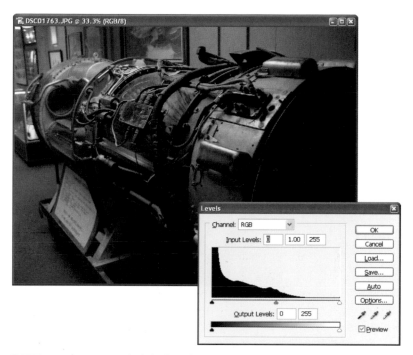

**FIGURE 4.22**    Image too dark, lacking brightness.

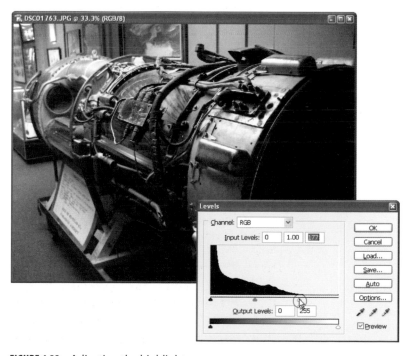

**FIGURE 4.23**    Adjusting the highlights.

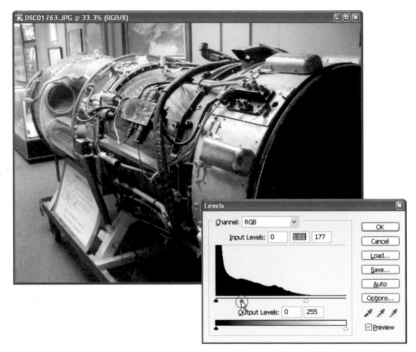

**FIGURE 4.24**  Adjusting the midtones.

The image is looking much better, but it is still a bit dark in the midtones. Slide the middle slider to the left to brighten up the midtones, as seen in Figure 4.24. Notice how much better the image looks after just two slides of the Levels controls.

### Fixing an Image That Is Too Bright

In Figure 4.25 you will notice that the image seems washed out, as if we are looking through mist. Actually, we were looking through some clouds when this picture was taken. The result is a hazy-looking image. It doesn't have enough contrast. We can strengthen the image by bringing back some of the shadows.

1. Open the Levels control. The keyboard shortcut for levels is Ctrl-L (Cmd-L in Mac).
2. Drag the Black Point Input slider just into the "mountain" to the right, as shown in Figure 4.26.

Notice that all the haze has disappeared, and the image is much stronger.

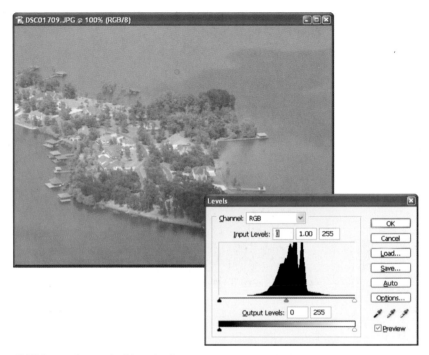

**FIGURE 4.25**    Image lacking shadows.

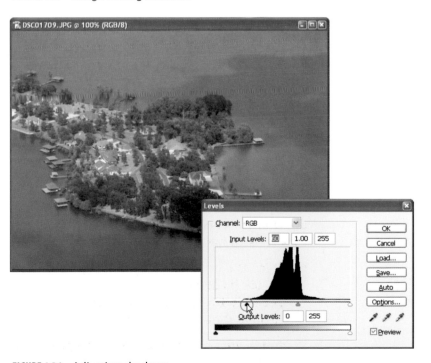

**FIGURE 4.26**    Adjusting shadows.

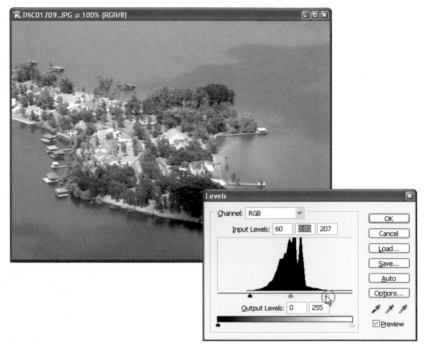

**FIGURE 4.27**   Adjusting the highlights.

In the histogram, you can see that the image is also missing some highlight detail.

3. Slide the White Point Input Slider to the left a bit, as in Figure 4.27.

See how much better the image now looks.

## AUTO LEVELS

When you open the Levels box, you will see a button called Auto. This is the Auto Levels control. You don't have any options on this one—just click and hope; it's worth a try. A lot of the time it produces some pretty good results. We started with the image from Figure 4.25 and clicked the Auto button. The result is in Figure 4.28. The result isn't quite as good as doing it yourself, but it makes a huge improvement very quickly. Auto Levels sets the darkest point in the image as black and the lightest point as white.

Another way to access Auto levels is by clicking Image > Adjustments > Auto Levels. This is a great one to use in a jam.

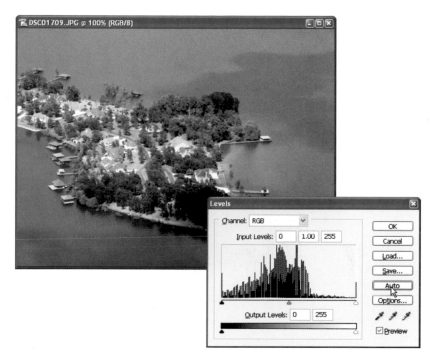

**FIGURE 4.28**    Auto Levels.

## AUTO CONTRAST

Auto Contrast is very similar to Auto Levels, with one difference.

With Auto Contrast, the color of an image is unaffected, whereas with Auto Levels, the colors may shift to try to achieve optimum results.

## CURVES

Of all the correction tools available, Curves gives you the most precise adjustments possible. With Curves you can target any tone in the image and increase or reduce it. You have exact control over your entire image. Figure 4.29 shows the same image before and after Curves. Look at the overall difference, and notice how the details in the rocks and trees show clearly in the improved image. Notice the natural skin tones and the detail in the face. Curves give you the capability to turn snapshots into photographs. By the end of this section, you will be making corrections like this in Curves.

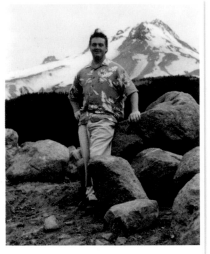 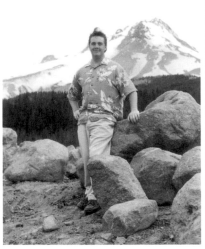

**FIGURE 4.29**    Image adjusted using nothing but Curves.

### Understanding Curves

The drawback to Curves is that there is a bit of a learning curve (forgive the pun). Stick with us here and don't just flip through to the next chapter. When you learn how to use Curves, it will change the way you use Photoshop and make you the king of image correction. Once you master Curves, you will rarely use any of the other correction tools in Photoshop. Sounds like big words? Take a walk with me through the world of Curves and judge for yourself.

Open the Curves dialog box by selecting Image > Adjust > Curves.

Figure 4.30 shows a simplified view of the Curves Palette. For now let's focus on three things:

**Input:** The horizontal grayscale gradient on the bottom.
**Output:** The vertical grayscale gradient on the left.
**Curve:** The red line.

The input tones are the starting values of the image and will never change. These are the tones seen in the original image.

Figure 4.31 shows the gray tones from an image. We have selected one tone of 4% brightness, one of 50% brightness, and one of 100% brightness. Notice how these shades of gray in the image are the same as the shades in the horizontal gradient.

In Figure 4.32, follow the red line that was added and you will see that the tone intersects with the diagonal line. The diagonal line is the

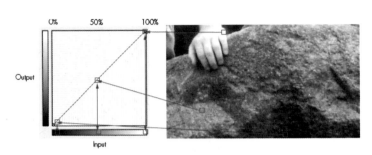

**FIGURE 4.30**  Input and output tones.    **FIGURE 4.31**  Tones and their values on the graph.

curve. Now follow the intersecting line to the left and you will see the vertical gradient. Notice that the shade of gray is exactly the same. The vertical line is called the output. This is what the image will look like after adjustment.

The relationship from the input gray to the output gray is called *mapping*. The curve will determine where the points intersect.

If you adjust the curve, the mapping will change. Notice in Figure 4.33 that the shape of the curve is changed. We started with the same input gray as in Figure 4.32 but dragged the point up the graph. Now follow the red arrow. The input is still the same and intersects with the curve in the same horizontal location.

**FIGURE 4.32**  a) The gray scale relationship to the curve. b) Mapping the input to the output of the curve.

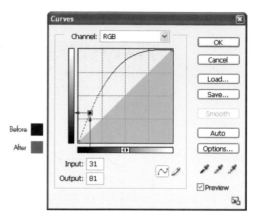

**FIGURE 4.33** Adjusting the curve changes the mapping.

What has changed? The vertical intersect point is now higher. Follow it to the left and see where it is now on the output bar. The shade of gray is lighter than it was. We have just lightened up the darker tones in the image. Notice that the curve doesn't just change the point that we moved, but it also affects the other points on the curve. Follow them and see how the output tones have changed.

In a nutshell:

- The bar across the bottom determines what shade of gray we are working on in the image. Black is to the left, and white is to the right. If we move the curve up, at that point it lightens the image, and if we move it down it darkens the image. You cannot move it up from white, because there is nothing brighter. You cannot move the curve down from black because there is nothing darker.
- To determine the change, follow the graph up from the input level, see where it intersects with the curve, and follow to the left to see what your output will be.

### Using Curves

Now that you have an understanding of how Curves work in theory, we can move on to the more practical aspects. First we will look at the mechanics of Curves and how to use the controls; then we will adjust some images and finish this section with a few tips on using Curves.

### Creating Curves

By default, every curve begins with the same diagonal line. This indicates that the curve is in a neutral state, no changes have been made, and the

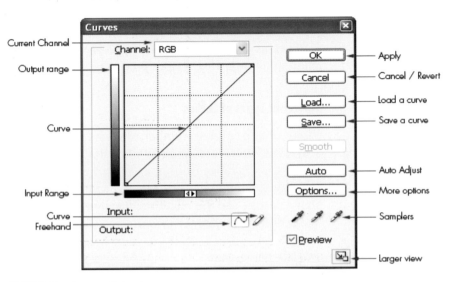

**FIGURE 4.34**   Curves dialog box.

input and outputs are the same. Figure 4.34 shows the curve in its neutral state.

To make changes to the curve, click on the curve with your mouse, and an adjustment point will appear. Drag the point up to brighten the tone or down to darken the tone. You can add up to 14 points on a curve. This will bring us to 16 points in total, because black and white points are always shown. To remove any points, just drag them out of the Curves window. All

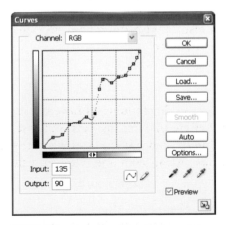

**FIGURE 4.35**   Curves with adjustment points.

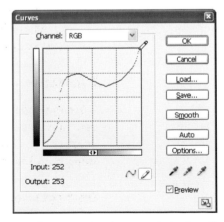

**FIGURE 4.36**   Points drawn with the Pencil tool.

points displayed in black are selected and those displayed in white are unselected. To select more than one point at a time, hold down Shift.

The Pencil tool also can be used to draw a freehand curve. This would have more uses in a special effects situation because it is not accurate enough for adjusting images precisely.

## Different Types of Curves

There are an infinite number of Curves that can be created for images. However, there are some typical shapes that achieve certain results. These Curves range from image correction to special effects. Curves will work with color images, but in this case let's display them in grayscale so that you can see the effect on the image tones. Figures 4.37A to 4.37L show different types of Curves.

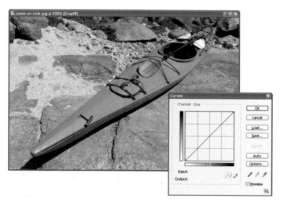

**FIGURE 4.37A**  Original. Royalty Free Image from Hemera™.

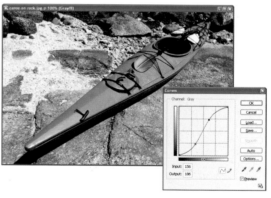

**FIGURE 4.37B**  S Curve, increases the contrast.

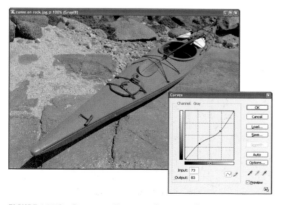

**FIGURE 4.37C**  Reverse S curve, lowers the contrast.

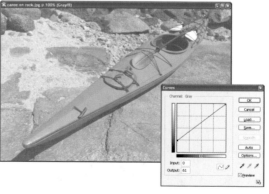

**FIGURE 4.37D**  Setting dark gray as the darkest point in the image by moving pure black up to dark gray.

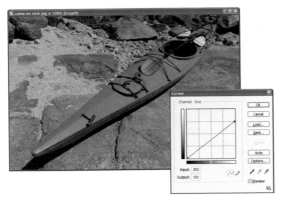

**FIGURE 4.37E** Setting light gray as the lightest point in the image by moving pure white down to light gray.

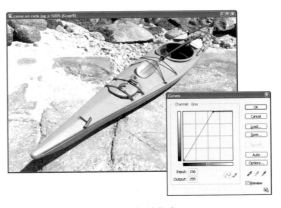

**FIGURE 4.37F** Clipping the highlights.

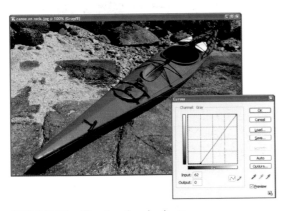

**FIGURE 4.37G** Clipping the shadows.

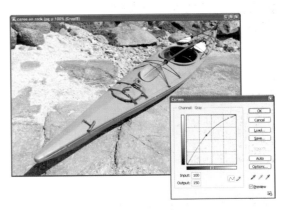

**FIGURE 4.37H** Lightening the midtones.

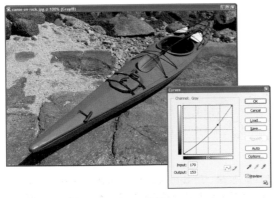

**FIGURE 4.37I** Darkening the midtones.

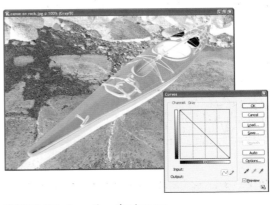

**FIGURE 3.37J** Inverting the image.

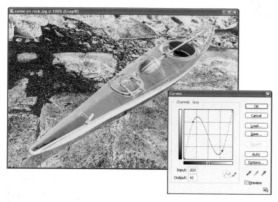

**FIGURE 4.37K**    Solarize.

**FIGURE 4.37L**    Posterize.

### Correcting Images with Curves

We are now going to correct two images with the most common tonal problems. The first image is all hazy and lacks contrast. The second image is so dark that you would think it was beyond repair. It's time to unleash the magic of Curves.

### Adding Contrast with Curves

The image in Figure 4.38 is very faded and hazy. It was shot from the top of the Sears Tower on a hazy day, with a Sony DSC-717 F. You have probably seen many pictures with this problem. This is how to fix it.

1. Open the Curves box by selecting Image > Adjust > Curves or pressing Ctrl-M (Cmd-M in Mac).
2. Since the image lacks contrast, the first move is to create an S curve. At the 3/4 Brightness point, drag the curve up to brighten the highlights.
3. Drag the shadows down to deepen them. Notice in Figure 4.40 that the image has more overall contrast now.
4. When you move the mouse into the image area, it turns into a Sampler tool. Click and drag the tool over the image, and you will see a circle on the curve. This indicates which image tone you are sampling.
5. Sample a tone in the image you want to emphasize. In this case it's the John Hancock Building.
6. Press the Ctrl key (Cmd in Mac) and click your mouse with the Eyedropper; an adjustment point will be added to the curve (see Figure 4.41).

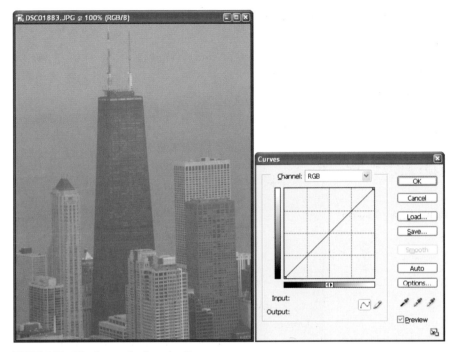

**FIGURE 4.38** The image before the Curves.

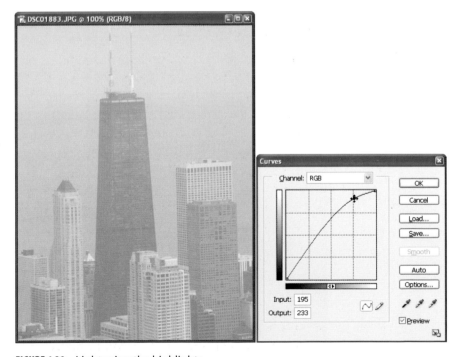

**FIGURE 4.39** Lightening the highlights.

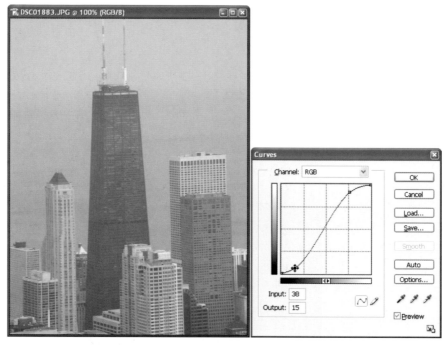

**FIGURE 4.40** Darkening the shadows.

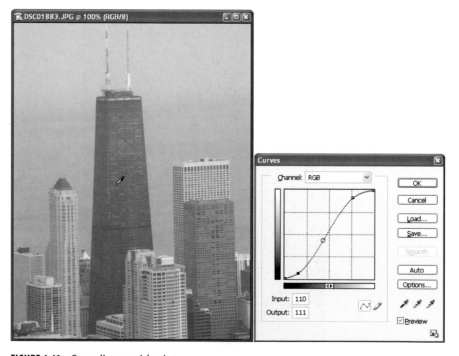

**FIGURE 4.41** Sampling a midpoint.

7. The contrast of the building is too bright, so drag down on the curve at the newly selected point as in Figure 4.42. This darkens the image at the chosen tone, bringing some detail and contrast to the building.

At this point we could be satisfied with the adjustment; it is a lot better than it was. Just for fun though, lets brighten up the sky a bit.

1. Ctrl-click (Cmd-click in Mac) on a brighter part of the sky with the Eyedropper tool to add the sky's tone to the curve (see Figure 4.43).
2. Drag the point up to brighten the sky. Notice that the curve is very steep between the two brightest points (see Figure 4.44). If a curve becomes too steep or even drops, then there can be some colorizing problems such as solarizing and inverted colors.

As a tweak, we smoothed off the curve in the highlights. This has caused a little clipping in the white, but it is quite acceptable in this case. Notice the difference between the image before and after (see Figure 4.45). It's amazing what Curves can do.

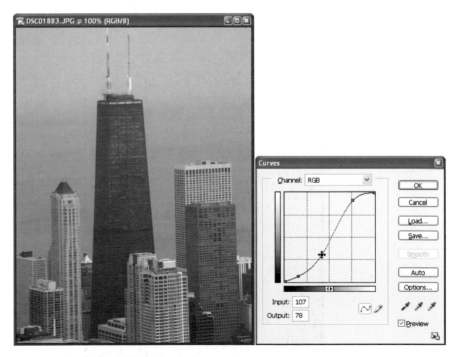

**FIGURE 4.42**  Adjusting the midpoint.

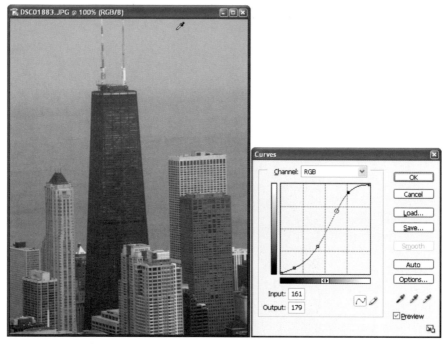

**FIGURE 4.43**  Sampling a highlight.

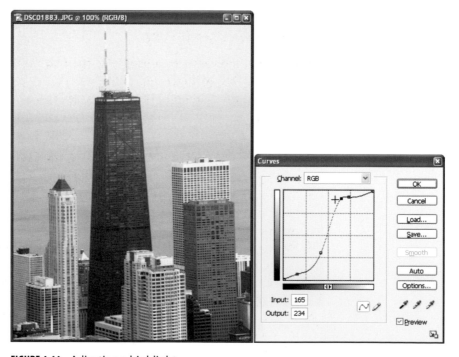

**FIGURE 4.44**  Adjusting a highlight.

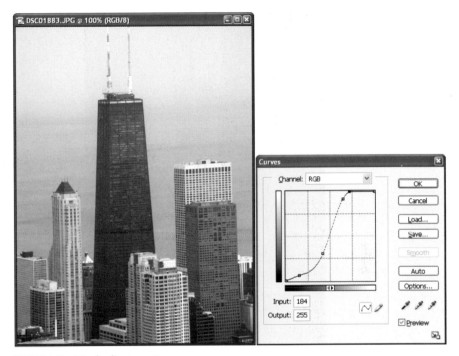

**FIGURE 4.45**    Final adjustments.

## Brightening an Image with Curves

The camera often captures more detail than you realize. You just need to know how to bring it out. Figure 4.46 shows one of those images that people may think is beyond saving as far as image details go.

1. Open the Curves dialog box.
2. Lighten the shadows until you can see some detail come into the image (see Figure 4.47). We will tweak these shadows later, but the goal right now is to see some image detail so that we can work with it.
3. Lighten the highlights until the lightest point of the image is where you want it to be (see Figure 4.48). These are some extreme adjustments, but this is an extreme image.
4. Move your mouse into the image and sample a midtone in the area where you want to bring out the detail (see Figure 4.49).
5. Move the curve up at this midtone. Notice how the image has brightened up in the mids now (see Figure 4.50).
6. In step 2 we brightened the shadows so that we could see some detail to work with. Let's darken the shadows now because they look too bright.

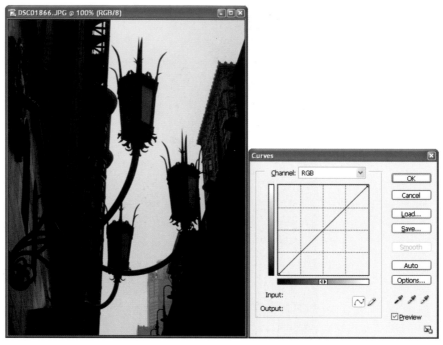

**FIGURE 4.46**    The beginning image.

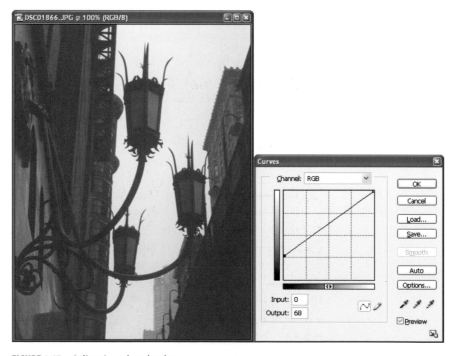

**FIGURE 4.47**    Adjusting the shadows.

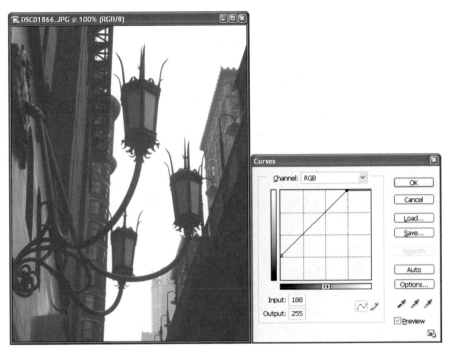

**FIGURE 4.48**    Lightening the highlights.

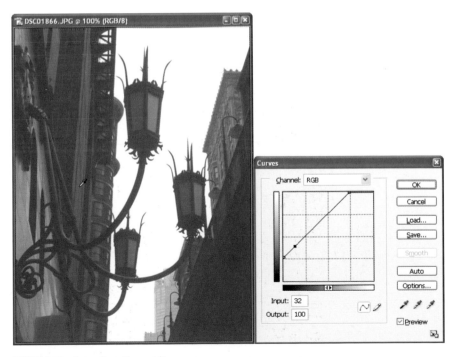

**FIGURE 4.49**    Sampling the midtones.

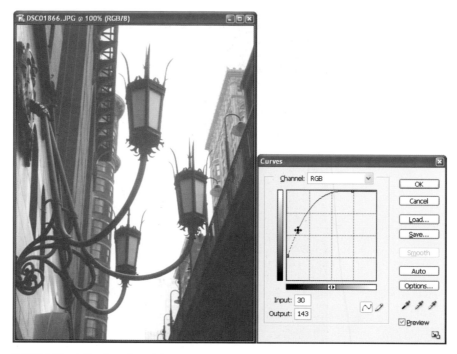

**FIGURE 4.50** Adjusting the midtones.

7. Drag down on the darkest point just a little bit (see Figure 4.51).
8. Finally, we make a little adjustment in the higher midtones to make the highlights and mids a bit softer (see Figure 4.52).

There you have it. We have brought out detail and color from an almost blacked-out image. Can you see the power of Curves and why it is worthwhile to learn this feature?

### Tips for Using Curves

Here are a few tips to make you more productive with Curves:

- Click the icon in the lower-right corner for a larger Curves display.
- Press Alt (Option in Mac) and click in the Curves window for a more accurate grid.
- Hold down Shift and click on adjustment points to select more than one point at a time.
- Press the arrow keys on your keyboard to move the selected points.
- Avoid falling Curves, which means that tones have become inverted at that point.
- Press Ctrl-Tab (Cmd-Tab in Mac) to move through adjustment points on the curve.

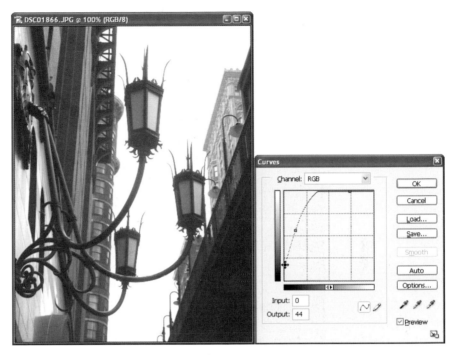

**FIGURE 4.51**    Darkening the shadows.

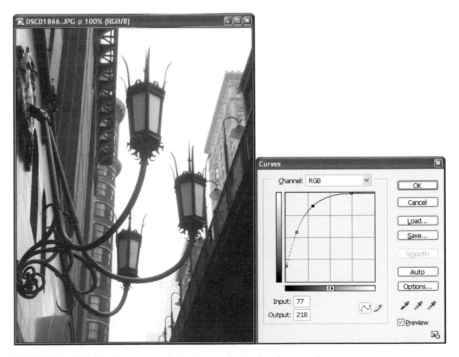

**FIGURE 4.52**    Final adjustments.

- Press Ctrl-click on the image (Cmd-click in Mac) to add an adjustment point to the curve.

### Adjustment Layers

One thing you will find when making repeated image adjustments is that the quality of the image eventually will deteriorate. This is because all the pixels have to be rearranged each time you apply an adjustment. Don't despair though; that's why we have adjustment layers (see Figure 4.53).

Adjustment layers offer the same controls and dialog boxes as the adjustment filters, but they are nondestructive, which means that they do not change the actual image. Instead of affecting the pixels directly, these layers sit on top of the image and affect the way it looks. (Shadows/Highlights is not available as an adjustment layer.)

The advantages of the adjustment layers are:

- They are nondestructive.
- Settings can be changed at any time.
- It is easy to apply more than one adjustment to an image at the same time. Refer to Figure 4.53, which has two levels and two Curves adjustments made to it.

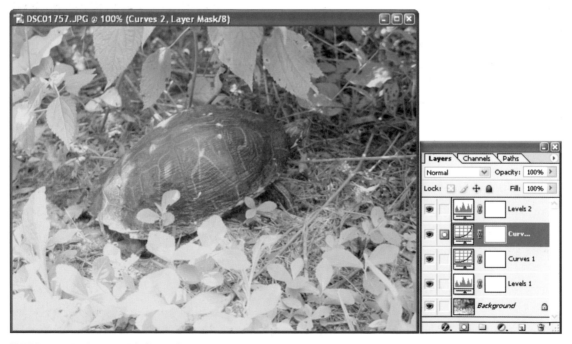

**FIGURE 4.53**   An image with four adjustment layers.

- They can result in smaller file sizes.
- If you don't like the results, you can delete the adjustment layers, and your original image is unaffected.

## Creating Adjustment Layers

To create an adjustment layer is very easy:

1. Click on the New Adjustment Layer icon in the Layers Palette. It's the icon with the black and white circle.
2. When the pop-up menu opens, choose an adjustment layer from the list, as seen in Figure 4.54.
3. The Adjustments dialog box opens.
4. Make your adjustments.
5. Click OK.

Adjustment layers are saved with the file, so even after you close an image, you can always reopen it and make further adjustments at any time. To change the settings in an adjustment layer, double-click on its icon in the Layers Palette, and the dialog box will open as seen in Figure 4.55.

FIGURE 4.54   Creating a new adjustment layer.

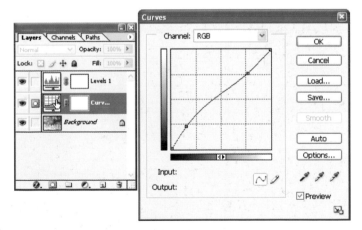

FIGURE 4.55   Modifying an adjustment layer.

## Adjustment Layer Mask

Another advantage of an adjustment layer is that each comes with a layer mask. This enables you to apply an adjustment to an image selectively. The layer mask is the box you see to the right of the Adjustment Layer

icon. By default, the layer mask is white. This means that the effect is showing full strength.

To select the mask, click on it with the mouse. If you were to paint on the image with a black brush now, you would paint away the effect. If you were to paint with white, you would paint back the effect. This performs just like any other layer mask. We go into the details a bit more in Chapter 11, "Collaging Techniques."

These masks are great for both fun and practical uses. You can do some really wild things with the adjustment layers, and they don't destroy your original photo. Another advantage of an adjustment layer is that it doesn't add to the file size of the image unless you use a layer mask. This makes archiving PSD files easier.

## Special Effects with Adjustment Layers

To create the curve in Figure 4.56, refer to the gallery of Curves in Figure 4.37. Figure 4.37L shows the shape of a posterized effect.

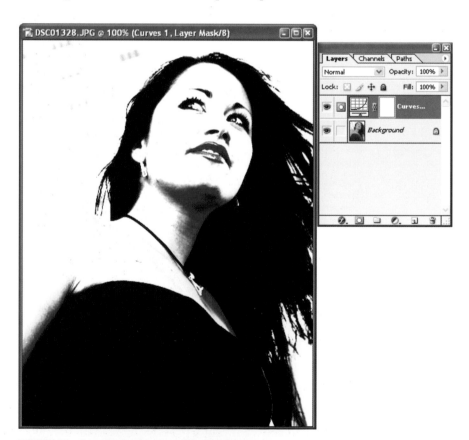

**FIGURE 4.56**    A posterized curve added to the image.

1. Create the Curves adjustment layer.
2. Choose the Linear Gradient tool. Set the foreground and background to black and white, respectively, and choose the Foreground to Background option.
3. Select the layer mask by clicking on it.
4. Drag the gradient in the image from three-quarters way up the right edge to half way into the face.
5. Release the mouse, and you will see the gradient in the layer mask.

Figure 4.57 shows how the adjustment layer fades out where the gradient blends.

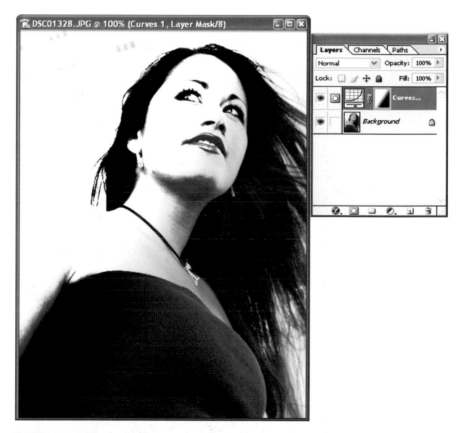

**FIGURE 4.57**    Adding a gradient to the adjustment layer.

## SELECTIVE ADJUSTMENTS

There are times when you want to touch up just a small part of an image, but you like everything else as it is. Perhaps you love the tones of an

image but want to bring out some details without affecting the rest of the image.

In this example we have a picture of an escalator (see Figure 4.58). We want to bring in the details of the stairs, but we don't want to affect the rest of the image.

Here is how to do it:

1. Add the Curves adjustment layer.
2. Sample the tone you want to adjust.
3. Brighten up your curve, as seen in Figure 4.59. The stairs are now showing detail, but the rest of the image has been brightened, too.
4. Choose a large soft brush and set the foreground to black.
5. Click on the adjustment layer's mask.
6. Paint the parts of the image that you want excluded from the adjustment (see Figure 4.60). Notice that as you paint, the original image shows through, and you are painting away the adjustment.
7. Paint away all the unwanted adjustment with black.

In Figure 4.61, you can see that only the stairs are in white. Only the stairs have been affected by the adjustment layer; the rest of the image is intact.

**FIGURE 4.58**   Original photo.

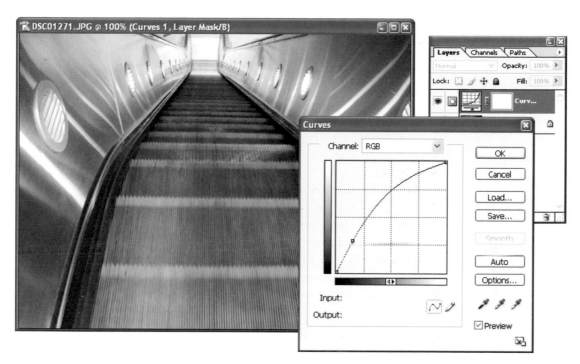

**FIGURE 4.59**    Brightening up the target portion of the image.

**FIGURE 4.60**    Painting away the adjustment from the unwanted areas.

**FIGURE 4.61** Selectively adjusted image.

## SUMMARY

In this chapter you learned a lot about the tonal qualities of your images. You learned how to strengthen the details, brighten, and add contrast to your images. You will not have to despair again if your images don't look quite right out of the camera. You can import them to Photoshop and transform them into masterpieces.

# 5

# COLOR CORRECTION

I n the world of computers, there are two ways to understand color. One type of color is called additive, and another is called subtractive. We are not going to get bogged down in a lot of theory right now, but we will go through a very brief overview to help you understand how color is generated on your computer.

## ADDITIVE COLOR

In additive color, all the colors added together make white. This type of color is based on light. This is the way that the natural eye perceives color. For example, when you view a lemon, you see yellow. All the colors of the spectrum are targeted at the lemon from the sun or other light source. The lemon absorbs all the light except for the part that looks yellow, and the light is then reflected to the viewer's eye and perceived as yellow. A rainbow displays this principle perfectly. When the light hits the raindrops at the correct angle, it splits the spectrum of light, and you can see red, orange, yellow, green, blue, indigo, and violet; all the colors added together make white light. Because of the way this light works, you can imagine that different types of artificial light are not as pure as the sun's rays, and this produces what is called a color cast in your image. A *color cast* is when an image has an unnatural color tint. We can fix this color cast easily in Photoshop, as you will learn in this chapter.

Your computer's monitor also uses additive color. There are three different colors, red, green, and blue (RGB). The monitor mixes these three primary colors (monitor primaries, or RGB primaries) and creates all the colors that you view on the screen.

## SUBTRACTIVE COLOR

Subtractive color is so named because an absence of color will produce white (or more correctly, transparence). Subtractive color is not based on light, it is based on ink and resembles mixing color as you did with your first paint set. The three main primaries used in subtractive color are cyan (light blue), magenta (pinkish purple), and yellow. Because these colors cannot produce a really dense black, black usually is added in the world of printing. This is where you get CMYK color: C = cyan, M = magenta, Y = yellow, and K = black (called K and not B so it's not confused with blue). Subtractive colors are the colors you will deal with when printing. You do not have to work in the CMYK colorspace unless you are printing to a commercial printing press.

## COLOR CORRECTION TOOLS

In the previous chapter we looked at tonal correction, and we worked on the grayscale portion of images. In this chapter we are going to look at the color portion of the images. When you shoot under light, it affects images in different ways. For example, the sun produces a warm-colored light, but the moonlight produces a bluish cast and is much cooler. Shooting indoors under artificial light tends to give images a yellow cast, whereas fluorescent light adds some green to the image. The best lighting conditions are outside with an overcast sky. The clouds nicely defuse the harshness of the sun's rays without taking too much brightness away.

Most cameras are equipped with a white balance that helps you to compensate for different lighting conditions. You can also use different lens filters to help with the color. Even after all that, there are times when the color is still a bit off in the photo. This is not a problem with Photoshop. There are several ways to restore natural color, and you may even want to use these techniques to alter the color for something more creative, such as to warm the skin tones of a model.

### Adjustment Layers

All the color correction filters are available from the Image > Adjustments menu, but it is best to avoid them as much as possible. Instead, try using adjustment layers. Adjustment layers provide exactly the same filters and functionality, but you make the adjustment to a blank layer. Adjustment layers have several advantages:

- The original image is left untouched, thus preserving it.
- Adjustment layers add nothing to the file size.
- You can use multiple adjustments of the same filter for precise re-sults.
- If you change your mind later, it is easy to make modifications.

To use adjustment layers, click on the Adjustment Layer icon in the bottom of the Layers Palette, as shown in Figure 5.1A. Choose the type of adjustment you want from the menu.

As you can see in Figure 5.1B, you can make multiple adjustments on a single image. You can even have multiple instances of the same type of adjustment. For example, you could have three level adjustments, five curves, and two color balances in the same image. Adjustment layers are also covered in Chapter 4, "Image Correction."

**FIGURE 5.1A**    Adding an adjustment layer. Royalty Free Image from Hemera™.

**FIGURE 5.1B**    Two adjustment layers in the Layers Palette.

### Auto Color

This is a hit-or-miss filter. It's great when you are in a hurry or you have only a few seconds to get an image cleaned up a bit. Since there are no settings for this adjustment filter, it is very unpredictable. Auto Color will attempt to balance the color and does a pretty good job a lot of the time.

In Figure 5.2 we have an image with a green color cast due to fluorescent lighting.

To apply Auto Color, select Image > Adjustments > Auto Color.

In this case, Auto Color did a pretty decent job of removing the green color cast. Notice the color restored on the right wall. There is a bit of a purple color cast on the white areas of the sign, but the image is a huge improvement over the original.

### Color Balance

Color Balance is a very useful tool for making color corrections. This tool allows you to target the shadows, midtones, or highlights and then change the balance of color in the image.

**FIGURE 5.2**    Image with a green cast.

**FIGURE 5.3**    The image after Auto Color.

There are six main colors used in this tool, the two sets of primary colors:

- Monitor primaries (additive color) are red, green, and blue.
- Print primaries (subtractive color) are cyan, magenta, and yellow.

In the Color Balance tool, these colors are arranged into three sets of opposites, using the primary colors:

- Cyan and red
- Magenta and green
- Yellow and blue

You can target a range of colors and then shift the balance of any of the primaries.

*ON THE CD*

On the CD-ROM, open the file Ch 5-CB.tif.

Figure 5.4 shows an image that suffers from a bad blue color cast.

**FIGURE 5.4**    The original image with a blue color cast.

1. Choose the Color Balance adjustment layer by clicking on the white and black circle at the bottom of the Layers Palette and choosing Color Balance. (To use the tool directly, select the Image > Adjustments menu.)
2. Choose Preserve Luminosity, which prevents the tonal qualities of the image from changing.
3. Choose the Midtones option.
4. Slide the balance to more red and less cyan (see Figure 5.5A). Also, move away from blue and toward yellow. Be careful not to overdo it. Figure 5.5B shows the image after the midtone adjustments.

**FIGURE 5.5A**   Adjusting the midtones.

**FIGURE 5.5B**   The image after the midtone adjustments.

5. Choose the Highlights option.
6. Increase the Red and Yellow settings, as shown in Figure 5.6A.

Figure 5.6B shows the image after the adjustments. The picture looks much more natural now. Can you see how we neutralized the blue color cast by shifting the balance of color? In this case we don't need to make any changes to the Shadows portion of the image.

FIGURE 5.6A Adjusting the highlights.

**FIGURE 5.6B** The image after the highlight adjustments.

## Color Correction Using Variations

The Variations tool works just like the Color Balance, but with a more visual interface. This is one of the most commonly used tools to fix color shifting in an image because of the great results and ease of use.

Figure 5.7 shows an image that is suffering from a pretty bad yellow color cast. There should be some yellowing of the paper to show the signs of age, but the plate should be more neutral colored.

1. Choose Image > Adjustments > Variations. You will see five main areas when you open the Variations dialog box (see Figure 5.8).
    a. The top left shows the original image and a preview of the image after the current adjustment.
    b. The next area to the right allows you to choose a tonal range or the saturation of color.
    c. Directly under the tonal range you will see a sensitivity slider that changes the intensity of the adjustment from less (fine) to more (coarse).
    d. The main area shows previews of the image with color shifting in different directions with the current pick in the center.

**FIGURE 5.7**    Picture with a yellow color cast.

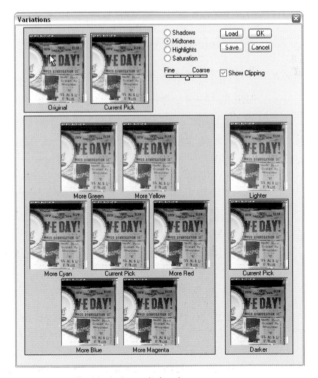

**FIGURE 5.8**    The Variations dialog box.

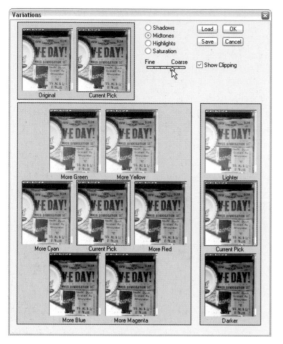

**FIGURE 5.9**   Changing the intensity.          **FIGURE 5.10**   Making an adjustment.

e. The area to the right is where you can lighten or darken the image.
2. Target the midtones (default).
3. As you slide the intensity slider, you can see how it affects the thumbnails. As you choose the coarser settings, the color differences are more radical (see Figure 5.9).

To adjust the image, click on the thumbnail that is closest to the result you are looking for. The current pick will be updated to the colors of the thumbnail you clicked, as shown in Figure 5.10. Notice that all the thumbnails have changed to offer variations of the newly selected color.

The color is now close but not quite there. As shown in Figure 5.11:

1. Lower the intensity to make the adjustment more subtle.
2. Choose more blue.
3. Click on the lighter thumbnail to brighten the image.

If you have Show Clipping turned on, the area will be highlighted in a bright color on some thumbnails, as shown in Figure 5.12. This indicates where image detail will be lost if the highlighted variation is chosen. This is usually a good indication to turn down the sensitivity to a finer setting.

Figure 5.13 shows the image after the color correction has been applied with the Variations feature.

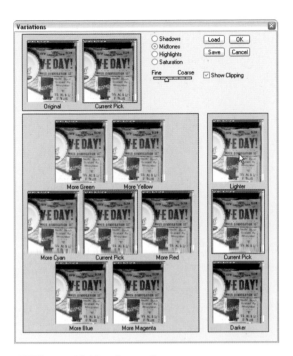

**FIGURE 5.11**   Making finer adjustments.

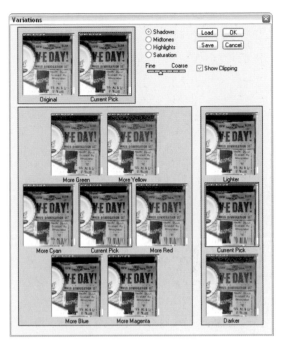

**FIGURE 5.12**   Clipping indicated.

**FIGURE 5.13**   The image after adjusting.

To reset the colors in Variations, simply click on the thumbnail at the top left labeled Original. All the settings will be reverted. It's a good thing to click this button whenever launching Variations, since the previously used settings are always retained in memory.

## MATCH COLOR

Another new feature in Photoshop CS is Match Color. With this filter we can copy the color information from one photo to another. This is a great way to fix studio shots that are inconsistent and remove color casts. This tool also opens up some amazing creative opportunities.

### Removing a Color Cast with Match Color

Match color is a new feature in Photoshop CS, and it is quite an amazing tool. We are going to use it to take the warmth from one picture and apply it to another later in this chapter. For now, we are going to use the Match Color option to painlessly remove a color cast from an image.

Begin with an image that has a color cast. Figure 5.14 has a yellowish color cast from the artificial lighting. You must be in RGB mode for this filter to work properly.

ON THE CD

1. Open `Match.tif` from the Chapter 5 folder on the CD-ROM, or use your own image.
2. From the menu, select Image > Adjustments > Match Color.
3. You will see the dialog box shown in Figure 5.15. Check the Preview box to make sure it is on.
4. Click on the Neutralize box. The overall color temperature of the image should change.
5. Adjust the Fade slider until the image's color looks correct.
6. Adjust the Luminance setting to darken or lighten the image.
7. If you need to adjust the saturation of color, move the Color Intensity slider (this is unnecessary most of the time).
8. Click OK and you are done.

Figure 5.16 shows the image after correction. This is a pretty quick and painless way to remove color casts, and it works well on most images. If you just want to adjust a portion of the image or a particular color, make a selection around the area first and then follow the previous steps.

**FIGURE 5.14**    A yellow color cast.

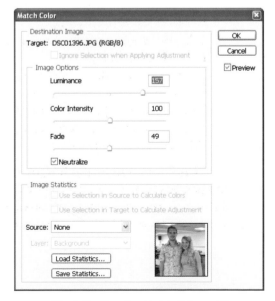

**FIGURE 5.15**    Adjusting the Match Color settings.

**FIGURE 5.16** Image after color correction.

### Adding Life to an Image with Match Color

Match Color also enables you to take the color palette of one image and apply it to another image. In this example we are going to take an image that has a very cold feel and warm it up using another image.

*ON THE CD*

      We will begin with an image that has a bit of blue hue to it, making it feel cold (see Figure 5.17). You can use an image of your own that is on the cool side or use `match 2.tif` from the Chapter 5 folder on the CD-ROM.

*ON THE CD*

1. Open an image that has a much warmer feel to it (`match 3.tif` from the CD-ROM). The image in Figure 5.18 shows a much warmer-looking setting.

**FIGURE 5.17**    The picture has a cold feel before correction.

**FIGURE 5.18**    Open a warmer image.

2. Click on the image in Figure 5.17, which is the image we are now working on.
3. Choose Image > Adjustments > Match Color.
4. Choose the warmer picture under the Source drop-down menu.
5. Turn on Preview.
6. Adjust the Fade slider until you are happy with the colorizing, as shown in Figure 5.19.
7. Increase the Luminance setting to brighten the image.
8. Click OK to apply the changes.

Notice how much warmer the image appears in Figure 5.20. Match Color is an amazing tool that can make short work out of color correction.

**FIGURE 5.19**   The image after color correction.

**FIGURE 5.20**   The image after color correction.

## HUE/SATURATION

A useful tool for fixing color shifts is the Hue/Saturation tool. This tool has many uses that we will be exploring later in the book. In this exercise we will use Hue/Saturation to shift the color in an image. The advantages of this tool are its simplicity of use, and that it offers the capability to target specific color tones (which is also covered in Chapter 7, "Image Retouching"). The disadvantage is that it shifts color across the board and does not have any separate high-mid-shadow control.

ON THE CD

1. Begin with an image that has a color shift. Figure 5.21 has a green color cast because of the fluorescent lighting. Open Hue/Saturation from the CD-ROM or choose your own image.
2. Choose Image > Adjustments > Hue/Saturation (or use an adjustment layer).
3. Adjust the Hue slider until the color looks more natural (see Figure 5.22).

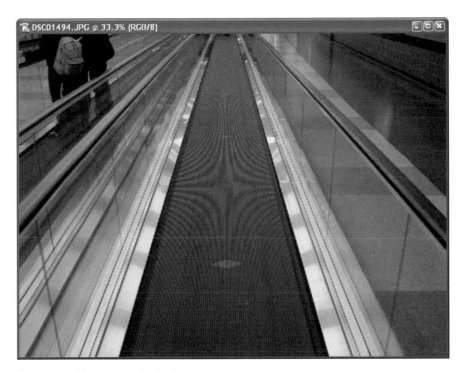

**FIGURE 5.21**    The image with bad green color cast.

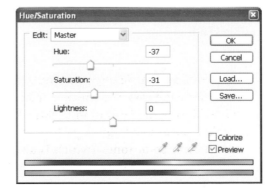

**FIGURE 5.22**    Hue/Saturation adjustment.

4. In this image we lowered Saturation to decrease the intensity of the color in the image.
5. Click OK when you are happy with the appearance of the image.

Figure 5.23 shows the image after correction with Hue/Saturation. The metal looks much more natural now.

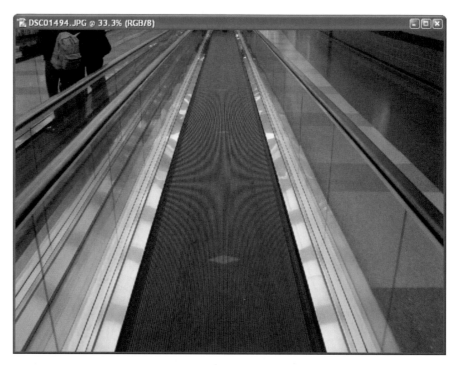

**FIGURE 5.23** The image after adjustment.

## Advanced Color Correction

We are going to look at a few color adjustment techniques that go beyond the simple click-and-slide techniques. These are professional-level techniques that will help you fix almost any image. You will be surprised by the power of Photoshop and also your capability to correct color by the end of this chapter. Read on!

### Fixing an Image with Washed Out/Shifted Color with Lab Color

The image in Figure 5.24 suffers from a reddish color shift and lacks saturation in the color. This book is for digital photographers, but even digital photographers may have to scan an old image or two from time to time, which has suffered the fading effect of age. In the case of this image, a lot of the film had expired and had a new date stamped on the box. Needless to say, the images lack a lot of color saturation because of bad film.

**FIGURE 5.24**  Faded image with color cast.

1. Open Ch 5-LAB before.tif from the CD-ROM, which is the original image in Figure 5.24, with a color cast and lacking any luster. In the real world, there will be times that you are forced to use such an image.
2. Choose the Hue/Saturation adjustment layer, or from the menu select Image > Adjustments > Hue/Saturation.
3. Slide the Hue slider to compensate for the color shift.
4. Boost the saturation to restore some color to the image, as shown in Figure 5.25.

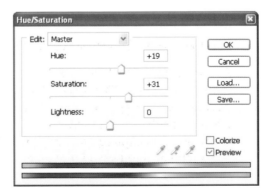

**FIGURE 5.25**  Hue/Saturation adjustment.

**FIGURE 5.26**    The image after adjustment.

Figure 5.26 is still not perfect, but it is a lot better than it was; the trees are showing some green now.

## Advanced Color Correction with Lab Color

We are now going to branch off into new territory. We are going to switch to Lab Color. Lab will split the image into three channels:

**L (Lightness) Channel:** This contains all the grayscale information in the image.

**A Channel:** This contains the magenta and green color information.

**B Channel:** This contains the yellow and cyan color information.

1. Choose Image > Mode > Lab Color.
2. Open the Channels Palette, as shown in Figure 5.27.
3. Click on the Lightness channel to activate it, as shown in Figure 5.28.
4. Adjust the levels by selecting Image > Adjustments > Levels. This will affect only the luminance (grayscale information) and will not shift the colors. Figure 5.29 shows the levels being adjusted. (This is also the channel where all sharpening should take place.)
5. Click on the A channel to select it.

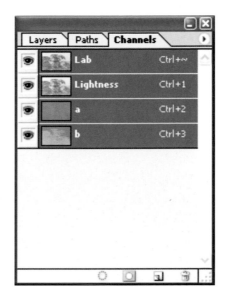

**FIGURE 5.27**    The Channels Palette in Lab mode.

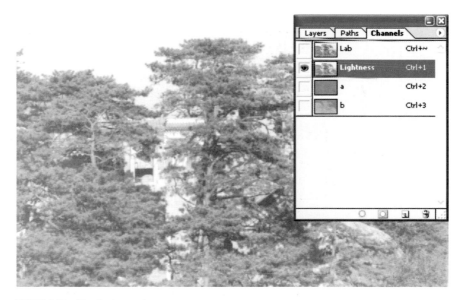

**FIGURE 5.28**    The L channel.

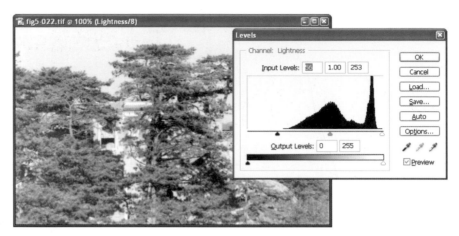

**FIGURE 5.29**   Adjusting the levels of the Lightness channel.

6. Turn on the Visibility icon next to the top (Lab) composite channel; the A channel should now be highlighted with all the channels visible, as shown in Figure 5.30.

7. Select Image > Adjustments > Levels.

You will now see the Levels slider, and we can adjust the color shift by sliding the middle slider. If we slide it to the left, we will increase magenta, and if we slide it to the right, we will increase green. Move the slider to the right a little and notice how the green in the trees begins to really pop, as seen in Figure 5.31.

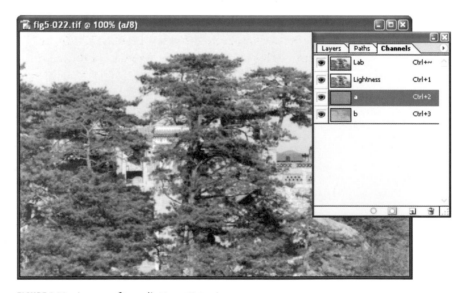

**FIGURE 5.30**   Image after adjustment.

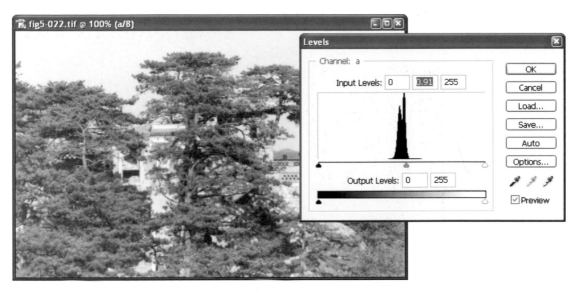

**FIGURE 5.31**   Increasing the green in the image.

8. Choose the B channel.
9. Open the Levels dialog box again.
10. The B channel contains yellow and cyan; move to the left for yellow and to the right for cyan (blue).
11. Move the slider a little bit to the right as shown in Figure 5.32 to bring some more blue to the sky.

You can see how much color has been restored in this image using the channels in Lab mode (see Figures 5.33A and 5.33B). When you are happy with the result, return to RGB mode.

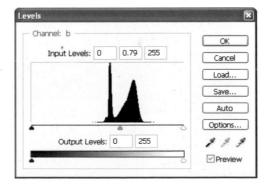

**FIGURE 5.32**   Adjusting the yellow/cyan.

**FIGURE 5.33A** The image before adjustment.

**FIGURE 5.33B** The image after adjustment.

## ADVANCED COLOR CORRECTION WITH LEVELS

This technique is a contrast/tone and color correction technique all in one. Once you run through this technique, you will see how just about any image can be improved, and you will use this technique many times over. For a number of years, this was just about the only correction technique I used.

*ON THE CD*

1. Open Ch 5-Hong Kong.tif from the CD-ROM.

Figure 5.34 shows an image from the amazing city of Hong Kong. As you can see, the image lacks a bit of contrast and also has a bit of a color cast to it. It's really not that bad (or is it?); it just looks a bit dirty. You will see a huge difference soon.

2. Choose a Levels adjustment layer from the Layers Palette. We are now going to set the black and white points in the Levels settings.
3. In the Levels dialog box, double-click the Set Black Point tool as shown in Figure 5.35.
4. You will see a color picker; set everything to solid black and then change the setting under B to 5, as shown in Figure 5.36. (This sets the black point to 95% black or 5% White.)
5. Click OK.
6. Double-click the Set White Point tool, which is the white eyedropper.

**FIGURE 5.34**  The image before adjustment.

**FIGURE 5.35**  Setting the black point.

FIGURE 5.36    Black point settings.

FIGURE 5.37    Setting the white point.

7. In the color picker, set for pure white and then enter 95 into the B setting as shown in Figure 5.37. The white point is now set to 95% white.

We are now ready to perform the image correction. We are going to click the Set Black Point tool in the darkest part of the image and the Set White Point tool in the lightest part of the image.

1. Locate the darkest part of the image. Hold down the Alt key (Option in Mac) and move the shadow slider to the right. The image should turn white as you move the slider, and you will see some areas begin to show through. This is the black point threshold, as shown in Figure 5.38. The areas that start to show are the darkest areas of the image.
2. Take note of where the dark portion of the image is on the threshold and return the slider to the far left.
3. Choose the Set Black Point tool and click on the darkest portion of the image in the main image window, as shown in Figure 5.39. The image will be shifted, and the area we clicked on will now be set to the 95% black that we selected in step 4 of the previous task.
4. Hold down the Alt key (Option in Mac) and move the right slider to the left to reveal the whitest point of the image. The image will begin as black, and the highlight areas will show through, as shown in Figure 5.40.
5. Choose the Set White Point eyedropper tool from the Levels Palette.
6. Click on the whitest area of the image as shown in Figure 5.41; the lightness of the image will be adjusted to match.

**FIGURE 5.38**    Finding shadows.

**FIGURE 5.39**    Adjusting the shadows.

**FIGURE 5.40**    Finding highlights.

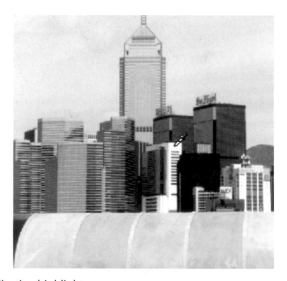

**FIGURE 5.41**    Adjusting highlights.

The tonal qualities of the image will be looking much better now, and the color cast will be reduced a bit. Now we'll totally remove the color cast.

7. Choose the Set Gray Point eyedropper from the Levels dialog box.

When we click on the image with this tool, it will choose the selected area as the gray point of the image and balance all the color to match.

8. Click on a portion of the image that should be a neutral gray, such as the small tower in Figure 5.42.

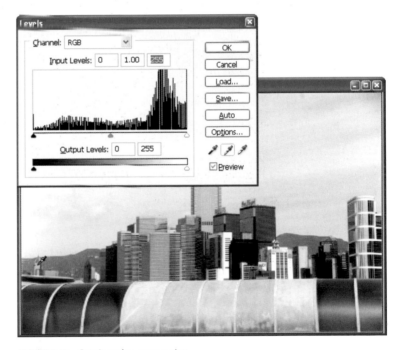

**FIGURE 5.42**  Setting the gray point.

The colors will shift; if you are not happy, keep experimenting by clicking the Set Gray Point tool in different parts of the image.

9. When you are happy with the result, click OK to apply the levels to the image.

You have now learned how to use the Levels tool correctly. It may seem like a lot to do, but with some practice you can perform this entire correction in under a minute.

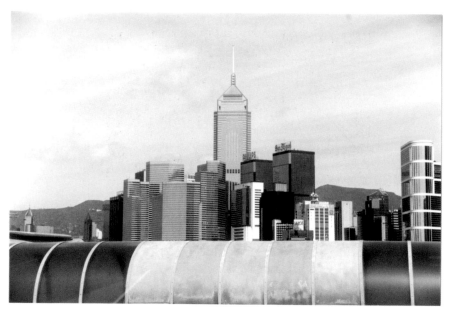

**FIGURE 5.43** The image after adjustment.

Figure 5.43 shows the final corrected image, a vast improvement from the original.

## ADVANCED COLOR CORRECTION WITH CURVES

We covered Curves in the previous chapter as a powerful tool for making tonal corrections and effects. Curves can also be used for color correction. Curves can be considered an advanced color correction method because it is possible to really mess up your images using Curves on color, if you don't know what you are doing. Some people avoid using Curves for color correction because it seems so random and difficult. Others do almost all color correction with Curves because of the control and power available. We'll discuss the benefits by showing you how to use Curves for color correction using a fairly simple method. If you have not yet read the section on Curves in the previous chapter, please do so before proceeding.

Figure 5.44 shows an image that is pretty good, but a little heavy in the red.

1. Choose a new Curves adjustment layer. We now want to sample the color in an area that is showing the excess red. A good place to begin when dealing with people is to sample the skin tones. Accurate skin tones are very important for natural-looking photos.

**FIGURE 5.44**    The image before adjustment.

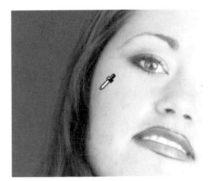

**FIGURE 5.45**    Sampling a region of color.

2. Hold down the Ctrl-shift keys (Cmd-shift in Mac) and move your cursor over the image (it will change to an eyedropper tool). Click on the region that you want to sample, as shown in Figure 5.45. This adds an adjustment point to the color channels; you will see nothing in the Composite channel (RGB).

3. In the Channels drop-down menu, choose Red as shown in Figure 5.46. You should now see the adjustment point on the curve.

4. Move the point up to increase red or down to decrease it. In this case we want to reduce red, so drag the point down and watch the image until the red looks correct, as shown in Figure 5.47. (If you see no change in the image as you move the curve, check that Preview is turned on.) The movements usually need to be very subtle.

5. Repeat for the Green channel as shown in Figure 5.48. We don't need much of a change in this image.

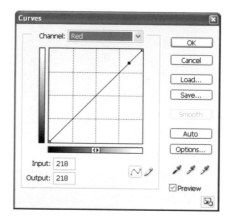

**FIGURE 5.46**   A point on the curve.

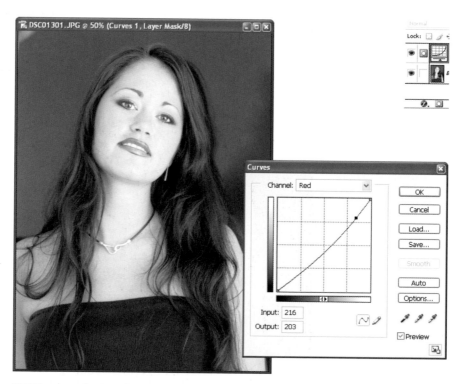

**FIGURE 5.47**   Adjusting red.

6. Choose the Blue channel and also make adjustments as shown in Figure 5.49.
7. Click OK to apply the adjustment layer.

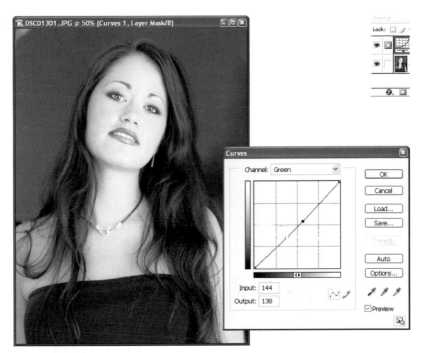

**FIGURE 5.48**    Adjusting green.

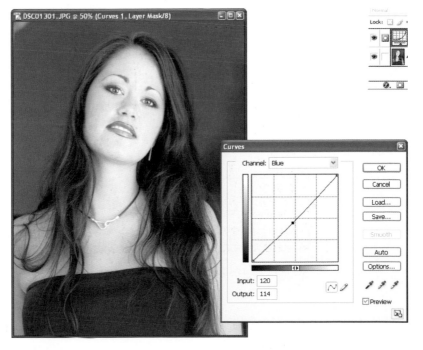

**FIGURE 5.49**    Adjusting blue.

**FIGURE 5.50**    The image after adjustment.

Figure 5.50 shows the image after the color adjustments with Curves. Notice that the skin tones are now more natural. If you want to target different tones in the image, create a new Curves adjustment layer and repeat these steps, with the exception of targeting a different color sample.

## SUMMARY

In this chapter we looked at various color correction techniques that will help you adjust your images to natural looking colors. We began with some very simple techniques and got more in depth as the chapter progressed. These techniques will help you salvage images that were taken with incorrect white balance settings and make them look great.

# SHARPENING AND NOISE REDUCTION

## SHARPENING

Whether it is improper focus, an unsteady hand, movement, or scanning, there are many things that introduce blurring to our photos. There is nothing quite like a nice crisp, sharp image, and Photoshop has the tools to help achieve that result without it looking fake. Sharpening is a task that you will perform many times throughout your career, and this chapter will introduce you to several useful techniques.

### Unsharp Mask

The most common method for sharpening images goes by the most unusual name *unsharp mask*. What this oddly named filter does is detect the sharp changes in tone in the image, and then it says "this must be an edge." The unsharp mask then adds a slight highlight to the edge to make it look more pronounced, and the result is a sharper image with more edge definition. We have control over three attributes of the filter:

**Amount:** This is how pronounced the effect will be.
**Radius:** The size of the highlight added to the image. If you turn this all the way up, you will see a "halo" around the image.
**Threshold:** Determines what Unsharp Mask interprets as edges by adjusting the sensitivity of edge detection.

| TUTORIAL | **SHARPENING AN IMAGE USING UNSHARP MASK** |
| --- | --- |

ON THE CD

1. Open `brugge-1.tif` from the CD. Figure 6.1 shows the image, which could use a little bit of sharpening.
2. Choose Filter > Sharpen > Unsharp Mask. You will see the Unsharp Mask dialog box, as shown in Figure 6.2.
3. Click anywhere in the image to sample that region as the preview in the dialog box.
4. Use the + and – buttons to zoom in or out of the image. The default is 100% view.
5. Make sure Preview is checked so that you can see the result on the image.
6. First adjust Amount according to the image and how much sharpening you want to apply. Usually 100 is a pretty good starting place.
7. Adjust Radius to get a good result without making the effect look artificial and filtered. Between 0.5 and 2.0 usually works well.
8. You may need to go back and forth between Amount and Radius a few times to get a good balance. Remember that you should sharpen a bit

**FIGURE 6.1**   Image in need of sharpening.

**FIGURE 6.2**   The unsharp mask.

**FIGURE 6.3**   Setting the options in the Unsharp Mask dialog box.

higher for buildings than you would for people; sharpening people is not flattering because it can bring out their flaws.

9. Finally, set Threshold. In this case we are keeping it at 0, which has no effect on the image at all. If you were sharpening a person's face, you might use Threshold to ignore certain things such as the face's texture.

10. When you are happy with your settings, such as in Figure 6.3, press OK to apply the effect.

Immediately after applying the filter, navigate to Edit > Fade Unsharp Mask. Change Blending Mode to Luminosity, which ensures that the sharpening is applied only to the image without shifting the color.

Figure 6.4 shows the image after sharpening.

 *It's best to avoid overdoing sharpening because it can make an image look too harsh and artificial. Most corrections should be done with subtlety.*

### SHARPENING USING LAB MODE

In the previous chapter we moved into the realms of Lab mode as a way of correcting images. Lab mode is also great for sharpening images because

**FIGURE 6.4**    The sharpened image.

we can apply the sharpening to just the Grayscale channel. This has two advantages:

- It prevents any color shifting because the color information is untouched.
- It minimizes the introduction of noise to the image. Sometimes there is a lot of noise or grain in the color of a photo, particularly in the blue regions. If we were to sharpen the blue, it would also accentuate the grain and noise.

ON THE CD

1. Open the image `brugge-3.tif` from the CD or use one of your own images. Figure 6.5 shows the image before sharpening.
2. Convert to Lab mode by choosing Image > Mode > Lab Color.
3. Choose the Channels Palette and click on the Lightness channel, as shown in Figure 6.6.
4. Apply the unsharp mask in the usual way by selecting Filter > Sharpen > Unsharp Mask.
5. Choose the best settings for your image as shown in Figure 6.7.
6. Press OK to apply the sharpening effect.

**FIGURE 6.5**    Image before sharpening.

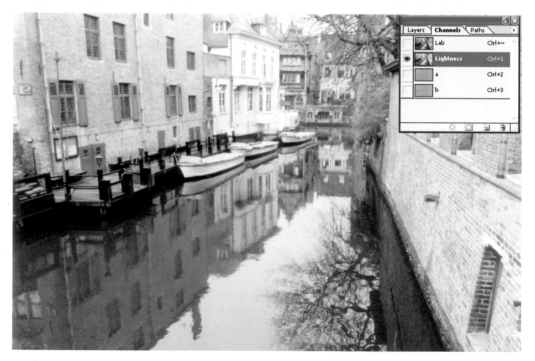

**FIGURE 6.6**    Choosing the Lightness channel in Lab mode.

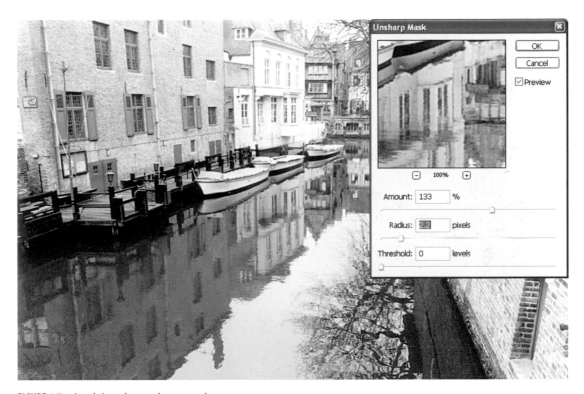

**FIGURE 6.7**    Applying the unsharp mask.

7. Click on the Top channel to display all the channels and preview the image in color again.

Figure 6.8 shows the image after sharpening to the Lightness channel. This is a great way to apply sharpening. When you are finished, you can convert the image back to RGB mode.

### FADING THE SHARPNESS (OPTIONAL)

Immediately after applying a filter, there is a Fade option available so that you can adjust the intensity of the effect. This option is available only when the previous command was a filter. It is not available after you have done anything else to the image, even changing the visibility of a layer or channel.

1. To apply this effect, choose Edit > Fade *name of last filter*.
2. Adjust the opacity; to the left is the original image, and to the right is the filtered image. Choose the right balance, and you can even choose a blending mode if you want. Figure 6.9 shows us fading an unsharp mask.

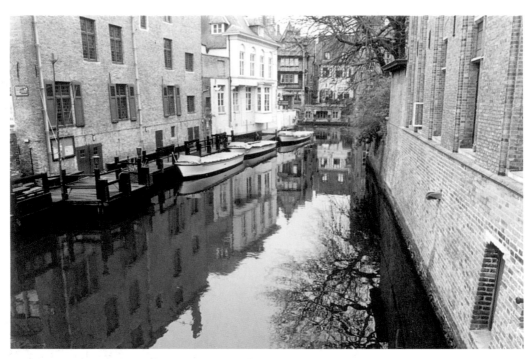

**FIGURE 6.8** The sharpened image.

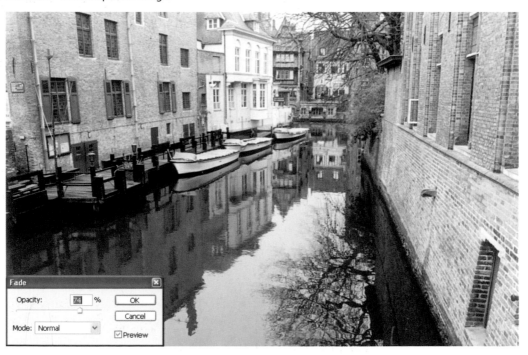

**FIGURE 6.9** Fading the previous filter.

### NON-DESTRUCTIVE SHARPENING

This technique sharpens the image very well and is not destructive. This technique is called non-destructive because it does not affect the original image. Instead, it works through a layer that we will call a sharpening layer.

1. Open `brugge-2.tif` from the CD. Figure 6.10 shows the image before sharpening.

**FIGURE 6.10**    Image before sharpening.

**FIGURE 6.11**   The sharpening layer.

**FIGURE 6.12**   High Pass filter.

2. Duplicate the Background layer by dragging the layer thumbnail to the New Layer icon in the Layers Palette.
3. Change the blending mode of the new layer to Overlay as shown in Figure 6.11 (this will be our sharpening layer).
4. Choose Filter > Other > High Pass. See Figure 6.12.
5. Turn on Preview if it isn't already.
6. Adjust Radius until the image looks good. A lower setting will give you less sharpening. This is a very subtle technique, and lower settings should work for most cases.
7. Press OK to apply the effect to the image.

Your image is now sharpened as shown in Figure 6.13. If you ever want to reduce the sharpening effect, just lower the opacity of the layer. If you want to remove the sharpening effect altogether, just delete the sharpening layer.

**FIGURE 6.13**    The final sharpened image.

## NOISE REDUCTION

With film we had to deal with grain, and with digital cameras we have to deal with noise. Usually when the lighting is low, noise can be introduced to the image; on a cheaper camera, you will have noise on just about every image. The techniques you are about to learn are the same for reducing both noise and film grain.

| TUTORIAL | REDUCING NOISE WITH SMART BLUR |
|---|---|

1. Open an image that has some noise or grain, as shown in Figure 6.14.
2. Choose Filter > Blur > Smart Blur (you can also use the Median filter if you prefer).
3. Choose High Quality.
4. Adjust Radius and Threshold until the noise is gone, but as much detail as possible remains in the image, as shown in Figure 6.15.
5. Click OK to apply.

Your image will have all the noise removed as shown in Figure 6.16. The only problem is that, depending on the severity of the noise problem, the image could be too blurred and appear as if it is hand painted or lacking in detail.

6. Choose Edit > Fade Smart Blur. If this command is not available, undo the blur, reapply it, and then choose Fade.
7. Change to Luminosity mode.
8. Adjust the opacity until you reach a good balance of blur and detail, as seen in Figure 6.17.

**FIGURE 6.14** The image with some noise present.

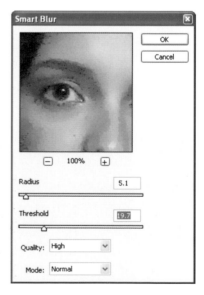

**FIGURE 6.15** Using Smart Blur.

**FIGURE 6.16**    Blurred image.

**FIGURE 6.17**    The final corrected image.

## USING CHANNELS FOR NOISE REDUCTION

When reducing noise, it's a good idea to look at the individual channels. Sometimes most of the noise is present in one channel. It makes sense to correct the offending channel rather than blur the entire image. That way we can reduce the noise without affecting too much of the image. In digital photography, it's common for most of the noise to be present in the Blue channel.

1. Open an image that contains noise, such as is seen in Figure 6.18.
2. Choose the Channel Palette. Open it from Window > Channels if it is not already open.

**FIGURE 6.18**    The beginning image.

3. Click on the Red channel thumbnail to view the Red channel by itself, as shown in Figure 6.19a.
4. View the Green and the Blue channels, as shown in Figures 6.19b and 6.19c. Notice that most of the noise is in the Blue channel.
5. With the Blue channel selected, choose Filter > Noise > Median.

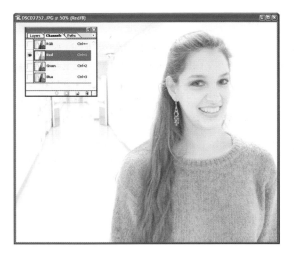
a

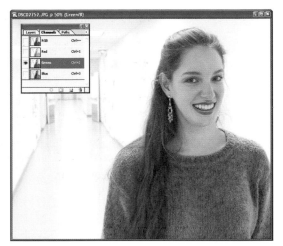
b

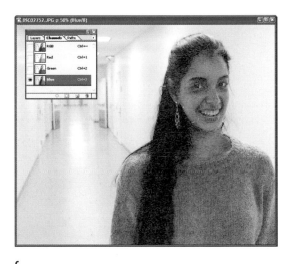
c

**FIGURE 6.19**    Viewing the channels: a = Red, b = Green, c = Blue.

6. Adjust Radius until the noise is gone, as shown in Figure 6.20 (you could also use Smart Blur).
7. Click Ok to apply.
8. Choose the RGB thumbnail from the Channels Palette to return to the normal color view.

Figure 6.21 shows the image with the noise reduced. On a particularly bad image you may need to blur more than one channel. If that is the case, just repeat the steps for the other channels.

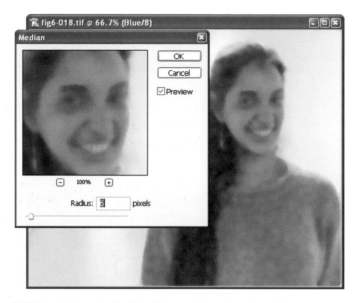

**FIGURE 6.20**    Run the Median filter on the noisy channel.

**FIGURE 6.21**    The final image.

### NOISE REDUCTION USING LAB MODE

Once again we come to Lab mode. This is the best method of noise reduction that preserves as much of the original detail as possible.

ON THE CD

1. Open `Street.tif` from the CD, as shown in Figure 6.22.
2. Choose Image > Mode and select Lab Color. This will separate the color channels from the luminosity (grayscale).
3. Choose the A channel from the Channels Palette.

**FIGURE 6.22**    Image with noise present.

You can see in Figure 6.23 that there is a lot of noise present in this channel. The good thing about Lab mode is that we have the color channels separate from the grayscale, and we can blur the color channels without affecting the sharpness of the image too much.

4. Apply the Median filter as we did in the previous exercise. Choose Filter > Noise > Median. The result should look like Figure 6.24.

**FIGURE 6.23**    Examining the A channel.

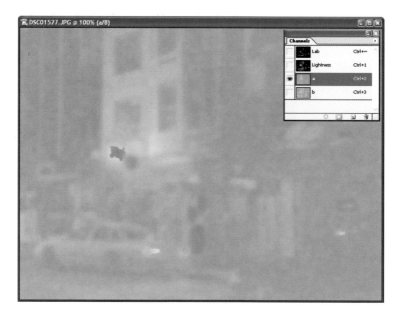

**FIGURE 6.24**    Blurring the A channel.

5. Select the B channel as shown in Figure 6.25.
6. Choose Filter > Noise > Median.

The result should resemble Figure 6.26.

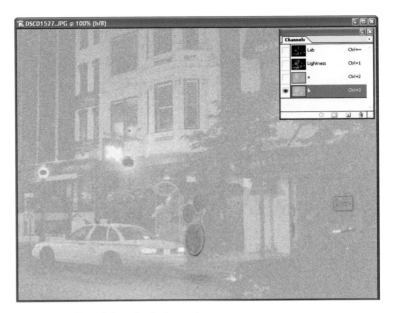

**FIGURE 6.25**   Examining the B channel.

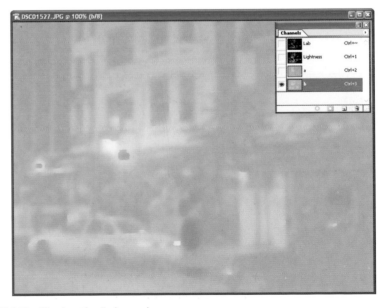

**FIGURE 6.26**   Blurring the B channel.

7. Choose the Lab Composite channel at the top of the Channels Palette to return to the regular color view.

Examining the image now (Figure 6.27), most of the noise has been removed, and the image has retained its sharpness and detail.

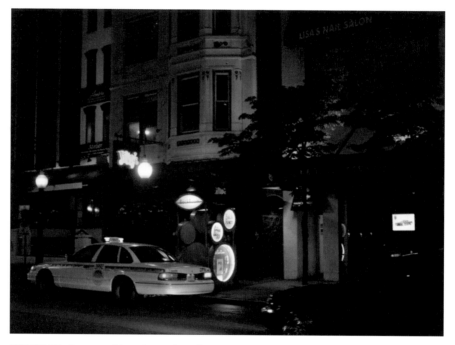

**FIGURE 6.27**    Image with noise reduced.

## SUMMARY

In this chapter you learned about sharpening and noise reduction. These two techniques can seem to fight against one another, but in a correct balance they can happily coexist in the same image. The techniques you learned in this chapter will help you to increase the sharpness of your images with a minimum of distracting noise. Bear in mind that these techniques will assist in enhancing your images, but they are not substitutes for good photography. For instance, correctly focusing the camera, holding it steady, and using adequate lighting and correct exposure will minimize the need for sharpening and noise reduction.

PART

III

# EFFECTS

# 7

# IMAGE RETOUCHING

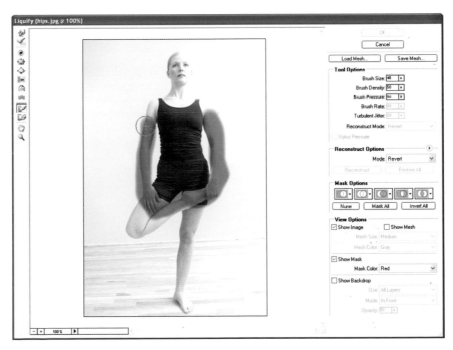

Royalty Free Images from Hemera™.

This chapter will show you ways to make people look better. After the images are captured and long after the models have retired to their cozy dwellings, it's time to do a little work. This is where we will make people look younger, remove moles and freckles, and perform instant weight loss. If only this was possible in the real world, we would make a fortune!

There is the ethical question, of course. How much is too much? The answer is up to you and your client. Even supermodels are retouched for the covers of magazines, and all imperfections are smothered out. You can use these techniques to fix minor problems or turn someone into a totally different person. Figure 7.1 shows an image that was deliberately over-retouched using the techniques shown in this chapter. It's a bit rough, but it shows you the dangers of getting too excited. Even her own mother would not recognize her.

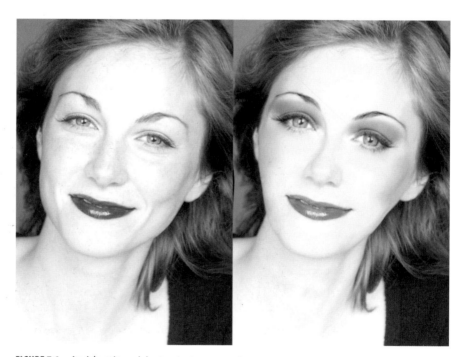

**FIGURE 7.1**   An identity crisis. Royalty Free Images from Hemera™.

## REMOVING MOLES AND BLEMISHES

This technique will quickly and painlessly remove moles. The same technique works just as well on pimples, warts, boils, and other unwanted growths.

**TUTORIAL**

*ON THE CD*

1. Open `mole.jpg` from the CD-ROM or use your own image. We have a picture of a pretty face as shown in Figure 7.2, except for the addition of the mole. Always check with your client before removing moles, because these can be desired distinguishing marks in some cases, such as with Cindy Crawford.

2. Choose the Healing Brush. This tool is almost magical. When you paint with the healing brush, it matches the texture and color tone of the image and attempts to blend the strokes to the surface you are painting on, without the blemish.

3. Choose a portion of the skin similar to the portion with the mole. Press the Alt key (Option in Mac) and click to capture a sample of the tone.

**FIGURE 7.2**    The original image. Royalty Free Images from Hemera™.

4. Click and drag the mouse over the bad area of the image.

5. Release the mouse, and the stroke will blend into the existing image, as shown in Figure 7.3.

Just like magic, the mole is gone. Figure 7.4 shows the same image after just a few seconds of work.

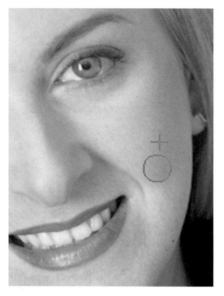

**FIGURE 7.3**    Removing the mole.

**FIGURE 7.4**    The repaired image.

## WRINKLE REDUCTION

Alas! While we are still waiting for the invention of the miracle wrinkle cream, Photoshop can quickly remove a few years off our faces. In this tutorial we will once again be using the Healing Brush. This time we will use it to remove the signs of aging by removing wrinkles.

**TUTORIAL**

*ON THE CD*

1. Open the image `wrinkles.jpg` from the CD-ROM or begin with one of your own. The woman in this image is about to drop 10+ years off her appearance.

   A good practice to get into is creating a new layer and naming it Retouched (Figure 7.6). This way we will leave the original layer intact. We can also adjust the opacity of this layer later to lessen the effect of the digital plastic surgery and produce a much more realistic result.

2. Select the Healing Brush tool.

**FIGURE 7.6**   A new layer.

**FIGURE 7.5**   The beginning image. Royalty Free Images from Hemera™.

**FIGURE 7.7**   Choosing Use All Layers.

3. Choose the Use All Layers option from the options bar (see Figure 7.7). This will enable us to work on a blank layer. If you do not turn on this option, nothing will happen when you work on the Retouched layer.
4. Press Alt-click (Option in Mac) to sample.
5. Click to paint over the target area of the image. Rather than dragging the mouse with the Healing Brush, it's a better idea to "dab" the effect. Click, move the mouse a little, and click again, slowly building up your effect. This technique will produce a more subtle effect and will blend much better. There are exceptions, such as when working on a larger, more contrasted area, when you may need to drag a little, but this is the exception rather than the norm.
6. Release your mouse button, and Photoshop does the blending.

**FIGURE 7.8**   Sampling.

**FIGURE 7.9**   Painting with the Healing Brush.

*Adjust the brush size for the area you are working on. Make frequent samples for a more accurate match.*

7. Take a sample from below the eye as shown in Figure 7.8.
8. Paint away the wrinkles around the eyes as shown in Figure 7.9.

   Figure 7.10 shows the area of the eye being smoothed out.

9. Keep working on the image until all the wrinkles are removed from around the eyes (Figure 7.11), also remove the smile lines.
10. Repeat the same process around the mouth and remove the wrinkle marks.

**FIGURE 7.10**   The wrinkles are smoothed away.

**FIGURE 7.11**   The eyes retouched.

 *You may find dark marks appearing on the working areas. This is because either the brush is too soft or the sample is wandering into shadowed areas of the image. Here is the fix: Reduce the size of the brush and make the edge hard rather than soft. You can do this from the Brush option on the options bar.*

11. Finish retouching all the wrinkles on the image. Don't worry if it looks a bit plastic and unnatural, we will fix that now.
12. Reduce the opacity on the Retouched layer as shown in Figure 7.13. This fades the retouch and lets a hint of the wrinkles show through. By doing this we retain the character of the person, without all the adverse effects of the wrinkles. This produces a younger-looking natural face.

**FIGURE 7.12**   The mouth has been retouched.

**FIGURE 7.13**   Reducing the Retouched layer's opacity.

**FIGURE 7.14**    After: a realistic looking retouch.

Figure 7.14 shows the image after the retouch. Compare this to the original image in Figure 7.5.

## REMOVING TATTOOS AND BIRTHMARKS

This tutorial will show you how to retouch larger portions of the image. We are going to use the Patch tool. This is similar to the Healing Brush but can affect much larger areas quickly.

**TUTORIAL**

1. Begin with the image `tattoo.jpg` from the CD-ROM (see Figure 7.15) or use your own.
2. Choose the Patch tool; click and hold your mouse on the Healing Brush, and the Patch tool will appear from the fly-out menu, as shown in Figure 7.16.
3. Choose Source from the options bar as shown in Figure 7.17.

ON THE CD

**FIGURE 7.16**   The Patch tool.

**FIGURE 7.15**   The image showing the tattoo. Royalty Free Images from Hemera™.

**FIGURE 7.17**   Choosing the settings.

4. Make a selection around the area that you want to replace using the Patch tool (see Figure 7.18). Click and drag as you would if using the Lasso tool.
5. Click anywhere inside the selection and drag with the Patch tool. You will see the destination area previewed in the selected area as you move your mouse (see Figure 7.19). This preview is new in Photoshop CS.
6. Move the mouse until you have a pretty smooth-looking match.
7. Release your mouse, and the Patch tool will smooth the edges of the selection.

As you can see in Figure 7.20, the area looks pretty good except for some small areas of color above and below the replaced area.

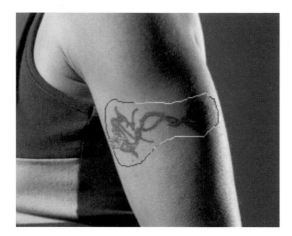

**FIGURE 7.18**    Making a selection.

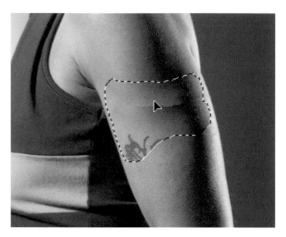

**FIGURE 7.19**    Choosing the replacement area.

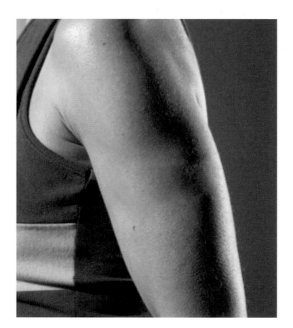

**FIGURE 7.20**    The image patched.

**FIGURE 7.21**    After a little fine-tuning with the Healing Brush.

8. Choose the Healing Brush and clean up the edges as shown in Figure 7.21.

You would never know that a tattoo used to sit right there on her arm. This technique is also great for birthmarks and other areas that require larger fixes.

## REMOVING REDEYE

A common problem caused by using a flash that is too close to the lens is redeye. We are all familiar with it and can reduce the effect by shooting without flash, defusing the flash, or using an off-camera flash. Many digital cameras have a redeye reduction mode. This pre-fires the flash, causing the iris to contract, and then fires another flash to take the image. This option works sometimes and doesn't at other times. The good news is that with Photoshop CS, redeye is fixed easier than ever, using a new tool called the Color Replacement tool.

### TUTORIAL

ON THE CD

1. Open `redeye.jpg` from the CD-ROM (Figure 7.22) or choose an image of your own that suffers from this common problem.
2. Choose the Color Replacement tool. It resides right in the fly-out menu with the Healing Brush and Patch tool. See Figure 7.23.

**FIGURE 7.22**    A little too much redeye.

**FIGURE 7.23**    The Color Replacement tool.

3. Click on a dark portion of the image to sample some color as shown in Figure 7.24. The dark area in the hair will work well. If there is no dark portion of the image, select black as the foreground color.
4. Adjust the brush size in the options bar until it is the size of the red area.
5. Click once, and the red is replaced with the new color (see Figure 7.25).
6. Repeat for the other eye.

The redeye has been eliminated just like that! Figure 7.26 shows the corrected image.

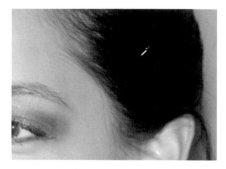

**FIGURE 7.24** Sampling a dark color.

**FIGURE 7.25** Painting the eyes.

**FIGURE 7.26** No more redeye.

Another method for reducing redeye is to retouch the Red channel. Since a channel in RGB mode is based on light, it will show more color when the shade of gray is lighter and less color as it becomes darker.

1. Open the Channels Palette.
2. Choose the Red channel.
3. Select the Burn tool.
4. Adjust the size of the brush to the size of the pupil.
5. Paint over the pupil with the Burn tool.
6. Click back on RGB at the top of the Channels Palette to restore the composite view.

The redeye should now be gone.

## EYES WIDE OPEN

There are many things that cause a person to squint: bright lights, smog, smiling, and even age. Even when the eyes are perfectly fine, they are enlarged by many professionals for cover shots and such uses because doing so causes the eyes to attract more attention, and slightly enlarging them (20% or so) will make a big difference in the image. We will show you two methods to open and enlarge the eyes. The first method is the traditional way. The second is with the Liquify tool. Be very wary of the second method because it's easy to change the shape of the eyes, unless of course that is the result you are looking for.

**TUTORIAL**

ON THE CD

For both methods, first open `eyes.jpg` from the CD-ROM (Figure 7.27) or begin with an image of your own.

**FIGURE 7.27**   The original image with squinting eyes.

### METHOD 1

1. Choose the Lasso tool.
2. Make a selection around the eye area as shown in Figure 7.28. Try to keep a little distance between the selection and the eyes and eyebrows.
3. Choose Select > Feather to soften the selection. See Figure 7.29.
4. Enter a 10-pixel feather. This will change according to the resolution of the image. The higher the resolution, the higher the settings. If you think about 10 pixels in a 72 ppi image, that can cover a reasonably large area. In

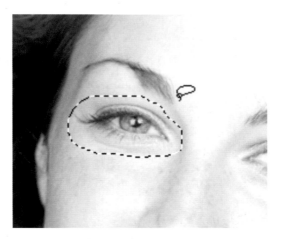

**FIGURE 7.28**  Making a selection.

a 600 ppi image, 10 pixels would be a much smaller area. Experiment with this setting if you are not getting the desired result.

5. Select Layer > New > Layer Via Copy or press Ctrl-J (Cmd-J in Mac) to copy the eye to a new layer.
6. Repeat this process for the other eye. (Make sure you choose the background with the pixels on it again before trying to copy to a new layer. It's easy to forget.)

Your Layers Palette should now look like Figure 7.30, with the original image and each eye on its own layer.

7. Choose Edit > Free Transform or press Ctrl-T (Cmd-T in Mac).
8. Click and drag on the resizing handles to open and enlarge the eye. Be careful not to overdo it (see Figure 7.31).
9. You may have to reposition the eyes after transforming as the center may have shifted slightly.

**FIGURE 7.29**   Softening the selection.

**FIGURE 7.30**   Copying the eyes to new layers.

The image now has the eyes opened and enlarged (see Figure 7.32). See how much more eye-catching it is? This is a very flattering technique for the subject if it's performed with care.

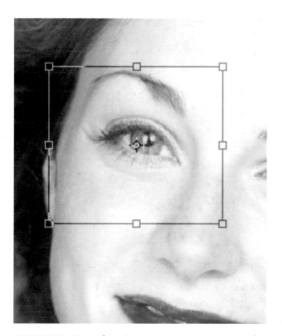

**FIGURE 7.31**   Transforming.

**FIGURE 7.32**   Opened eyes.

### METHOD 2

You can really get carried away with this technique if you are not careful. You can also have a lot of fun with this tool.

1. Choose Filter > Liquify.

   You will see the Liquify tool open.

2. Choose the Forward Warp tool as shown in Figure 7.33.
3. Position the crosshairs outside the actual eye as we have in Figure 7.34. This is so that we don't warp the iris and make "cats eyes" by accident.
4. Click and drag carefully. Pull the edge of the eye to open it up. Be careful to be subtle with this technique or it will look bad.

   Figure 7.35 shows us opening the top of the eye.

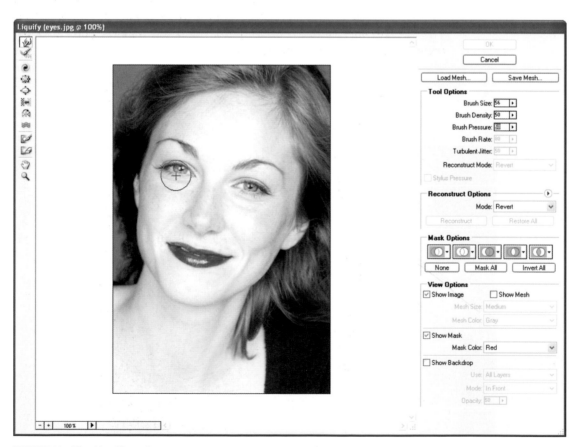

**FIGURE 7.33**   The Liquify tool.

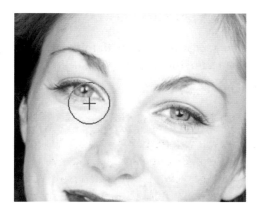

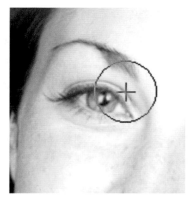

**FIGURE 7.34**   Liquefying the eyes.

**FIGURE 7.35**   Open the tops, too.

Figure 7.36 shows the eyes after liquefying. This technique is more useful if you are working with an anonymous model rather than with a portrait for someone because when you change the shape of the eyes, you can really transform the appearance of a person.

**FIGURE 7.36**   The finished image.

## REDUCING NOSES

The girl in Figure 7.37 doesn't really have an oversized sniffer. She just got a bit too close to a wide angle lens and suffers from a case of barrel distortion. By now, I'm sure you have discovered that some interesting perspectives can appear when you shoot really close. Never fear, we will reduce that nose in a jiffy.

**FIGURE 7.37**   She got a bit close to the lens. Royalty Free Images from Hemera™.

## TUTORIAL

*ON THE CD*

1. Open nose.jpg from the CD-ROM.
2. Choose Filter > Liquify to launch the Liquify tool.
3. Choose the Freeze Mask tool, as shown in Figure 7.38.
4. Freeze Mask protects portions of the image from the results of liquefying. Paint around the nose to protect the eyes, lips, and cheeks. The mask will not hurt your image (see Figure 7.39).
5. Grab the Pucker tool from the list of tools on the left of the interface. Figure 7.40 shows the Pucker tool selected.

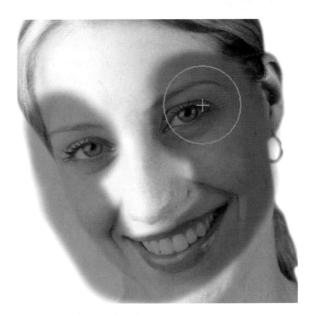

**FIGURE 7.38**   Choosing the Freeze Mask tool.

**FIGURE 7.39**   Protecting the image.

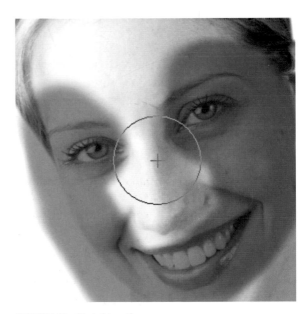

**FIGURE 7.40**   Choosing the Pucker tool.

**FIGURE 7.41**   Shrinking the nose.

**FIGURE 7.42**    The final image.

6. Carefully click with the Pucker tool to reduce the nose a little (see Figure 7.41). This trick is very easy to perform, but be delicate with it.

Figure 7.42 shows the image after a little nose surgery. Notice that it looks natural because we didn't overdo it.

## DABBING AWAY FRECKLES AND ACNE

There may be times when you want to touch up tiny blemishes such as acne and stray freckles. Just use the Healing Brush. Make the brush size very small, just a bit larger than the mark you want to replace. Figure 7.43 shows some very minor spots that we will remove.

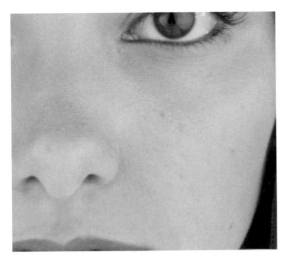

**FIGURE 7.43**    Some small blemishes. Royalty Free Images from Hemera™.

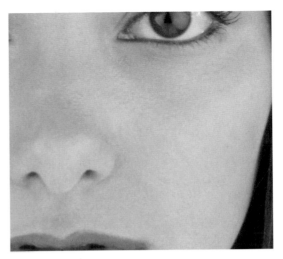

**FIGURE 7.44**    Retouched.

1. Choose the Healing Brush.
2. Select Use All Layers from the options bar.
3. Choose a small brush size.
4. Hold down Alt (Option in Mac) and click on a clean portion of skin to take a sample.
5. Click once on the affected area without dragging. The blemish should disappear. This technique is called "dabbing." Dabbing away the blemishes is a good way to fix tiny spots without disturbing the surrounding skin.

Figure 7.44 shows the same image after a few seconds with the Healing Brush. The same technique will work with larger and more widespread spots.

## ENHANCING THE EYES

One of the most important parts of facial retouching is the eyes, and they deserve extra attention. The eyes are the one thing that will always capture the viewer's attention. Look at any photo of a face—what is the first thing you look at? The eyes. It's in our nature to look at eyes; it's how we communicate and read people. We will walk through a few techniques to add some extra zing and life to the eyes.

**TUTORIAL**

For this section of the chapter, open `teen girl.jpg` from the CD-ROM (Figure 7.45) or choose an image that you have taken showing some eyes. You probably have plenty in your collection.

**FIGURE 7.45** The beginning eye.

### REMOVING THE RED FROM THE WHITES

ON THE CD

1. Using the Magnetic Lasso tool, carefully draw around the whites of the eyes as shown in Figure 7.46. (Actually, you can use any tool you prefer, including the Magic Wand.)

Figure 7.47 shows the eye with the white selected.

**FIGURE 7.46** Making a selection.

**FIGURE 7.47** The white of the eye selected.

**FIGURE 7.48**    Softening the edges of the selection.

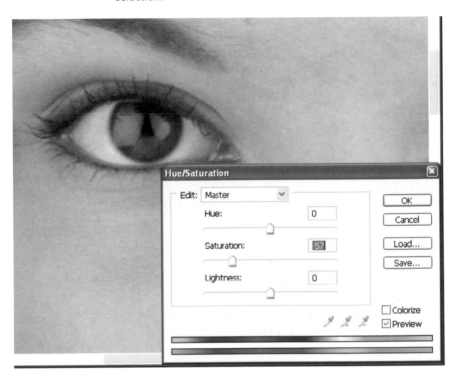

**FIGURE 7.49**    Removing the red color.

We will need to soften the edges of the selection so that our effect looks natural. Hard lines are a sure giveaway because they rarely exist in nature.

2. Choose Select > Feather and enter a Radius of 1 (Figure 7.48) . If you are working on a high-resolution image, you will need to enter a larger setting such as 3.
3. With the selection active, choose a Hue/Saturation adjustment layer. Click the Adjustment Layer icon at the bottom of the Layers Palette and select Hue/Saturation.
4. Lower the saturation until just about all the red is gone as seen in Figure 7.49 . (Use this same technique for instant dentistry: Yellow to white teeth in a few clicks.)

**FIGURE 7.50** Adjustment layer.

Figure 7.50 shows the Layers Palette with the adjustment layer. Notice that a mask was automatically created around the selected area. This mask ensures that only the eye will be affected, and the rest of the image is protected from the correction.

### ENHANCING THE IRIS

1. Choose the elliptical Marquee tool and make a selection that covers the iris as shown in Figure 7.51. It can be tricky to get the selection in the correct position.

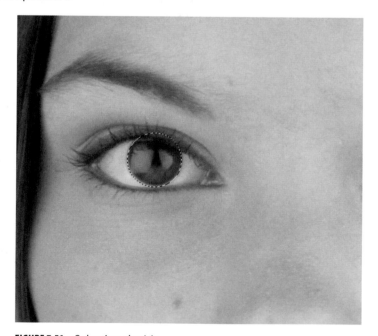

**FIGURE 7.51** Selecting the iris.

**FIGURE 7.52**  Creating the Darken layer.

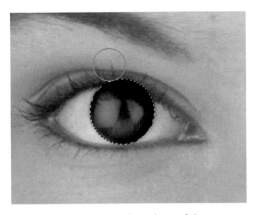

**FIGURE 7.53**  Darkening the edges of the eye.

 *Hold down the spacebar as you are making the selection. When the spacebar is depressed, you are able to reposition the selection.*

2. Create a new layer and name it Darken as seen in Figure 7.52.
3. Change the blending mode to Color Burn.
4. Choose the Brush tool. Choose a soft brush and set the foreground color to black.
5. Using only the soft edge of the brush, paint around the perimeter of the eye as shown in Figure 7.53.
6. Lower the Opacity to 20% so that this effect is subtle as seen in Figure 7.54.

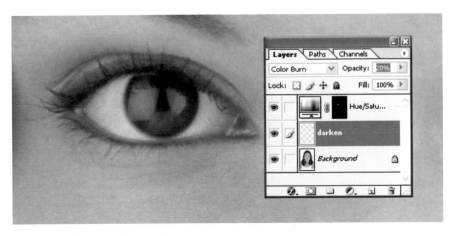

**FIGURE 7.54**  Lowering the opacity.

**FIGURE 7.55**   Softening the edges a little.

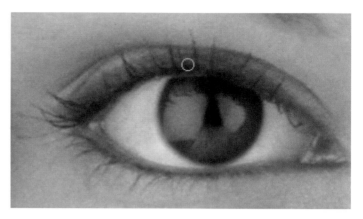

**FIGURE 7.56**   Erasing the overspray.

7. Select Filter > Blur > Gaussian Blur. Choose a setting of 1 pixel to soften the edges as shown in Figure 7.55. This will produce a natural blend and avoid the image looking retouched.

8. Choose the Eraser tool and remove any overspray from the eyes. See Figure 7.56.

Now we have brought more contrast between the iris and the white of the eye, and it's time to add some contrast to the pupil. It's hard to darken a black pupil. Instead, we will lighten the iris around the pupil.

9. Crete a new layer and name it Lighten.

10. Change the blending mode to Color Dodge.

11. Grab the elliptical Marquee tool and make a selection around the pupil as shown in Figure 7.57.

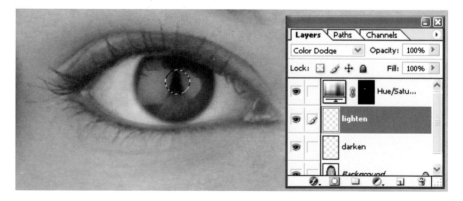

**FIGURE 7.57**   Choosing the pupil.

12. Choose a soft brush, just a little larger than the pupil, as seen in Figure 7.58. Set the foreground color to white.

13. Choose Select > Inverse so that the pupil is now protected and the rest of the image is selected.

14. Click once with the Brush tool to add some white as shown in Figure 7.59.

15. Press the D key on the keyboard to turn off the selection.

16. Choose Filter > Blur > Gaussian Blur to soften the edges (Figure 7.60). A setting of 1 pixel should work well.

17. Drop the opacity until the effect is just noticeable without being too obvious. A setting of 19% should do the trick.

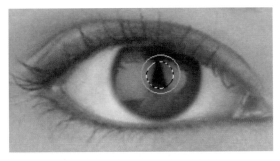

**FIGURE 7.58**    Brush slightly larger than the selection.

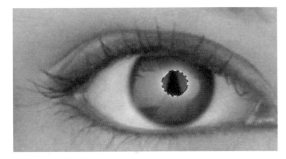

**FIGURE 7.59**    Lightening the center of the iris.

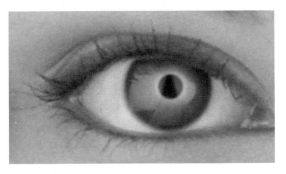

**FIGURE 7.60**    Softening the edges.

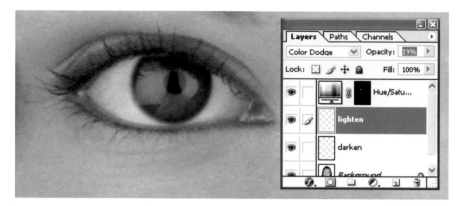

**FIGURE 7.61A**    A close-up after lowering the opacity.

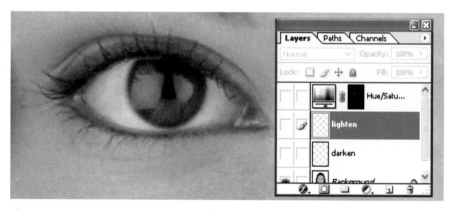

**FIGURE 7.61B**    A close-up before.

You can now see how crisp the eye is looking without being too obvious. Figure 7.61A shows a close-up of the result. Compare to the image before. Now you can really see the difference. Retouching should not really be noticeable until you compare it to the original. Figure 7.61B shows the enhancement layers hidden to reveal the original.

Figures 7.62A and 7.62B show the face after and before the work on the eyes. You can see how the eyes appear much brighter and more alive.

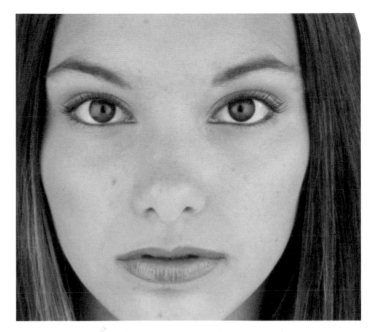

**FIGURE 7.62A**    After retouching.

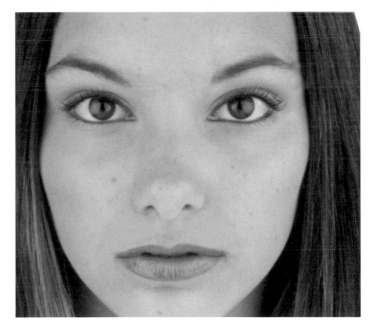

**FIGURE 7.62B**    Before retouching.

## INSTANT WEIGHT LOSS—SLIMMING THE HIPS

Especially around the holiday season, those hips can get just a little out of hand. Photoshop can perform crash diets to your photographs using the Liquify tool. You never have to worry about the weight coming back, and you can alter the image beyond what is even physically possible.

**TUTORIAL**

*ON THE CD*

1. Open `Hips.jpg` from the enclosed CD-ROM (Figure 7.63).
2. Choose Filter > Liquify.
3. Choose the Freeze Mask tool.
4. Paint the arms to protect them from stretching as soon in Figure 7.64.
5. Choose the Forward Warp tool (at the top left of the toolbar).
6. Click outside the hips with the tool and gently move it in, pushing in the hips as shown in Figure 7.65.
7. Move the Liquify tool over the bulged areas until you achieve a more athletic shape, as shown in Figure 7.66.
8. Click OK to apply the filter.

**FIGURE 7.63** The original image. Royalty Free Images from Hemera™.

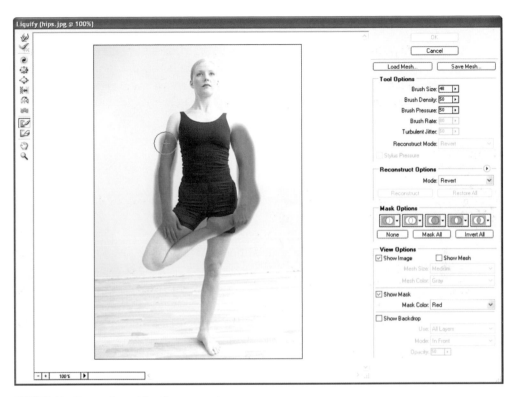

**FIGURE 7.64**    Protecting with a freeze mask.

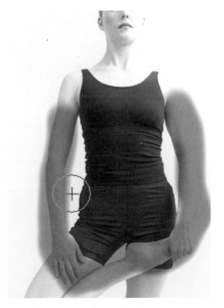

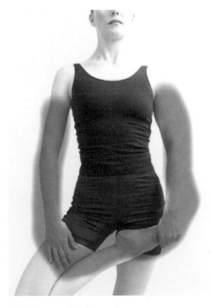

**FIGURE 7.65**    Liquifying the hips.            **FIGURE 7.66**    Reshaped.

**FIGURE 7.67**    The image after.

**FIGURE 7.68**    The results of ignoring subtlety.

Figure 7.67 shows the results after just a single Photoshop yoga session.

## SUMMARY

You just finished the chapter on photo retouching. You discovered amazing things that can be done with tools such as the Healing Brush and the Liquify tool. You will have lots of fun retouching your images and making people look better than ever. Remember to be subtle with these tools, or you could end up with unexpected results as shown in Figure 7.68!

# 8

# FRAME AND COLOR EFFECTS

## FRAME EFFECTS

In this chapter we will look at two types of effects: frames and color.

Frame effects are a lot of fun and can help present your images in a new way. The mood of the photo can really be enhanced or altered, by choosing different types of frames. The correct presentation can strengthen the feel you were looking for while taking the picture. Beware, though—overuse of these effects or choosing the wrong type of frame for your image can make it look cheap.

| | |
|---|---|
| **TUTORIAL**  | ## VIGNETTE |

One of the simplest and most classic edge effects is the vignette. This is when we take a picture and soften the edges as we fade it out. In this case we will be fading to white to help achieve a heavenly effect. There are several methods of creating this effect. The following method will not damage the original image, and it will allow flexibility later on.

*ON THE CD*

To follow along, open the image `angel.tif` from the CD-ROM (Figure 8.1) and begin with the image open in Photoshop.

1. Choose the elliptical Marquee tool from the toolbar.

**FIGURE 8.1** The original image. Royalty Free Image from Hemera™

2. Make a selection around the portion of the image that you want to add the edge to  (Figure 8.2).

 *If you hold down the spacebar while drawing the selection, it will enable you to reposition the selection while drawing.*

3. Choose Select > Feather from the main menu.
4. Enter a setting in pixels. This will determine the softness of the selection (Figure 8.3).

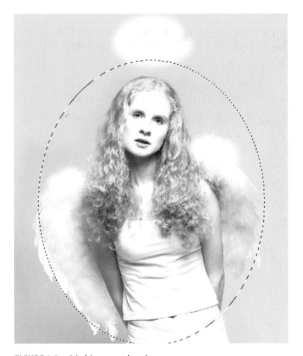

**FIGURE 8.2**  Making a selection.

**FIGURE 8.3**  Entering a feather radius.

Currently the main part of the image is selected, we want to just select the portions that we want to fill with white.

5. Choose Select > Inverse to swap the selection.
6. Create a new layer and fill with white as shown in Figure 8.4. Deselect. Creating the new layer protects the original image, and all the effects will be performed on a separate layer. This is a good way to work whenever possible.

**FIGURE 8.4**    Creating the effect on a new layer.

Another advantage of creating the effect on a new layer is that it gives you the capability to make modifications. If we want to make the feather softer, simply apply a Gaussian blur as we did in Figure 8.5 by selecting Filter > Blur > Gaussian Blur.

Figure 8.6 shows the final image with the Vignette effect.

**FIGURE 8.5**    Applying a blur.

**FIGURE 8.6**    The final effect.

## USING QUICK MASK TO CREATE AN EDGE EFFECT

This next edge effect is a bit more edgy (pardon the pun). No doubt you have seen different types of effects like this on brochures, posters, and commercials. They are the rough-cut type frames.

ON THE CD

1. Open `Whale Tail.tif` from the CD-ROM (Figure 8.7) to follow along, or use one of your own images.

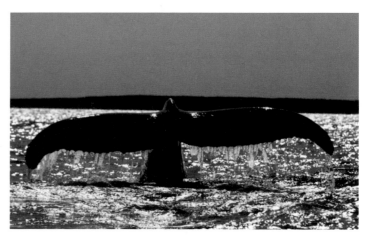

**FIGURE 8.7**    The original image.

**FIGURE 8.8** Making a selection.

2. Begin by making a selection. You could use the rectangular Marquee tool if you want. In this case we will use the Lasso tool because it allows a more organic/random type selection (Figure 8.8). We are not looking for perfectly straight edges for the type of effect we are after; we want something a bit more daring.

3. Press the Q key on the keyboard. You will see a pinkish color replacing the unselected portion of the image. The Quick Mask will replace a selection with a workable mask temporarily. (Actually, it creates a temporary Alpha

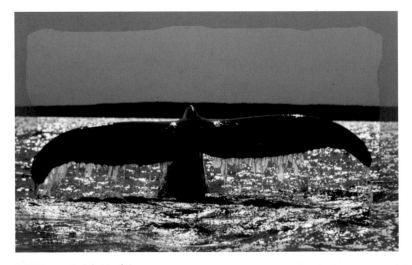

**FIGURE 8.9** Quick Mask is on.

channel, if you want to know what's going on "under the hood.") The advantage of Quick Mask is that we can apply filters to the mask that would be impossible to apply to the selection on its own. See Figure 8.9.

4. Let's apply some filters to the masked selection. Choose Filter > Artistic > Rough Pastels.

You will now see a large dialog box. This is a new feature in Photoshop CS. Many of the filters are now grouped into what is known as a Filter Gallery. The Filter Gallery allows us to combine a number of filters and change their settings, all the time previewing the result on the image without applying the filters. When you are satisfied with the result, you can apply them all at once rather than one at a time as we did in the past. The result is an image that holds more of its integrity because it hasn't been filtered many times.

Make the adjustments to the Rough Pastels as shown in Figure 8.10.

5. Click the New icon in the bottom right of the Filter Gallery. This will create a new Effect layer. This is how you combine effects.

**FIGURE 8.10**   Filter Gallery.

6. In the middle frame, all the different filters can be previewed. Choose the Distort set.
7. Select Glass and adjust the settings as shown in Figure 8.11.
8. Click OK to apply the filter. Your image should now look like Figure 8.12. Notice that the filter has been applied to the Quick Mask.
9. Click the Q key once again to convert the Quick Mask to a selection again. This time the selection reflects our filters.
10. Invert the selection by choosing Select > Inverse.

Do you remember that it's good to preserve the original image as much as possible? The same thing applies here, so create a new layer.

11. Fill the selection with your desired color. In Figure 8.13, it is filled with white.

There are infinite effects you can create using the Quick Mask method. Experiment with different filters to see what kind of effects you can come up with on your own.

**FIGURE 8.11**    Adding more than one filter.

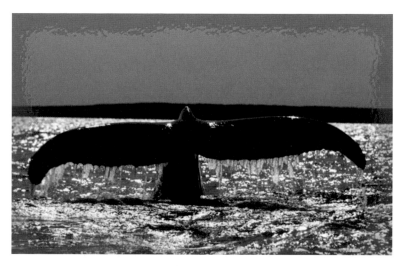

**FIGURE 8.12**   Quick Mask filtered.

**FIGURE 8.13**   The final effect.

## A Three-Dimensional Wooden Border

A third type of frame effect mimics reality. We are going to make a traditional wooden frame to add a bit of color and contrast to this old image.

ON THE CD

1. Open `oldship.tif` from the CD-ROM or choose one of your own pictures.
2. Using the rectangular Marquee tool, make a selection inside the image (Figure 8.14). This selection should be the desired thickness of the frame. Invert the selection so that only the border is selected.

**FIGURE 8.14**    The image with a selection. Royalty Free Image from Hemera™.

3. Create a new layer.
4. Fill the selection with white as shown in Figure 8.15. Do not turn off the selection.

**FIGURE 8.15**    A white border.

We are going to use an Alpha channel to create the wood texture. The reason to use Alpha channels instead of layers for this effect is to get more depth into the wood grain. This will produce a more aged wood effect.

5. Choose the Channels Palette.
6. Click the Create Alpha Channel button. You should see a black screen with the white frame on the edges, as shown in Figure 8.16.

Now create the wood texture:

7. Choose Filter > Noise > Add Noise. Use the Gaussian option for a more random noise pattern. See Figure 8.17.
8. Choose Filter > Blur > Motion Blur. Apply the blur at zero degrees of angle and make the distance around 10–20 pixels as shown in Figure 8.18. We need just enough to make the blurred streaks that will simulate wood grain. If you use a setting that is too high, it will reduce the opacity on the edges. We want to avoid that scenario, so keep the setting as low as possible but still achieve a nice streak.
9. Switch back to the Layers Palette (Figure 8.19) and choose the top layer where our border resides. The selection should still be active. We are now ready to apply our texture.

**FIGURE 8.16**   The Alpha channel.

**FIGURE 8.17**  Adding some noise.

**FIGURE 8.18**  Adding blur.

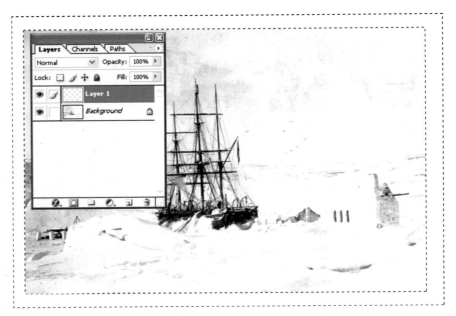

**FIGURE 8.19**  Back to the Layers Palette.

10. Choose Filter > Render > Lighting Effects. If this option is grayed out, you will need to convert to RGB mode.
11. Enter similar settings as you see in Figure 8.20. Be sure to choose a brown-colored light.
12. Choose Alpha 1 from the Texture channel, and the grain will be loaded into the Lighting effects.

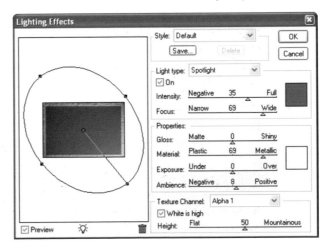

**FIGURE 8.20**  Lighting effects.

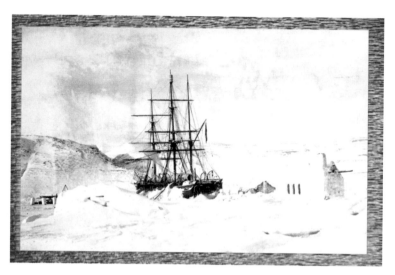

**FIGURE 8.21** Wood grain.

13. Click OK to apply the texture to the border (see Figure 8.21). Look at how much depth is in the wood grain! The only problem is that the border itself looks a bit flat. No problem, read on.
14. To bevel the edges of the border we will use Layer Styles. Choose the small letter f at the bottom of the Layers Palette and choose Bevel and Emboss.
15. Use the settings shown in Figure 8.22, and click on the Drop Shadow box to apply a default drop shadow.
16. Click OK to apply the layer style.

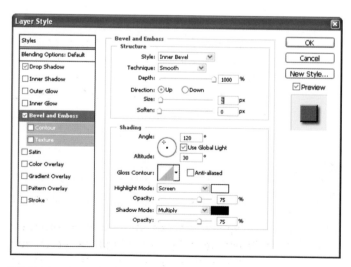

**FIGURE 8.22** Layer Styles added for depth.

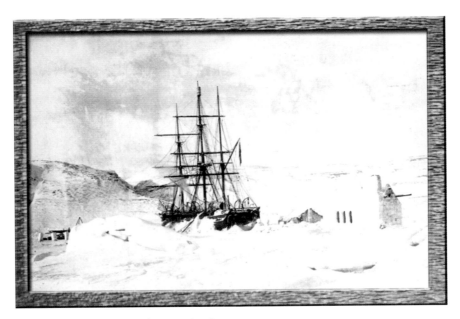

**FIGURE 8.23**    The image with a wooden frame.

We now have a pretty convincing wooden frame for our picture as shown in Figure 8.23.

## COLOR TO GRAYSCALE

There are times when you will want to convert a color image to grayscale (otherwise known as black and white). There are several methods to achieve this result, but the quickest way is to convert the image to Grayscale mode. All the color information will be discarded, and you will be left with the gray tones. The problem with this method is that you have no control of the conversion, and a lot of detail will be lost when the details of an image are separated by color rather than tone. The process we will use will improve control over the conversion and allow you to retain maximum image detail.

**TUTORIAL**

1. Open `Rock Arch.tif` from the CD-ROM (Figure 8.24).

   Figure 8.25 shows the image converted either by choosing Image > Adjust > Desaturate or by converting to Grayscale mode. If you are looking for a quick fix, use one of those methods. Otherwise read on.

*ON THE CD*

**FIGURE 8.24**    The colored image. Royalty Free Image from Hemera™

**FIGURE 8.25**    The desaturated image.

2. Click over to the Channels Palette and examine the image one channel at a time as we did in Figure 8.26. The image looks best in the Red channel, but the sky, which is in the Blue channel, lacks some contrast. What we need is the Red channel with a bit of the blue. How can we do this?

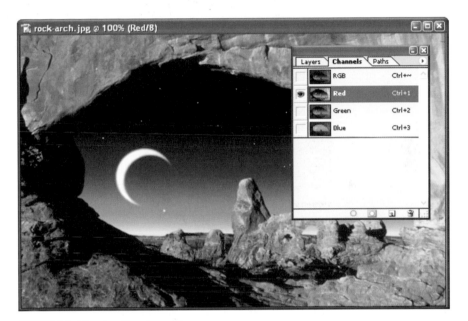

**FIGURE 8.26**    Viewing the channels.

3. Click on the New Adjustment Layer icon in the Layers Palette and choose Channel Mixer. Enter the Channel Mixer, which allows us to create a composite based on the amount of each channel we choose.
4. Click Monochrome, which will convert the preview to grayscale.

Remember that the Red channel looked the best. As a default, red is set for 100% and the other two channels to 0%. What we see in Figure 8.27 is the same as viewing the Red channel on its own.

5. Remember that we saw more detail and contrast in the sky in the Blue channel? Increase the blue until you are satisfied with the result as shown in Figure 8.28. We are now mixing in some of the Blue channel with the Red channel. Depending on the image, different settings would be used. This method is fairly simple to use and produces much better results than simply converting to grayscale.

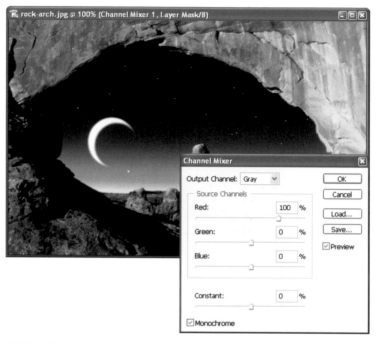

**FIGURE 8.27** Channel Mixer.

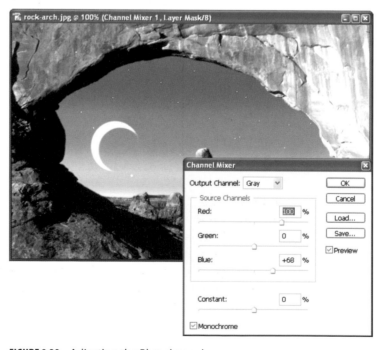

**FIGURE 8.28** Adjusting the Blue channel.

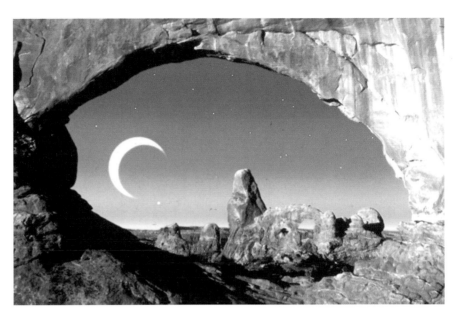

**FIGURE 8.29**    Conversion using the Channel Mixer.

Figure 8.29 is the result of a conversion using the Channel Mixer. Another advantage of this method is that since we used an adjustment layer, the original layer is still intact, and we can make changes whenever we want simply by double-clicking on the Channel Mixer Adjustment Layer icon.

Compare the grayscale conversion in Figure 8.29 to simply desaturating the colors in Figure 8.25. The difference is huge.

### CONVERTING TO MONOCHROME (SEPIA TONE)

I'm sure you have seen monochrome images before. They are very popular in today's design culture because the retro look has made a big comeback. Perhaps the term *sepia tone* will ring a bell with you. Whatever you decide to call the effect is up to you, the result is the same. The effect is a single-colored tint over the entire image.

We will now walk through one of the best methods for producing this result. It is the best because once again the original image will remain unchanged, and the result can be updated and changed very easily.

Open any image in Photoshop (such as the one shown in Figure 8.30) to follow along.

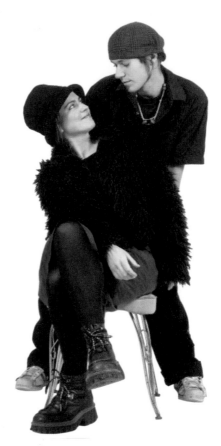

**FIGURE 8.30**    The original image. Royalty
Free Image from Hemera™.

1. Choose The Hue/Saturation adjustment layer from the bottom of the Lay-
   ers Palette.
2. Choose the Colorize box in the bottom right of the dialog box as shown in
   Figure 8.31. The image will now turn into a monochrome image.
3. Adjust the Hue slider to choose the desired color. Adjust the Saturation
   slider to choose the amount of the color with the far left setting being fully
   grayscale.

   You now have the basic monotone image (Figure 8.32).
   Now to really give you control and set this method above other methods,
we are going to combine the previous technique to control the image tones.

4. Choose the Background layer.

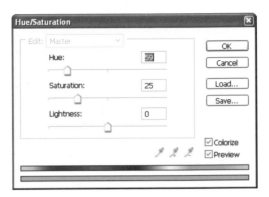

**FIGURE 8.31**   Hue/Saturation dialog box.

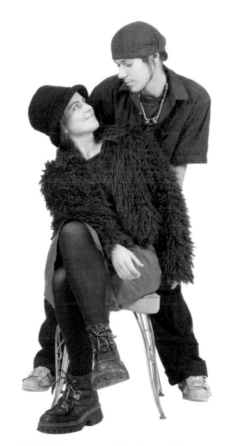

**FIGURE 8.32**   A monotone image.

5. Add a Channel Mixer adjustment layer (see Figure 8.33) and make the grayscale adjustments as we did in the previous exercise. As you can see, several different adjustment layers can be combined for spectacular results.

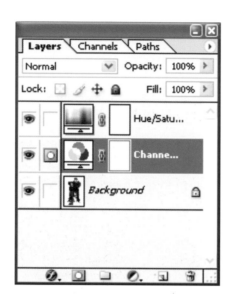

**FIGURE 8.33** Adding a Channel Mixer adjustment layer.

**FIGURE 8.34** Final sepia tone image.

Figure 8.34 shows the image after converting. Notice how this technique preserves image detail that would be lost with a simple colorization without the Channel Mixer.

## DEPTH OF FIELD EFFECTS

We are going to use two methods to simulate a narrower depth of field. This will keep the foreground objects sharp while blurring the objects in the distance. The first method is the quick and dirty way. The second method produces spectacular results using a new feature in Photoshop CS called Lens Blur.

## DEPTH OF FIELD WITH A LAYER MASK

This method produces pretty good results and works best on images that have smooth flat surfaces.

**TUTORIAL**

ON THE CD

1. Open `building.tif` from the CD-ROM (Figure 8.33).
2. Duplicate the image to a new layer.

**FIGURE 8.35**    The original image. Royalty Free Image from Hemera™.

3. Select Filter > Blur > Gaussian Blur. Add a 3.2 pixel blur as we did in Figure 8.36. Vary the setting according to the resolution and size of your image. The larger the resolution, the higher the setting will need to be.

Figure 8.37 shows the image with the top layer blurred.

To produce the desired effect, we will need to slowly fade the blurred copy with the original sharp image. The layer mask is the key to achieving this result.

**FIGURE 8.36**    Adding a Gaussian blur.

**FIGURE 8.37**    Blurred layer.

4. Click on the Create Layer Mask button at the bottom of the Layers Palette to add a new layer mask, as shown in Figure 8.38.

When a layer mask has been applied to a layer, it is filled with white by default. White has no effect on the layer. However, if the mask is painted with black, the underlying layer will show through. The mask sees the grays as levels of transparency instead of solid tone. For example:

White = 100% opaque
25% Gray = 25% transparent
50% Gray = 50% transparent
Black = 100% transparent

You get the picture. It makes sense that to produce a smooth transition from solid to transparent, a gradient will do the job.

FIGURE 8.38    Adding a layer mask.

FIGURE 8.39    Drawing a vertical gradient.

5. Press the D key to reset the palette colors to black and white.
6. Choose the Gradient tool. Select the Linear option from the options bar.
7. Click and drag the gradient up through the image from the bottom to the top, as shown in Figure 8.39.

When the gradient is drawn through the layer mask, the effect will be complete. Figure 8.40 shows our buildings with a depth of field that makes the buildings appear taller as they reach up into the sky and out of focus.

### Creating Depth of Field Using Lens Blur and Depth Map

Lens Blur is a new filter that simulates the effect of an aperture on a camera lens. To really get the best out of this filter, we will need to create a depth map. The filter can look at a map and blur the image selectively.

**FIGURE 8.40**   The final image with depth of field.

We can assign areas with different levels of grayscale and then have the filter focus in on the tones and apply a varying blur according to how dark or light the map is in the chosen areas.

## TUTORIAL

*ON THE CD*

1. Open `Fishing blur.tif` from the CD-ROM (Figure 8.41).
2. Duplicate the background to preserve the original image in case you change your mind later.
3. Create a new layer and name it Mask (Figure 8.42). This is where we begin creating the depth map. There is a map created on the sample image if you don't want to create one yourself. If this is the case, skip to step 15.

**FIGURE 8.41**    The original image. Royalty Free Image from Hemera™.

**FIGURE 8.42**    Creating the Mask layer.

4. Choose a white brush and paint the area of the image that should appear in focus. Usually this will be the highest point of the image. Use the Marquee tools to help with the painting if desired, as shown in Figure 8.43.
5. Create a new layer and move it beneath the mask layer. Name the new layer Mid Mask (Figure 8.44). This is where we will define the areas that should be half in focus.

**FIGURE 8.43** Assigning the highest points, which will be the sharpest.

**FIGURE 8.44** Creating a layer for the middle levels.

6. Use a soft brush set to 50% gray and paint over the portions of the image that are higher than the background but not as high as the main focused portion of the image, as shown in Figure 8.45.

**FIGURE 8.45**　Paint the mids in 50% gray.

7. Add a Gaussian blur to the midtones. The blur is added to soften the edges of the mask. If the blurs drop off softly, they will appear more natural. Choose Filter > Blur > Gaussian Blur, as shown in Figure 8.46.

**FIGURE 8.46**　Blur the map to soften the edges.

8. Create one more layer and name it Low Mask, as shown in Figure 8.47.
9. Choose a dark gray; around 75% will work. Define the low points of the image but leave the very lowest portions alone. These portions will be mostly blurred but retain a slight amount of sharpness. See Figure 8.48.

**FIGURE 8.47**   Create another layer for the lows.

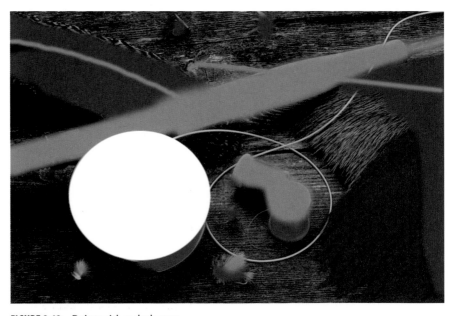

**FIGURE 8.48**   Paint with a dark gray.

10. Hide the background layers so that only the masks are visible. Now that we can see the mask more clearly, clean it up a bit with the brush tools and fill in any spots that may have been missed, as shown in Figure 8.49.

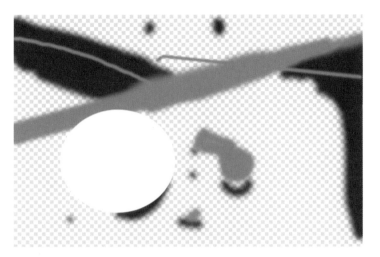

**FIGURE 8.49**    The map on its own.

11. Merge the three mask layers. Choose Merge Visible from the fly-out menu on the top right of the Layers Palette. Your Layers Palette should now look like Figure 8.50.

**FIGURE 8.50**    Merging the mask layers.

We have now created the Depth map. We will now transfer it to a channel and prepare to filter the image.

12. Select the entire mask layer by pressing Ctrl-A (Cmd-A in Mac).
13. Choose Edit > Copy
14. Open the Channels Palette.
15. Add a new Alpha channel by pressing the New icon at the bottom of the palette.
16. Choose Edit > Paste and then Deselect. The Alpha channel should now look like Figure 8.51. (You will notice that the sample image already has a map created for your use if you have had trouble creating one yourself. It is the Alpha channel Blur-Map.)

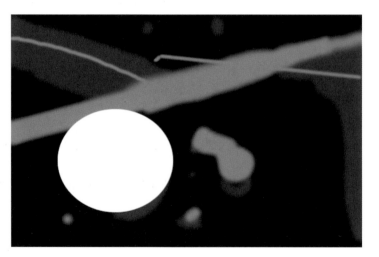

**FIGURE 8.51**   Copying the depth map into an Alpha channel.

17. Choose the Layers Palette, show the image layer, and hide the mask layer as shown in Figure 8.52.

    Everything is now set up; it's time to apply the filter.

18. Choose Filter > Blur > Lens Blur. See Figure 8.53.
19. Choose Alpha 1 for the source (Blur-Map if you used the included map).

    When you slide Blur Focal Distance, you will see the focus change in the preview as it interacts with the depth map. Move it to 255 (this represents the 256 shades of gray in an Alpha channel).

20. Adjust Radius to change the amount of blur. You can play with the other iris settings if you wish. The shape, curvature, and rotation all simulate the blades of a camera's iris.

**FIGURES 8.52**   Choose the top layer
and hide the mask.

21. Adjust Specular Highlights to cause bright parts of the image to become specular highlights. The brightness can be adjusted; Threshold determines the cutoff point at which tones will be turned into highlights.

    The noise is available for images with grain. As you know, when a blur is applied to an image, the grain is lost. These settings allow us to simulate the

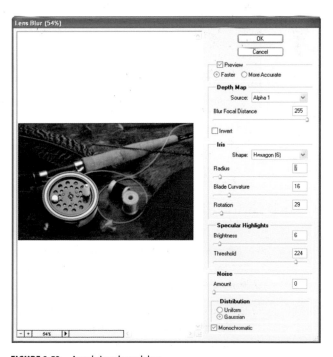

**FIGURE 8.53**   Applying lens blur.

grain back to the blurred portions of the image and make the effect more realistic. Since no grain is present in our image, we will leave the settings at 0. If we were applying grain, we would make a choice between Gaussian and Uniform under the distribution. The Gaussian setting is more random, but we would make the choice that best matches the existing grain of the image.

22. Click OK to apply the effect.

Figure 8.54 shows the image with the depth of field applied to it. Notice how portions of the image appear more in focus than others. This is a great filter and produces stunning results never seen before in Photoshop.

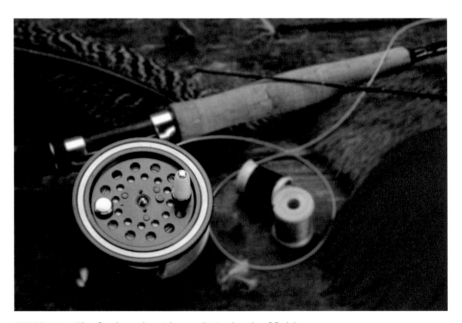

**FIGURE 8.54**    The final result, with a realistic depth of field.

## SUMMARY

In this chapter you learned how to transform the appearance of your images. Among other things, you discovered how to add some interesting color effects. These effects can totally change the feel of an image and add some excellent visual interest. We also looked at adding some nice frame and border effects. At the end of the chapter, we looked at some advanced uses of the new Lens Blur filter.

PART

# IV

# ADVANCED CONCEPTS

# 9

# SPECIAL EFFECTS

## NATURAL MEDIA

This section will look at the techniques used to turn photographs into images that mimic fine art. After you have finished this section, feel free to experiment, using what you have learned as a springboard into your own discovery.

### Turn a Photo into a Sketch

This technique will show you how to turn a photo into something that resembles a pencil sketch. (This technique has been modified a bit from its original form.)

**TUTORIAL**

ON THE CD

1. Open `Canoe.tif` from the CD-ROM (Figure 9.1) or open your own image.
2. To preserve your original image, duplicate the Original layer; we will work on the duplicate.

**FIGURE 9.1**    The original image. Royalty Free Image from Hemera™

**FIGURE 9.2** Duplicated, desaturated layer.

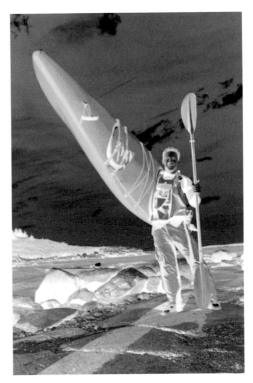

**FIGURE 9.3** The inverted layer.

3. Choose Image > Adjustments > Desaturate to remove the color as shown in Figure 9.2. The image should now appear in grayscale.
4. Duplicate the Grayscale layer.
5. Invert the duplicated layer as shown in Figure 9.3. Press Ctrl-I (Cmd-I in Mac) to invert.
6. Switch the layer blending mode to Color Dodge as shown in Figure 9.4. The image should now appear almost white.
7. Now set the outline of the sketch. Choose Filter > Blur > Gaussian Blur as shown in Figure 9.5. Be careful not to overdo the blur, or the result will resemble a photocopy more than a sketch (unless that is the effect you want).

You will now see something that resembles a pencil sketch (Figure 9.6). Creating two layers, one inverted over the other, and choosing the blending mode causes the layers to cancel each other out. When the blur is added, it will cause the blurred area to be visible because those portions have changes from the cancelled portions.

**FIGURE 9.4**    Changing the blending mode to Color Dodge.

**FIGURE 9.5**    Setting the blur.

**FIGURE 9.6**    A pencil sketch.

**FIGURE 9.7**    An etched effect.

A variation would be to change the blending mode to Hard Mix. This will produce an etched effect, as shown in Figure 9.7.

### Turn a Photo into a Watercolor Painting

This effect will show you how to turn a photo into a watercolor-type painting.

**TUTORIAL**

1. Open `Mt-Fuji.tif` from the CD-ROM (Figure 9.8) or begin with one of your own.
2. Duplicate the background image twice. You should now have three identical layers.
3. Choose the top layer.
4. Select Filter > Stylize > Find Edges. The image will take on the appearance of an outline.

**FIGURE 9.8**   The original image. Royalty Free Image from Hemera™

5. The midtones need to be reduced so that mainly the outline is showing. Choose Image > Adjustments > Levels. Slide the midtone slider to the left as shown in Figure 9.9. This will clean up the stray detail.
6. Hide the top layer and choose the middle layer (see Figure 9.10).

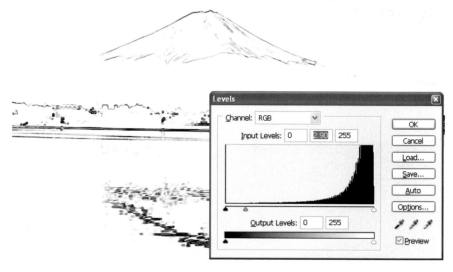

**FIGURE 9.9**   Adjusting the filtered layer.

**FIGURE 9.10**   The Layers Palette.

The Filter Gallery will be used to create the effect of a painting:

7. Choose Filters > Artistic > Paint Daubs.
8. Apply a setting that will produce a result similar to Figure 9.11. The desired result is enough of an effect that the image appears painted, but not so much that all definition is lost.

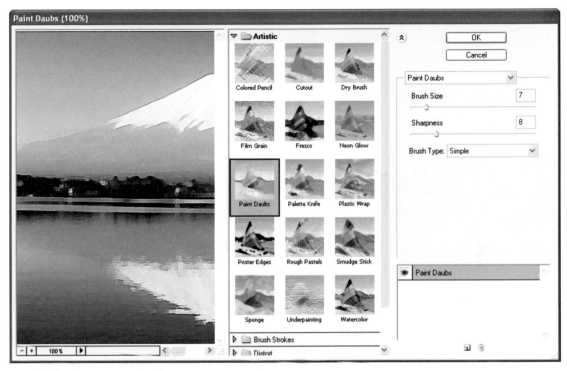

**FIGURE 9.11** The Paint Daubs filter.

9. Click the New Layer icon in the Filter Gallery to choose a second effect.
10. Select Underpainting. We are going to use this filter to add some texture to the image.
11. Choose settings similar to what we used in Figure 9.12.

So far the image should resemble Figure 9.13. The image reminds us of a watercolor, but it clearly lacks the fine brush detail.

12. The top layer will provide the fine brushed detail. Turn the top layer's visibility on as we did in Figure 9.14. Change to Multiply mode and experiment with the Opacity around 50%.

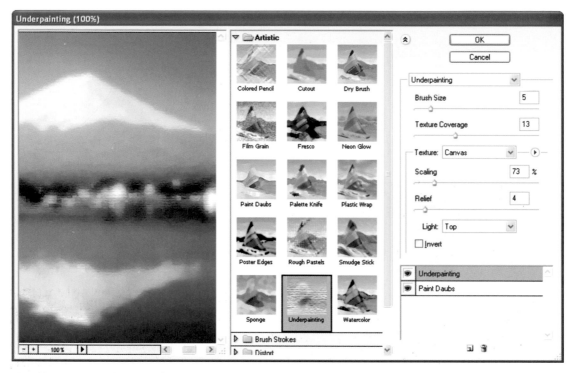

**FIGURE 9.12** Adding the Underpainting filter for some texture.

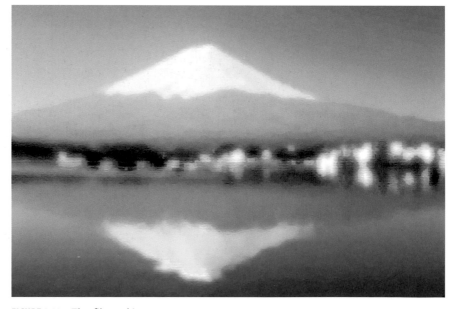

**FIGURE 9.13** The filtered image.

**FIGURE 9.14**   Turning on the top layer.

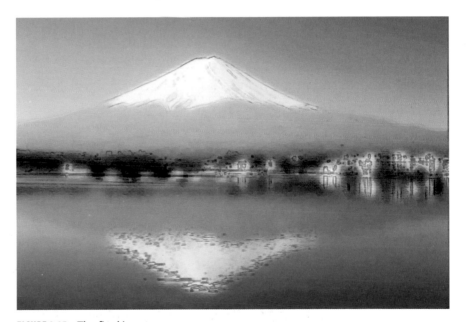

**FIGURE 9.15**   The final image.

As you can see in Figure 9.15, the final image resembles a hand painting.

## TRENDY EFFECTS

The next two effects use repeating patterns in different ways to produce results that are very popular in the advertising industry. These effects can add some real visual punch to your images.

### Pop Dots

Pop dots are very popular with the youth and sports culture. If you turn on MTV, you won't have to wait long to see this effect in action. To make it easier to focus on the effect, an image has already been extracted and prepared for you on the CD-ROM. The process for extracting an image is covered in this book so that you can apply the same effects to your own stock of images.

**TUTORIAL**

ON THE CD

1. Open `motocross.tif` from the CD-ROM (Figure 9.16).

   On opening the image, you will notice that there is a hidden layer called Cutout. We will be using that layer soon.

**FIGURE 9.16** The original image. Royalty Free Image from Hemera™

2. Duplicate the background layer by choosing Layer > Duplicate Layer or just drag the thumbnail into the New Layer icon in the Layers Palette.

3. Fill the background with white or whatever the preferred color is that will show through on the final image. By adding this extra layer, we have the flexibility to change the background color at any time. The Layers Palette should look like Figure 9.17.

4. Choose the middle layer as in Figure 9.17.

5. Click on the Quick Mask button as shown in Figure 9.18. This will activate Quick Mask. When we paint in Quick Mask mode, we are creating a mask that will be converted to a selection when Normal mode is resumed. Pressing the Q key will also invoke Quick Mask.

**FIGURE 9.17**   The background is a solid color.

**FIGURE 9.18**   Quick Mask.

6. Choose the Linear Gradient tool. Press D to reset the color palettes to black and white. Select the Foreground to Background option from the options bar.

7. Drag the gradient from right to left so that the image resembles Figure 9.19.

The advantage of using Quick Mask is that filters can be applied to the gradient before it is toggled back to a selection.

8. Select Filter > Sketch > Halftone Pattern.

9. Choose Dot as the pattern type and select settings similar to Figure 9.20.

**FIGURE 9.19**    Adding a gradient.

**FIGURE 9.20**    Adding the Halftone Pattern filter.

**FIGURE 9.21**    The filtered gradient in Quick Mask mode.

10. Click OK to apply the filter. Your image should now resemble Figure 9.21. See how the pattern has affected the gradient? This is exactly the result we are looking for.
11. Press the Q key to toggle back to Normal mode. The mask will be turned into a selection as in Figure 9.22.

**FIGURE 9.22**    Selection active.

Be very careful that the image layer and not the background is active or this won't work.

12. Press the Delete key to remove all the selected pixels.
13. Press the D key to turn off the selection. You should now see something like Figure 9.23. This is the basis of the effect. To wrap things up, we are going to dress things up a little.

**FIGURE 9.23**   Pop dots.

**FIGURE 9.24**   The final image.

**FIGURE 9.25**    Pop dots with a drop shadow.

14. Turn on the visibility for the Cutout layer.

   This completes our effect. Figure 9.24 shows the final result.
   An optional step that adds some visual interest is to add a drop shadow to the Cutout layer. Notice in Figure 9.25 how this makes the image appear to float above the background. The drop shadow is easily added with the layer effects.

### Scanlines

The Scanline effect reproduces the interlacing effect that is seen on a TV screen. To accomplish this effect, a custom pattern will be created. This effect is included in the book because it is extremely useful to know how to create and use patterns.

**TUTORIAL**

1. Begin with any image open in Photoshop, such as in Figure 9.26.

   We will now create the pattern that will be used for the effect.

2. Create a new document and make it 4 pixels × 4 pixels in RGB mode with a white background and 72 ppi. At the end of this tutorial you will see why we chose a white background rather than a black one. (Here's a clue: It has to do with flexibility.)

**FIGURE 9.26**    The original image. Royalty Free Image from Hemera™

3. Zoom into 1600% so that you can see what you are doing.
4. Use the Pencil tool. Make the settings a single pixel and black in color. Fill in half the image with black as shown in Figure 9.27.

   We will now turn this image into a reusable, repeating pattern.

5. Press Ctrl-A (Cmd-A in Mac) to select the entire document.
6. Choose Edit > Define Pattern to add the selection to the Pattern Library.
7. A dialog box (see Figure 9.28) will open with a preview, offering the opportunity to assign a name to the pattern. Enter Scanline and click OK. The pattern is now added to the Pattern Library. The document that the pattern was created on is no longer needed and can be discarded.

**FIGURE 9.27** Creating the pattern.

**FIGURE 9.28** Defining a pattern to the library.

8. Choose the image that will have the Scanline effect applied to it.
9. Create a new blank layer.
10. Choose Edit > Fill from the menu.

   A dialog box like that shown in Figure 9.29 will open.

**FIGURE 9.29** Using a pattern as a fill.

11. Select Pattern from the Use menu. Click on the thumbnail and select the Scanline pattern from the library.
12. Click OK to apply the pattern to the top layer.

   The pattern will now fill the entire screen, hiding the image underneath as in Figure 9.30.

13. Change the layer blending mode to Screen and lower the Opacity to around 25% to blend the scanline into the image. Figure 9.31 shows the result of the scanline. Tweak the opacity to produce the desired result.

**FIGURE 9.30**    The Scanline pattern.

**FIGURE 9.31**    The final image with scanlines.

Another alternative is to use Multiply mode to produce darker scanlines. This is the reason we created a black-and-white pattern and not a transparent pattern for the scanline. We can make the pattern darker or lighter than the base image.

## DAY TO NIGHT

In this tutorial we are going to take a daytime photo and turn it into a nighttime scene.

**TUTORIAL**

*ON THE CD*

1. Open `day-night.tif` from the CD-ROM (Figure 9.32). You will see a house that is well lit. In a few moments the image will be transformed into a nighttime scene.
2. Press the Q key to switch to Quick Mask mode.
3. Double-click the Quick Mask icon on the toolbar (the right button under the color palettes) to open the options. Choose Selected Areas from the options.

**FIGURE 9.32**    The original daytime scene. Royalty Free Image from Hemera™.

4. Using a soft edges brush set to 30 pixels, paint all the areas that will be light in the final image. Paint over the windows that will be lit.
5. Paint some areas on the pavement to represent areas of light cast from the windows. Use a larger brush for this and drop the opacity down to around 80%. Figure 9.33 shows what the image should look like at this stage.
6. Press the Q key again to change the Quick Mask into a selection.
7. Press Ctrl-J (Cmd-J in Mac) to copy the selected areas to a new layer.
8. Duplicate the Background layer; you should now have two layers of the house and the highlights layer on top, and a total of three layers.

**FIGURE 9.33**   Adding some light to the pavement.

9. With the duplicated Background layer selected, choose Image > Adjust > Hue/Saturation. See Figure 9.34A.
10. We are going to simulate a night scene in moonlight. Moonlight tends to have a bluish hue. Click the Colorize tab and choose blue with the Hue slider. Lower the lightness until it has a nice dark bluish color, as shown in Figure 9.34B.

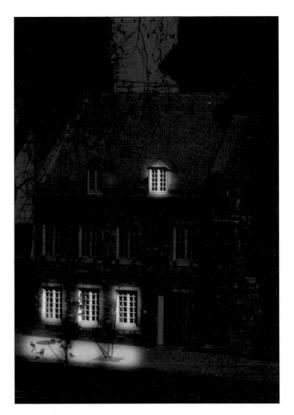

**FIGURE 9.34A**    Adjusting Hue/Saturation.

**FIGURE 9.34B**    The night color with moonlight.

11. Choose the background as shown in Figure 9.35.
12. Hide the middle layer for now.

**FIGURE 9.35**    The Layers Palette so far.

We are now going to change the color on the background to the night scene without moonlight; this will look nice in the shadow areas.

13. Click on the Background layer. Choose Image > Adjustments > Hue/Saturation. Lower the Saturation to –80 and the lightness to –75. The image should look like Figure 9.36.
14. Make the middle active and turn the visibility back on.
15. Add a layer mask (see Figure 9.37); we are going to fade the moonlight into the shadows for more depth and realism in the image.

**FIGURE 9.37** Layer mask on the middle layer.

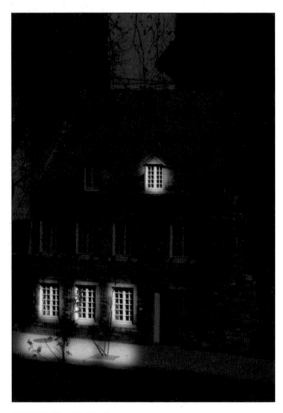

**FIGURE 9.36** Night shadows.

16. Choose the linear Gradient tool.
17. Press the D key to reset the color palettes.

18. Begin 3/4 way down the roof and drag to just below the roofline. The image should now look like Figure 9.38. If the bluish hue is on the bottom instead, undo and repeat the gradient, but drag the mouse in the opposite direction.

19. Choose a very large brush and set the color for white.

20. Drag along the bottom to allow some moonlight through the shadow of the house as shown in Figure 9.39.

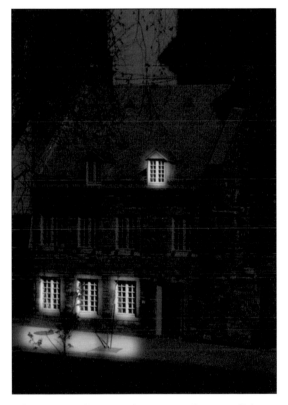

**FIGURE 9.38**  Using a mask to merge the moonlight into the shadows.

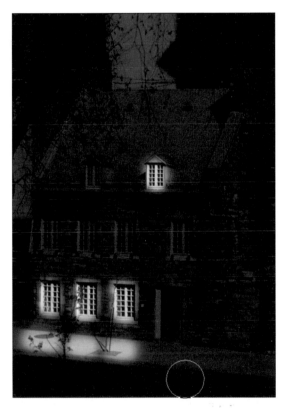

**FIGURE 9.39**  Painting on a mask to allow some more moonlight through.

The night scene is looking good now. It's time to work on the windows and lighting. The glass in the windows is dark, and the frames are light. For light to be shining out of the windows, we really need the opposite effect. To achieve this, we will select all the window frames and invert the tones.

21. Choose the Highlights layer.

22. Using the polygon Lasso tool, select one of the window frames as shown in Figure 9.40.
23. Hold down the Shift key (to add to a selection) and select all the dark regions of the window frames as shown in Figure 9.41.

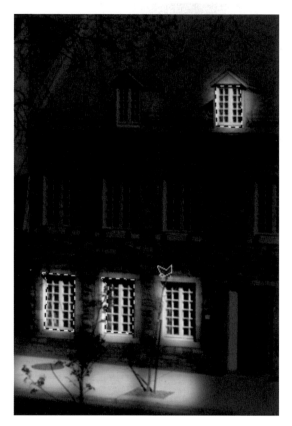

**FIGURE 9.40**    Selecting a window.

**FIGURE 9.41**    Selecting all the window frames.

24. When all the lit windows are selected, press Ctrl-I (Cmd-I in Mac) to invert the windows and make the glass light and the frames dark as shown in Figure 9.42. Don't deselect yet.

In the real world at night, cool outside light is bluish and inside artificial light is a warmish yellow.

25. Choose Image > Adjustments > Hue/Saturation.
26. Check the Colorize button, change the hue to yellow, and push Saturation all the way up (see Figure 9.43).

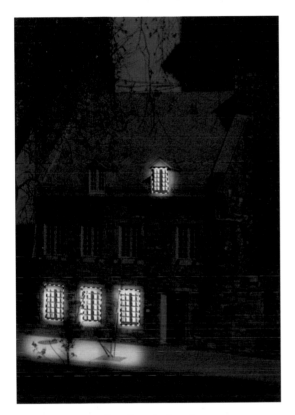

**FIGURE 9.42**    Inverting the window frames.

**FIGURE 9.43**    Making the lights in the windows warm yellow.

Figure 9.44 shows the windows with a warm yellow light in the glass. Don't deselect yet.

The light is almost right. All that remains is to add a slight amount of yellow to the glow around the windows and the pavement.

27. Select > Inverse to invert the selection so that only the glows are selected now, as shown in Figure 9.45.
28. Choose Image > Adjustments > Hue/Saturation.
29. Choose Colorize and make the hue yellow. This time choose a lower saturation amount than we did for the windows. See Figure 9.46.
30. Click OK to apply the adjustment. Press Ctrl-D (Cmd-D in Mac) to turn off the selection.

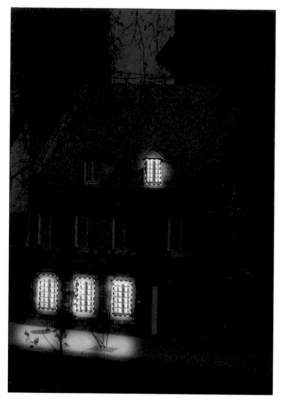

**FIGURE 9.44** Warm and inviting light in the windows.

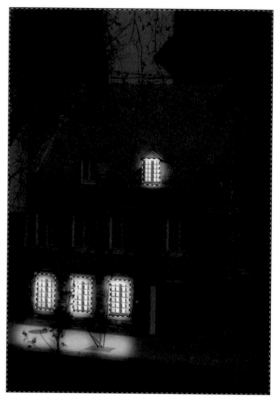

**FIGURE 9.45** Inverting the selection.

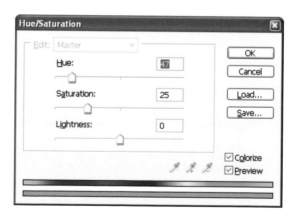

**FIGURE 9.46** Hue/Saturation for the glows.

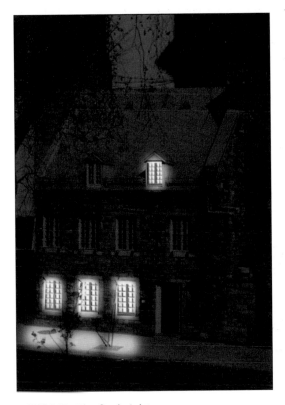

**FIGURE 9.47**    The final night scene.

Figure 9.47 shows our final night scene. Use this tutorial as a foundation to create other night scenes. The settings will vary a bit, but the technique will be pretty much the same.

## SPEECH BUBBLES

Speech bubbles are containers that hold words. The bubble points at a person who is perceived as saying the words in the bubble. They are mainly used in cartoons but occasionally used for photographs.

**TUTORIAL**

1. Begin with a photo of someone speaking, such as in Figure 9.48.
2. Create a new layer.
3. Choose the Custom Shapes tool from the toolbar.
4. Click in the options bar to see the Shape Library. It is right in the middle where it says Shape. Click on the arrow to open the Shape Library. If you don't see any speech bubbles, click on the arrow located at the top right of the palette. Choose Talk Bubbles from the list. When a box pops up, choose Append to add the bubbles to the existing library.

**FIGURE 9.48**    The original image. Royalty Free Image from Hemera™.

5. Choose a bubble as shown in Figure 9.49.
6. Make sure that the Fill Pixels option is chosen from the three options on the left of the options bar (see Figure 9.50). This will cause the custom shape to fill with a solid color.
7. Choose white as the foreground color.

**FIGURE 9.49**    Shape sets.

**FIGURE 9.50**    Choosing the Fill Pixels option.

8. Drag your mouse to draw the bubble on the new layer as shown in Figure 9.51.
9. To add a bevel to the bubble, click on the small letter f at the bottom of the Layers Palette and choose Bevel and Emboss. Make adjustments until you have the desired sized bevel, as shown in Figure 9.52.
10. To make the bubble semitransparent, lower the fill opacity in the Layers Palette as shown in Figure 9.53.

**FIGURE 9.51**    The speech shape.

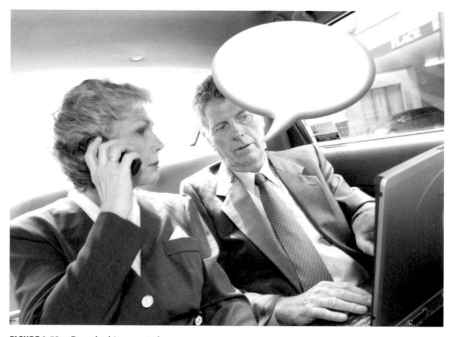

**FIGURE 9.52**    Beveled Layer style.

**FIGURE 9.53**    Lowering the fill opacity.

11. Finally, as we did in Figure 9.54, add some text so that the subject is saying something.

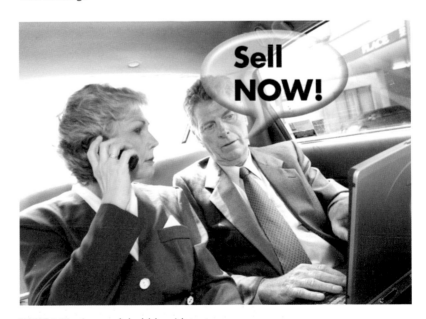

**FIGURE 9.54**    A speech bubble with text.

## SUMMARY

In this chapter we took a peek into the world of special effects, but we just skimmed the surface. These are a lot of fun to experiment with. The only limit to the special effects that can be created is your imagination. The key to producing interesting effects is an understanding of how different filters work together. Remember the importance of experimentation! If you have special interest in these types of effects, check out the videos at *www.photoshopCD.com* or see the *Photoshop Most Wanted* series of books written by Al Ward and the author of this book.

# WORKING WITH
# MULTIPLE IMAGES

n the next two chapters we are going to be working with multiple images. This chapter deals with extracting an image from its background and the technicalities involved in achieving a believable placement into a new environment.

The next chapter will deal with some of the more creative expressions of collaging and compositing images.

## REMOVING AN OBJECT FROM ITS BACKGROUND

At the very core of compositing is the challenge of removing an object from its background. The long method would be to use the Pen tool or the Lasso tool. These tools are covered in some depth in the user's manual and online help. We will look at two quicker approaches in this section.

### Using Color Range

The first method works best for an image that is on a somewhat uniform background color. Most people's natural instinct is to reach for the Magic Wand tool. Although this is a viable method, we are using Color Range because of the extra control we have over the fine-tuning of the selection. A fine-tuned selection will have cleaner edges.

**TUTORIAL**

ON THE CD

1. Open Motocross.jpg from the CD-ROM. You can see the image in Figure 10.1.
2. Choose Select > Color Range.

   You will see the Color Range dialog box, as shown in Figure 10.2.

3. Choose Selection from the options so that we can see a grayscale preview of the selected area.

   It will be much easier to select all the blue areas instead of the intricacies of the subject itself. Move the cursor into the image area, and you will notice that the cursor turns into an eyedropper.

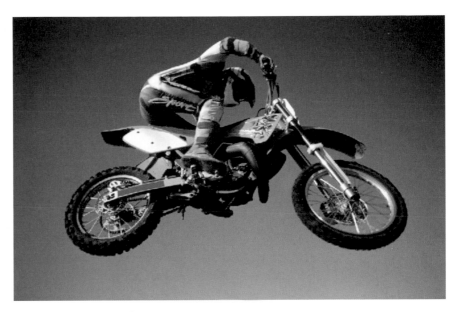

**FIGURE 10.1**    The original image.

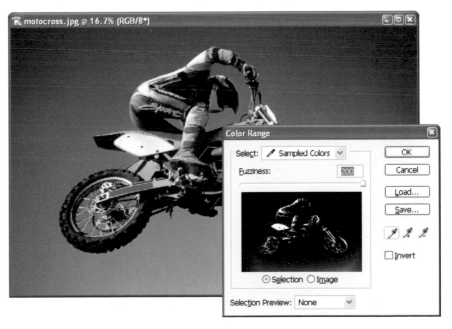

**FIGURE 10.2**    Color Range.

4. Click the blue area as in Figure 10.3. Notice that the selected color turns white in the preview.
5. Choose the Eyedropper tool with the plus sign (+) next to it in the Color Range dialog box. The tool will now add any selected colors to the existing selection.

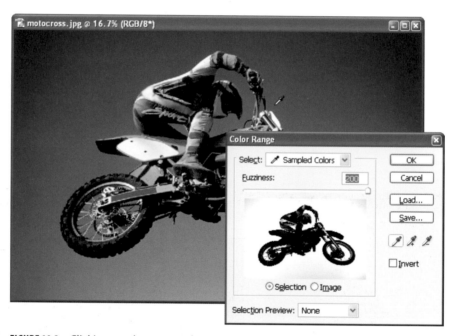

**FIGURE 10.3** Clicking a color to sample.

6. Click on the darker blue to add it to the selection. Keep clicking on the different blues until the background shows as a solid white as in Figure 10.4.
7. Move the Fuzziness slider to fine-tune the selection. We are looking for the background to remain white while the object turns black as shown in Figure 10.5. This is defining the selection area. You cannot perform this fine-tuning step with the Magic Wand, which is why we used this method, instead.
8. To temporarily toggle between the Selection view and the image, press and hold the Ctrl key (Cmd in Mac) as shown in Figure 10.6. This can help to refine the selection.

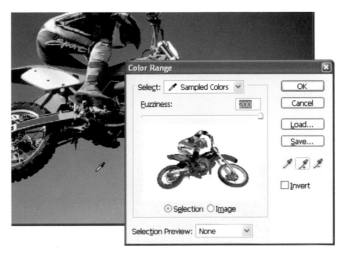

**FIGURE 10.4** Adding colors to the sample.

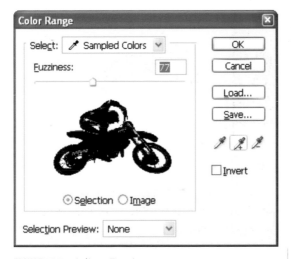

**FIGURE 10.5** Adjust Fuzziness.

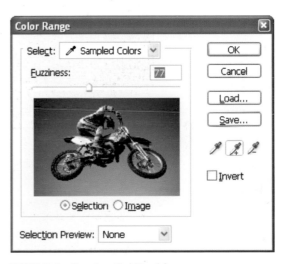

**FIGURE 10.6** Pressing Ctrl/Cmd for a temporary preview of the image.

9. Click OK to apply Color Range. A selection will now appear around the areas that were white in the Preview window, as shown in Figure 10.7. The blue areas are all selected now.

**FIGURE 10.7** The blue is selected.

10. Since some of the object is blue, the selection has also selected unwanted portions of the image. Let's clean these up the easiest way possible. Click the Q key on the keyboard or click the Quick Mask button at the bottom of the Layers Palette to enter Quick Mask mode as shown in Figure 10.8. The selection will now be painted in a mask. Another method is to extract the image and use the History brush to paint back the missing areas. The

**FIGURE 10.8** Choosing Quick Mask.

Quick Mask method enables us to get a clean selection right away. This is useful if we want to save the selection as an Alpha channel.

11. Choose a hard-edged brush and black for the foreground.

12. Paint over the unmasked areas of the image until the entire object is painted a rubylith color, as shown in Figure 10.9.

**FIGURE 10.9**    All the gaps are filled.

13. Press the Q key again, or select Standard Mode from the bottom of the Layers Palette to turn the mask into a selection again. The selection should now be fine-tuned as in Figure 10.10.

14. Choose Select > Inverse to change the selection from the background to the object.

15. Press Ctrl-J (Cmd-J in Mac) to copy the selected object to a new layer and hide the background to reveal the extracted image, as in Figure 10.11. We could have just deleted the background instead for step 14, but it's a good practice to preserve the original image whenever possible.

**FIGURE 10.10** Fine-tuned selection.

**FIGURE 10.11** The image has been removed from the background.

**FIGURE 10.12**    The image has been placed on a different background.

Figure 10.12 shows the extracted object placed onto another picture. To do this, simply open another image and drag and drop the extracted layer to the new document. The object will become a new floating layer.

### Extracting Images Using the Extract Tool

This method is the best for objects that are on multicolored and complex backgrounds. The Extract tool also works well for complex soft edges, such as hair and fur. The Extract tool works by defining an edge. You tell Photoshop what you want to keep by filling a defined area. Everything inside the area is preserved, and everything outside the area is discarded. Where the magic happens is on the line that is drawn around the edges. The Extract tool will separate what should be kept and what should be discarded based on the color on either side of the edge. There are also a couple of touch-up tools available to further refine the edges of extracted images.

## TUTORIAL

ON THE CD

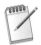

1. Open `couple-sailing.jpg` from the CD-ROM. The task is to cut out the people and the wheel from the background. Figure 10.13 shows the original image.

*Make a duplicate layer and work from the duplicate, hiding the background. This is done purely for the purpose of preserving the original image. The reason to do this rather than just save a copy is that by duplicating the layer and hiding it, it will always be there and travel with the image. For instance, if in a year we go to work on this image, the original will be embedded in the PSD file, and we will not have to hunt for another document. This workflow is preferred by the author and is recommended but not necessary; you should use a workflow you are comfortable with.*

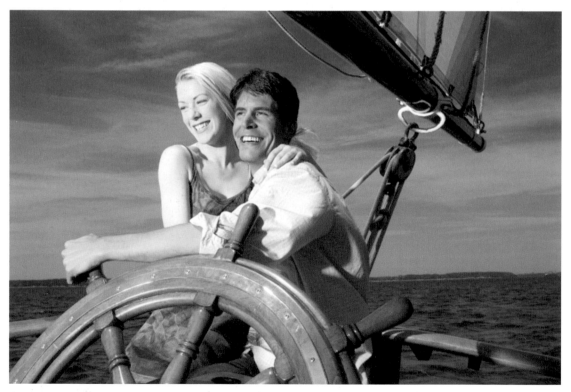

**FIGURE 10.13**    The original image. Royalty Free Image from Hemera™.

2. Using the Edge Highlighter tool, draw along the hard edges of the object. It is important for the pen to be in the middle of the desired edge, with half the stroke in the foreground and half covering the background. This is how the Keep and Discard colors are flagged. Choose the Smart Highlighting box for the hard edges. This will attempt to detect the edges and snap the tool to the recognized edges, thus making it easier to draw around the perimeter of the object, as shown in Figure 10.14.

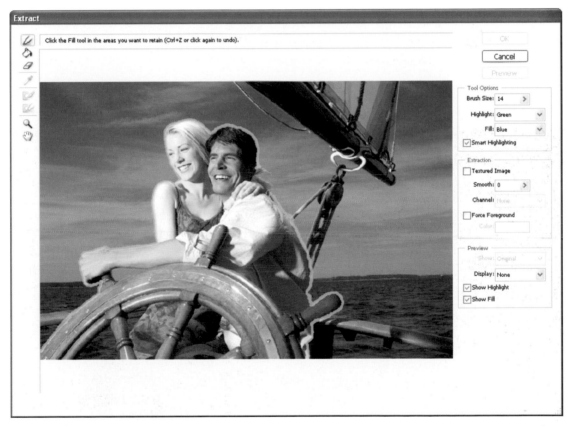

**FIGURE 10.14**    The Extract tool.

3. Switch off Smart Highlighting and choose a larger brush size for soft areas such as hair. Cover all the hairs that you want to keep, as shown in Figure 10.15.

**FIGURE 10.15**    Defining the edges.

4. Be sure to define areas where holes are present, as shown in Figure 10.16.
5. Make sure that there are no gaps present in the defined edge. The edge of the screen is included in the edge, so there is no need to draw around the edges of the screen.

**FIGURE 10.16**    Filling in the gaps.

6. When the edges are defined, choose the Fill tool and fill the area that you want to keep by clicking inside it as shown in Figure 10.17. This tells Photoshop what area should be discarded.

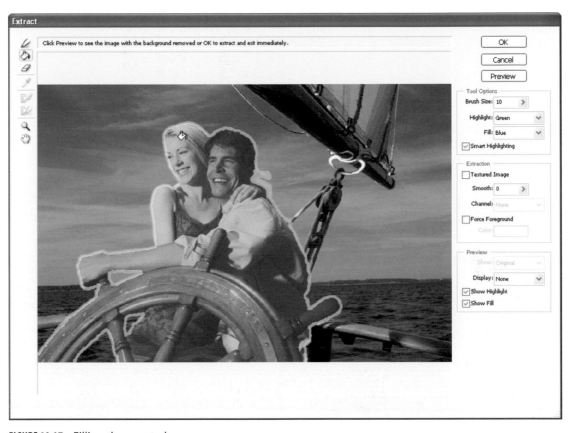

**FIGURE 10.17**   Filling the area to keep.

7. Choose the Preview button (see Figure 10.18). Extract will now remove all the areas outside the filled selection and calculate what should be kept and what should be discarded from the edges.

8. To see what is going on better, choose a solid color from the Display window. The white matte chosen in Figure 10.19 is for display purposes only and will not affect the image.

You can see there are some areas that need to be cleaned up.

9. Use the Edge Touch Up tool to clean up any stray pixels on the edges, as shown in Figure 10.20. Use the 0–9 keys to adjust the pressure.

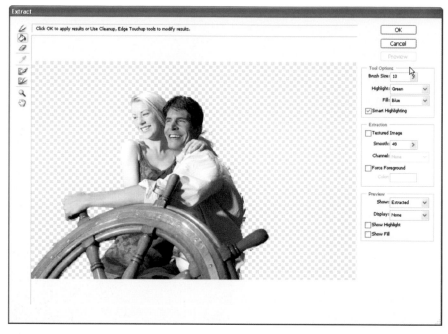

**FIGURE 10.18**    Preview.

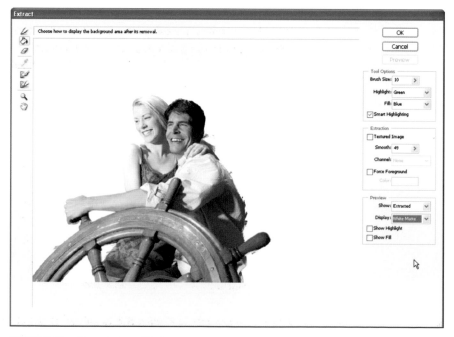

**FIGURE 10.19**    Choosing a white matte.

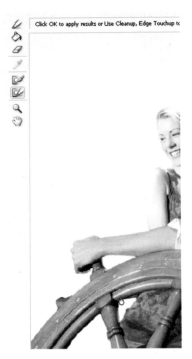

**FIGURE 10.20**    Cleaning up the edges.

10. Finally, use the Clean Up tool to fix areas manually. As you paint with the Clean Up tool, it will erase pixels. To paint back pixels that were erased accidentally, hold down the Ctrl key (Cmd in Mac) as shown in Figure 10.21, where we are painting back a portion of the shoulder that was removed by an overzealous extraction.

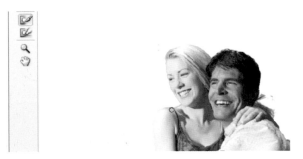

**FIGURE 10.21**    Fixing the selection.

11. When you are satisfied with the preview, click OK to apply the extraction to the image. It should now look like Figure 10.22.

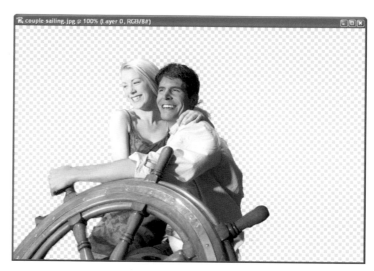

**FIGURE 10.22** The image separated from its background.

12. Drop the image against another background for a fantasy effect as shown in Figure 10.23.

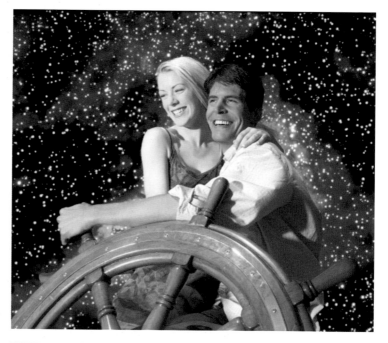

**FIGURE 10.23** The image on a new background.

## RULES FOR COMPOSITING TWO IMAGES

When taking a selected portion of one photo and dropping it into another photo, there are a few things to watch out for. If these rules are ignored, the image will appear fake.

Figure 10.24A shows a correct composition. We will look at some bad compositions and discuss what rules are being ignored.

**FIGURE 10.24A**    A correctly composited image. Royalty Free Image from Hemera™.

**Color/Hue Match:** In Figure 10.24B, the girl has a redder tint than the background, making it obvious that she was added after the fact. The solution is to color correct the girl using one of the methods discussed in Chapter 5, "Color Correction."

**Brightness:** In Figure 10.24C, the girl is brighter than the rest of the image. This is a real giveaway and sometimes can be seen in green screen situations in movies when poor correction techniques are applied. The solution is to use the techniques in Chapter 4, "Image Correction," to either darken the girl or brighten the rest of the image so that they match.

**FIGURE 10.24B**   Color mismatch.

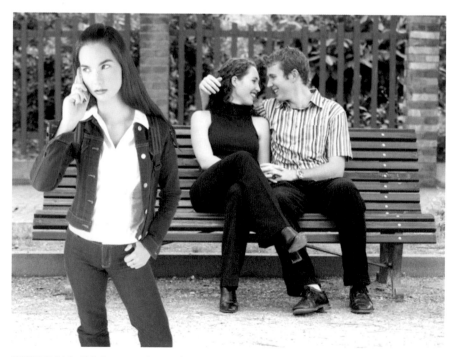

**FIGURE 10.24C**   Brightness mismatch.

**Saturation:** Saturation is the amount of color. In Figure 10.24D, the girl is more saturated than the rest of the image. In this case it is exaggerated. Saturation is easy to miss and will cause the image to appear mismatched. The solution is to use the Hue/Saturation or Curves tools discussed in Chapter 5 to reduce the saturation of the color in the girl.

**FIGURE 10.24D**    Saturation mismatch.

**Film Grain:** Different ISO settings and lighting conditions can cause inconsistent grain in the images. In Figure 10.24E our girl is more grainy than the rest of the image. The solution is to either reduce the grain in the girl using techniques discussed in Chapter 6, "Sharpening and Noise Reduction," or add grain to the rest of the image using Filter > Noise > Add Noise or Filter > Artistic > Film Grain.

**FIGURE 10.24E**   Grain mismatch.

There are some other things to watch for, too:

**Proportion:** Make sure that objects are scaled to the correct size to fit in with the perspective of the target image.

**Shadows/Light Source:** Make sure that the light source matches the images. If they are lit from opposite sides, it will look very artificial. Use of the Dodge and Burn tools can help with this, but it's best to choose your images carefully before compositing.

**Wind:** This problem is rare, but it's good to keep an eye on. If wind is present in the image, be sure it is blowing in the same direction.

## COMBINING IMAGES TO CREATE AN ADVERTISEMENT

Using what we have learned so far, we will create an advertisement for a fictitious timetable Web site of someone who has missed his train.

**TUTORIAL**

*ON THE CD*

1. Open `train-station.jpg` and `teenager pose.jpg` from the CD-ROM, or choose a couple of your own images. Figure 10.25 shows the original image.

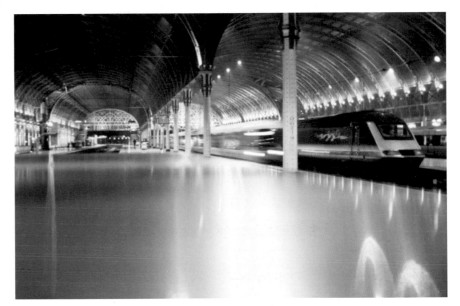

**FIGURE 10.25**    The original image. Royalty Free Image from Hemera™.

2. The image of the teenager is part of the Hemera Photo-objects series and comes with an Alpha channel already included. To remove from the background, Ctrl-click (Cmd-click in Mac) on the Alpha channel thumbnail to load the selection. Choose the Layers Palette and drag the object into another image as shown in Figure 10.26. If you are using another image, use the techniques demonstrated at the beginning of the chapter to remove the object from its background.

Sometimes there can be a tiny fringe visible around the object. This can be removed by choosing Layer > Matting > Defringe and choosing a small setting, as shown in Figure 10.27.

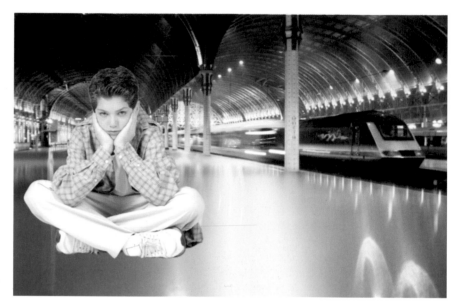

**FIGURE 10.26**  Drop the object onto the background.

**FIGURE 10.27**  Defringing.

Notice in Figure 10.28 how the image looks much cleaner around the head now.

Presently it looks like the boy is floating in the air. We need to make him interact with the background. The floor is very reflective, so adding a reflection to the floor will cause the image to interact with the environment.

3. Duplicate the Teenager layer.
4. Choose Edit > Transform > Flip Vertical (see Figure 10.29).
5. Move the transformed layer beneath the Teenager layer.
6. Reposition the flipped layer as shown in Figure 10.30.

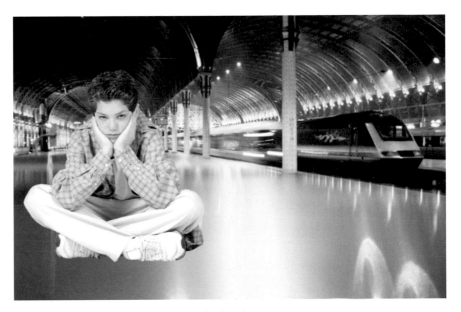

**FIGURE 10.28**   Cleaning up the halo on the head.

**FIGURE 10.29**   Duplicate the layer and flip it.

**FIGURE 10.30**   Dragging into position for a reflection.

Notice that other reflections in the floor appear streaky? We will need to do the same with the teenager to make the image believable.

7. Choose Filter > Blur > Motion Blur.
8. Choose an angle of 90 degrees and a distance of 8 pixels as in Figure 10.31.

**FIGURE 10.31**   Adding motion blur.

9. To complete the effect, reduce the opacity to 68%. It now appears that the teenage boy is sitting firmly on the floor while his train is speeding away. Figure 10.32 shows the final picture.
10. To wrap up the advertisement, add some text as shown in Figure 10.33.

**FIGURE 10.32**    The finished reflection.

**FIGURE 10.33**    Adding text for an ad.

### Adding a Cast Shadow

Another way to add realism is to reproduce the effects of light hitting an object at an angle and producing a cast shadow. This is a fairly easy effect to reproduce.

**TUTORIAL**

ON THE CD

1. Open `phone_man.psd` from the CD-ROM. Figure 10.34 shows the image.
2. Duplicate the layer with the man on it.

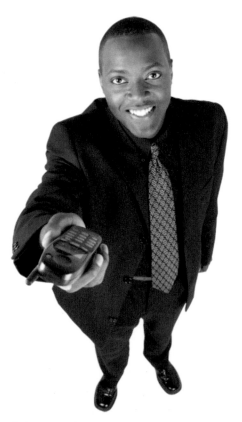

**FIGURE 10.34**   The original image. Royalty Free Image from Hemera™.

3. Select the bottom man layer as shown in Figure 10.35.
4. Fill with black.
5. Choose Free Transform by pressing Ctrl-T (Cmd-T in Mac).
6. Right-click (Control-click in Mac) and choose Skew.

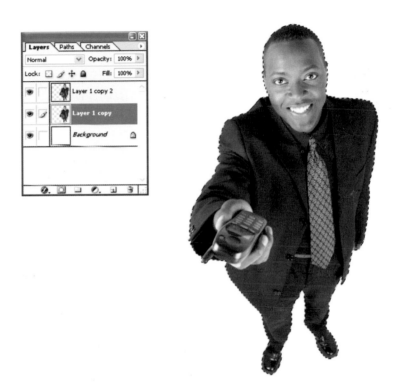

**FIGURE 10.35**   Duplicate the layer and select it.

7. Drag the top-center handle to the right as shown in Figure 10.36. The light is hitting the man on the left of the forehead, so the shadow should fall in the opposite direction.
8. We need to soften the shadow: Choose Filter > Blur > Gaussian Blur. Enter a setting of 2.5 (see Figure 10.37).

As a shadow gets further away from the object it tends to soften. We will create the softer shadow and then blend the two shadows together to create a gradual falling-away effect.

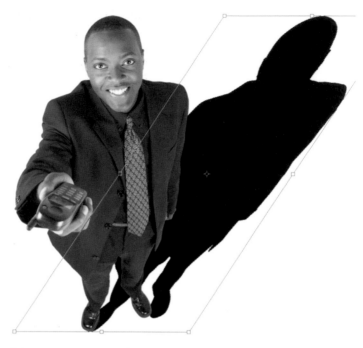

**FIGURE 10.36**    Creating the cast shadow.

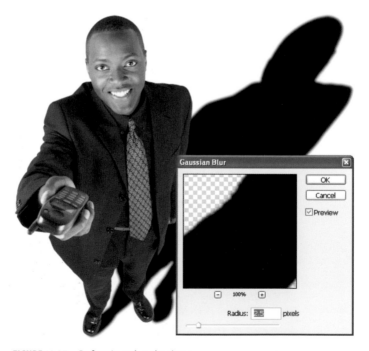

**FIGURE 10.37**    Softening the shadow.

**FIGURE 10.38**    Duplicating the shadow.

9. Duplicate the Shadow layer. Hide the top shadow and select the bottom one as shown in Figure 10.38.
10. Make this one softer with a 9.5-pixel Gaussian blur as shown in Figure 10.39.

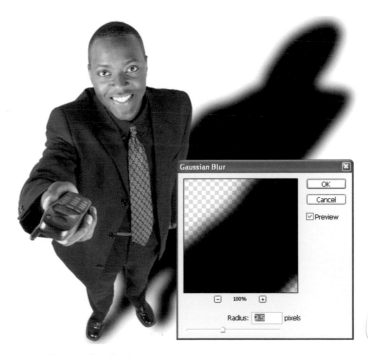

**FIGURE 10.39**    Softening the shadow.

11. Drop the opacity to 36% (see Figure 10.40).
12. Show the top shadow and make the opacity 38%. Figure 10.41 shows both shadows.

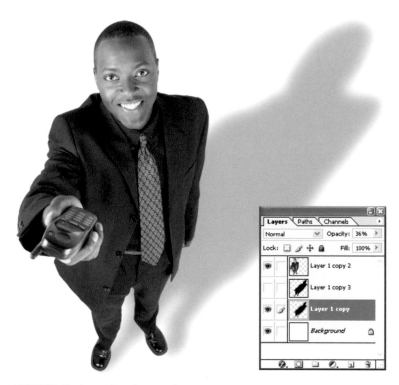

**FIGURE 10.40** Lowering the opacity.

We will now blend the shadows together.

13. Create a layer mask on the top shadow.
14. Choose the linear Gradient tool. With white as the background, black as the foreground, and the Gradient option set to Foreground to Background, drag the gradient from top to bottom in the layer mask as in Figure 10.42. The shadow should soften at the top.

The image can be easily added to another background for an interesting effect. Shadows are key to making an image fit within a new background and look like it was shot that way. Figure 10.43 shows the final image.

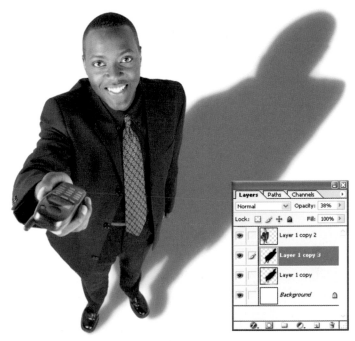

**FIGURE 10.41**   Showing both shadows.

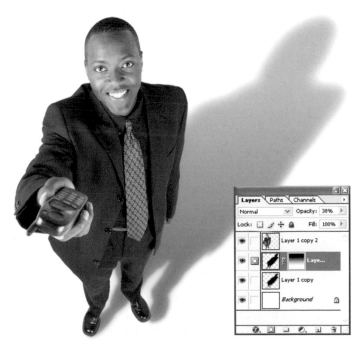

**FIGURE 10.42**   Blending the shadows.

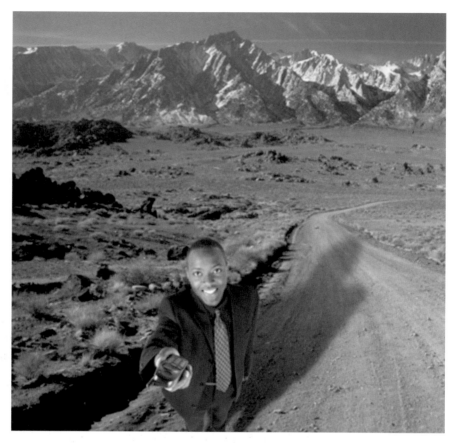

**FIGURE 10.43**    The final composite.

## SUMMARY

In this chapter you learned some different methods for extracting an image from its background. This is a great first step in creating composite images. You can make the images as surreal or as real as you wish, depending on the way you choose to combine them. We also looked at the basics of combining images to make them match. Once you have perfected these techniques, only the most discerning eye will be able to tell that you have created a photo manipulation. In the next chapter we will dive into some more creative uses of multiple images.

# 11

# COLLAGING TECHNIQUES

I n the previous chapter we looked at combining images in a single document. We are now going to take those principles a bit further and use features such as layer masks and blending modes to produce some artistic collages.

## A BLENDED COLLAGE USING LAYER MASKS

A layer mask can be applied to a layer. By default, the mask is filled with white, which has no effect on the host layer. When the mask is filled with black, it causes the host layer to be rendered invisible. Different levels of grayscale affect the host layer as levels of transparency. For example, if the mask were filled with 50% gray, the layer would render at 50% transparent. You might ask, "Why use a mask and not just adjust the opacity of the layer?" You can paint onto a mask with a paintbrush or gradient, thus changing the transparency of any part of the layer you choose.

## TUTORIAL

ON THE CD

1. Open three images for the CD-ROM: `Stars.jpg` (Figure 11.1), `Moon-surface.jpg`, and `Telescope.jpg`. Choose `Stars.jpg` as your base image that we will perform the collage inside.
2. Position the Moon surface image so that you can see inside the Stars image at the same time.
3. Click your mouse inside the moon image and, while holding down the mouse button, drag into the Stars image. The moon image will now become a new layer in the Stars image as shown in Figure 11.2.
4. Click the New Layer Mask icon in the Layers Palette.

   We will now blend the two images together smoothly.

5. Choose the Gradient tool. Press the D key on the keyboard to reset the colors. Select the Linear option and Foreground to Background from the options bar.
6. Click from the top of the moon image and drag most of the way to the bottom of the page. You should now see a smooth blend as shown in Figure 11.3. If you don't, try dragging the gradient in the opposite direction.

**FIGURE 11.1**    The star field image. Royalty Free Image from Hemera™.

**FIGURE 11.2**    Adding a photograph to an existing image.

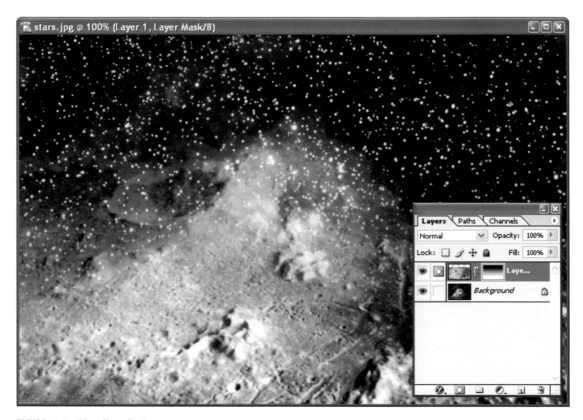

**FIGURE 11.3** Blending the image.

7. Drag the Telescope image into the working document and make sure it's on the top of the layer stack (see Figure 11.4). To move a layer up or down the stack, just click and drag the thumbnail in the Layers Palette. Think of the top of the Layers Palette as the front of the image stack and the bottom of the layers as the back. The higher upon the Layers Palette a layer appears, the more to the front of the document the layer will appear.

8. Add a layer mask to the telescope and create a horizontal gradient to blend it in as shown in Figure 11.5.

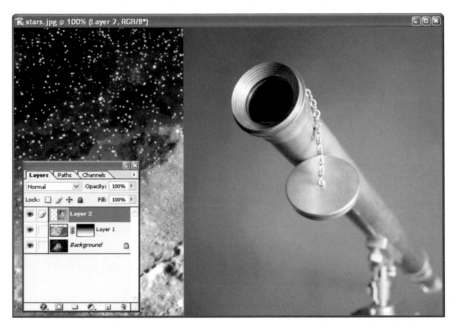

**FIGURE 11.4**    Inserting the telescope.

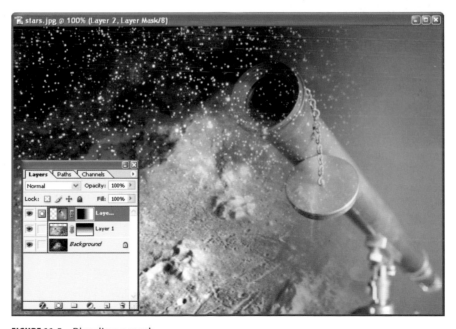

**FIGURE 11.5**    Blending a mask.

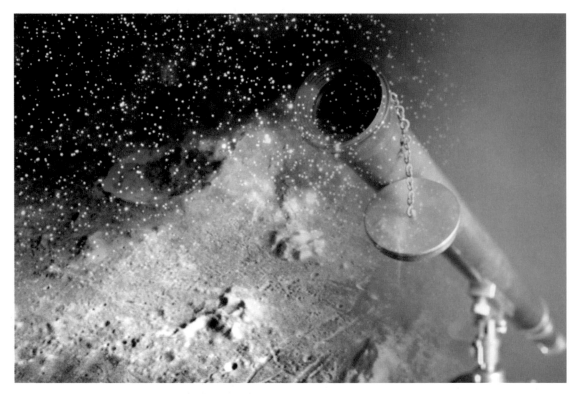

**FIGURE 11.6** The finished collage.

Figure 11.6 shows the completed collage. We can take it a bit further if we want.

A variation of the collage is the use of color to pull everything together. When an adjustment layer is added, it will affect everything underneath it.

9. Choose the New Adjustment Layer button in the Layers Palette. Choose the Hue/Saturation option.

10. Click the Colorize option and adjust the hue as shown in Figure 11.7.

Figure 11.8 shows the result of the Hue/Saturation adjustment layer. Whenever an adjustment layer is created, it comes with a built-in layer mask.

11. Click on the adjustment layers mask. Choose a black brush and paint inside the image. Notice that the black hides the effects of the adjustment layer.

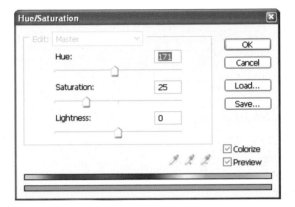

**FIGURE 11.7**    Hue/Saturation.

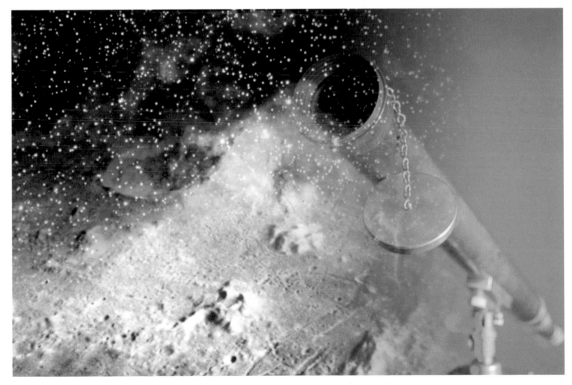

**FIGURE 11.8**    Colorized effect.

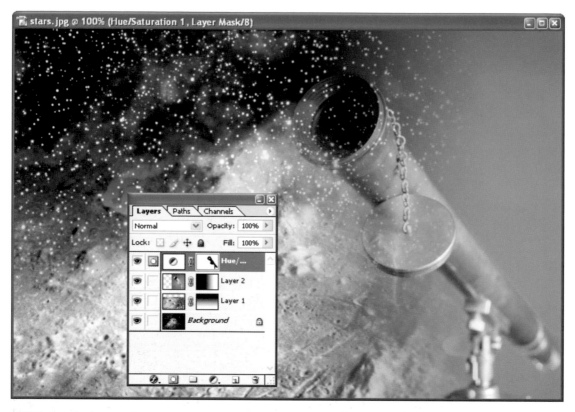

**FIGURE 11.9** The hue mask painted.

In Figure 11.9, the telescope's color is painted back using the adjustment layers mask. This provides one more creative option for collaging.

## USING BLENDING MODES FOR COLLAGING

More great tools for mixing images are the 23 layer blending modes. These blending modes affect the way that layers interact with one another. Some modes lighten, some darken, and some work on the grayscale portions of the image. For a full description of each, please refer to the online help in Photoshop. The best advice for the modes is experimentation. Try several different blending modes to see which one produces the most desirable results.

## TUTORIAL

*ON THE CD*

1. Open `mt-fugi.jpg` and `woman-laptop.jpg` from the CD-ROM (Figures 11.10 and 11.11).
2. Drag the woman image into the `mt-fugi` image. Hold down the Shift key as you drag, which will cause the image to be centered in the document.
3. Change to Hard Light mode as shown in Figure 11.12.

**FIGURE 11.10**    The base image.

**FIGURE 11.11** Two images together. Royalty Free Image from Hemera™.

**FIGURE 11.12** A blending mode applied to the images.

The image looks really interesting now. We just need to paint the face of the woman back in.

4. Duplicate Layer 1 of the woman.
5. Change the blending mode to Normal.
6. Create a layer mask and fill with black to hide the layer, as shown in Figure 11.13.

**FIGURE 11.13**    A new layer hidden by the mask.

7. Choose a soft edged white brush and paint the woman's features back in, as seen in Figure 11.14.

**FIGURE 11.14** Painting on the mask.

**FIGURE 11.15** The final collage.

Finally, as shown in Figure 11.15, we have a collaged image using not much more than a blending mode.

## ADVANCED BLENDING

We are now ready to jump into advanced blending. This is a lot easier than it sounds. We choose a range and adjust a threshold level, and this level measures the color of the top layer versus the layer underneath and assigns transparency to the top layer.

## TUTORIAL

ON THE CD

1. Open `advanced-blending.psd` from the CD-ROM. Figures 11.16 and 11.17 show the two images layered together.
2. Select the top layer and click on the Layer Styles button in the Layers Palette.
3. Choose the blending options (Figure 11.18).

**FIGURE 11. 16**    Background. Royalty Free Image from Hemera™.

**FIGURE 11.17**    The top layer.Royalty Free Image from Hemera™.

**FIGURE 11.18**    Choosing the blending options.

You will now see the Advanced Blending options. The only area that concerns us is the bottom section that says Blend If.

4. Choose Blue as the Blend If color, because we want to replace the blue from the sky with the nebula in the top image.
5. Hold the Alt key (Option in Mac) and drag the top right slider toward the left as shown in Figure 11.19. Pressing Alt will cause the slider to split, providing a smoother transition.

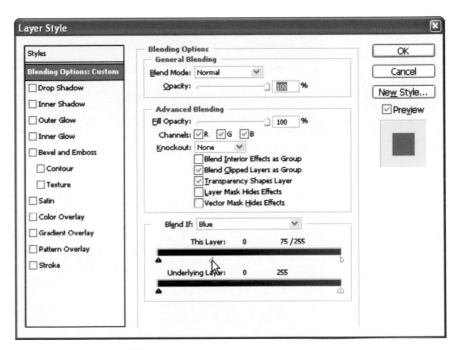

**FIGURE 11.19**    Advanced blending.

6. Slide the slider until the sky is replaced with the field of stars and the bridge is still visible (Figure 11.20).
7. Choose Image > Adjustments > Levels.
8. Slide the Midtone and Highlight sliders to fine-tune the blend as shown in Figure 11.21. As you slide you will notice that the transition between the layers changes.

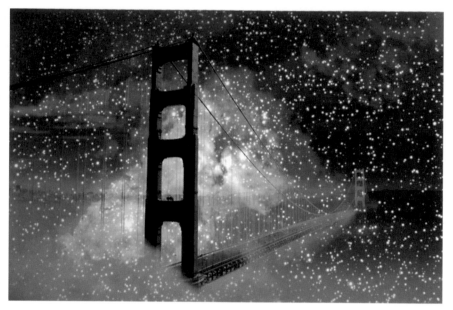

**FIGURE 11.20**   The image being blended.

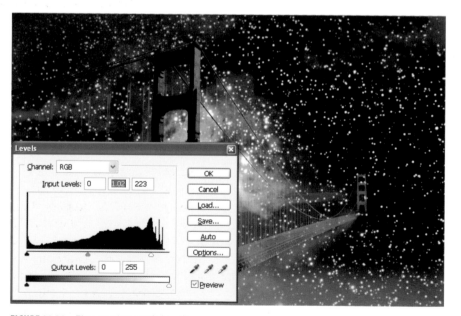

**FIGURE 11.21**   Fine-tuning with levels.

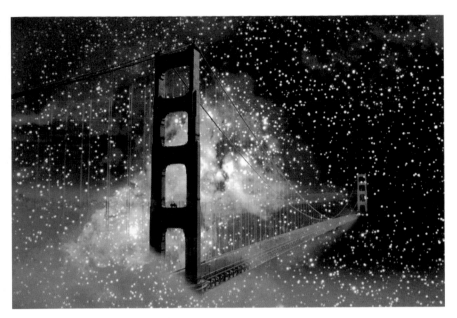

**FIGURE 11.22**    The finished blend.

As shown in Figure 11.22, the blended layers provide a nice fantasy sky to the Golden Gate Bridge, making it look like it is in space, without the need for any selections or extracting.

## CREATING A PANORAMIC IMAGE

When it comes to landscape and scenic photos, there is seldom anything as breathtaking as a sweeping panoramic image. With Photoshop CS, this is now within the grasp of any photographer. All you need is a camera, some scenery to shoot, and Photoshop. Of course, a tripod can help a lot.

Take three (or more) images of the scenery. Take a picture to the left, one in the middle, and another to the right of the scene. While taking the shot, be sure that the camera is held level and slightly overlap each image. The more overlap, the more headroom you will have to work with in Photoshop. Avoid shooting with auto exposure, because it's better if each image has the same exposure settings, which will maintain uniform brightness. Find the medium exposure for the three images and dial that into the camera and use it for all three shots Also, don't use a polarizer filter, which will give the sky a non-uniform look and make it more difficult for Photoshop to blend.

Once you have taken your pictures, it's time to work on this tutorial, which will show you how to splice them together using one of the newest features in Photoshop, Photomerge™.

*ON THE CD*

If you don't have your own images ready, use the three provided on the CD-ROM called `merge1.jpg`, `merge2.jpg`, and `merge3.jpg`. See Figure 11.23. These are three images of a sunset at Laguna Beach. These images offered a special challenge: The waves were always moving, and the light was changing constantly, so it was difficult to get a good set of starting images. In all, it took 120 photos to get three suitable candidates. If you can learn on a difficult image, it will be a snap for you to merge other images together.

**TUTORIAL**

1. Open the images on your desktop.
2. Choose File > Automate > Photomerge.

**FIGURE 11.23** Three pictures.

You will see a dialog box with the open images displayed. Alternatively, you could choose the images from a folder under the Use drop-down menu.

3. Click OK.
4. Photomerge will attempt to arrange the images automatically (Figure 11.24). In this case it was unsuccessful because of the differences of the wave position in the three images. There will be a warning dialog box telling you it couldn't arrange the images. This is fine; click OK.

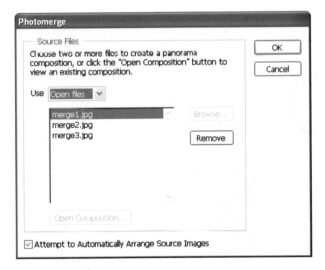

**FIGURE 11.24**    Photomerge.

Notice that the images will be displayed as thumbnails at the top of the dialog box (see Figure 11.25). We simply drag and drop the images into the main window to arrange them.

As we move one image over the other, the opacity will be lowered on the overlapping areas to assist us in achieving a close match.

Once you let go of the mouse button, Photomerge will attempt to produce a smooth blend between the overlapping areas (see Figure 11.26).

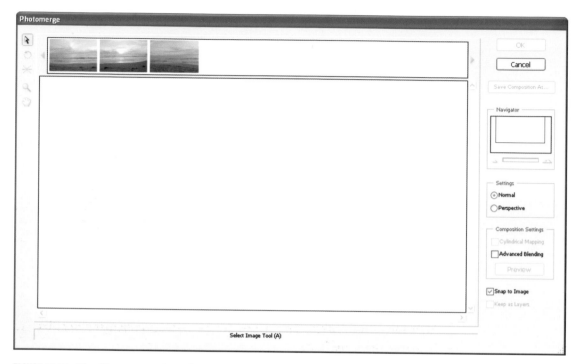

**FIGURE 11.25**   The Photomerge interface.

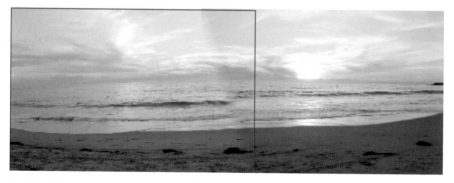

**FIGURE 11.26**   Dragging images into the window.

Sometimes the images will be tilted slightly. This issue can be alleviated by choosing the Rotate tool and rotating the picture to the correct angle, as shown in Figure 11.27.

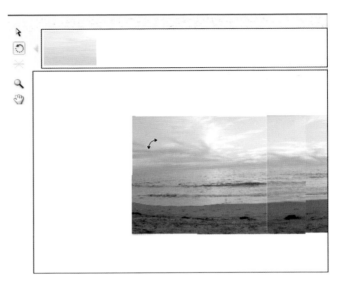

**FIGURE 11.27**    Rotating an image.

5. Position and rotate the images to the best arrangement possible, as shown in Figure 11.28.
6. Click OK to apply.

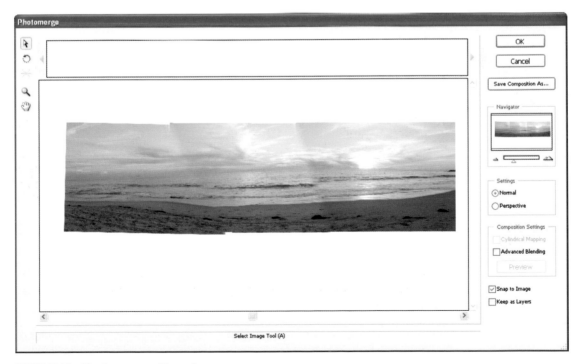

**FIGURE 11.28**    The images positioned.

The merged images will be opened as a single document in Photoshop. You will notice that Photoshop has done some blending work for you. In some cases, the image will look great right out of Photomerge. Most of the time, though, you will have to clean things up yourself.

7. Crop the edges of the image to produce clean edges as shown in Figure 11.29.

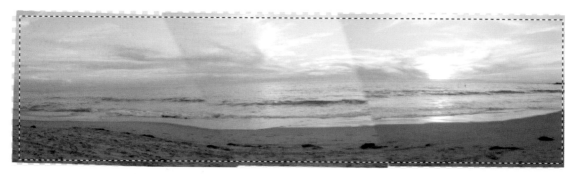

**FIGURE 11.29**    Select and crop.

Now it's time for a little manual work to make the image look like a single image and not three photos that have been stitched together. The Healing Brush is my weapon of choice, because of the smooth blending it produces and the ease of use.

8. We will begin with the sky because it is the easiest part of the image to re-pair. Sample a clean portion of the sky, similar to the area on the seam. To create a sample, hold down the Alt key (Option in Mac) and click on the area you want to sample.

9. Click and drag the Healing Brush tool. You will see that you are drawing with the sampled color and texture. As soon as you release the mouse button, the Healing Brush will attempt to blend your color and texture into the painted area, as shown in Figure 11.30.

10. Keep painting the merged areas of the photos until the edges are all gone. This will require a lot of sampling, painting, and some undoing.

With a little time and patience, your image should look quite seamless, as shown in Figure 11.31. With the Healing Brush, it is not that difficult, and the process will move pretty quickly. When you see your beautiful panorama, all the effort will be worth it.

**FIGURE 11.30**  Use the Healing Brush to clean up the joints.

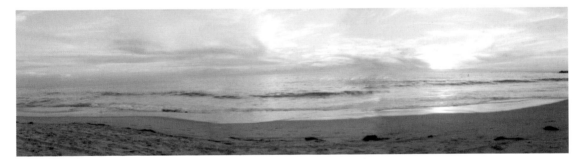

**FIGURE 11.31**  The final panoramic image.

There is a Keep as Layers option. If you check this box, all the pieces will be imported in one document, but each piece will be on a separate layer. This enables you to blend the seams together manually using layer masks. Allow Photoshop a chance to piece everything together automatically. If the result is very poor, then try the manual process. The beginning of this chapter shows you how to blend using layer masks and gradients.

## PRODUCING ANIMATION

You may have seen this effect on a Web page. A normal image sits and gently smiles at you, much like any image on the Web page. All of a sudden, the image changes into another image. Did your eyes play tricks on you? No you just witnessed an animated GIF (Graphics Interchange Format). Of course, with the advent of Macromedia® Flash™, a lot is possible in the area of animation. What we are talking about, though, is an image that can be placed onto an ordinary Web page, without the need for Flash or any programming. This image will be treated like any other image and can be handled in exactly the same way. What will make it different is the fact that there are actually several images hidden inside the one image. Over the course of time the images will cycle, changing, adding interest to your Web page. This effect is accomplished by using ImageReady, an application that ships with Photoshop and is installed on your computer right now, whether you are aware of it or not.

Let's walk through the process of creating an animated GIF.

## TUTORIAL

ON THE CD

Open the Advanced Blending image seen in Figure 11.32 from the CD-ROM or create a new document with two images, each on its own layer.

We will need to resize the image for online viewing. The smaller the image, the faster it will load. In this case we will size it to 450 pixels for the sake of learning. In reality, though, you wouldn't really want it much larger than 150 pixels because it would take a long time to download over the Internet. When you are shrinking an image, remember to use Bicubic Sharper at the bottom of the Image Size dialog box, as seen in Figure 11.33.

1. Click the very bottom button on the toolbar seen in Figure 11.34 to launch ImageReady.

Your image will now launch in ImageReady. The interface looks very much like Photoshop, and it works in a similar way. One big thing you will notice is that the image window has a few options and there are a few new palettes. Explaining the entire ImageReady is beyond the scope of this book, but we will learn what we need to create the animation.

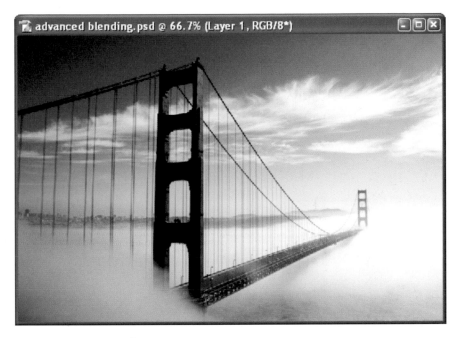

**FIGURE 11.32**    Opening the image.

**FIGURE 11.33**    Resizing.

**FIGURE 11.34**    Switch to ImageReady.

2. Choose Window > Animation to open the Animation Palette. This is where we will do the majority of our work for this task.
3. Click the New icon in the Animation Palette. This looks just like the New Layer icon in the Layers Palette, except this would create a new frame, as shown in Figure 11.35. The animations are based on frames. ImageReady will cycle through each frame, quickly producing the effect of movement in the same way that animations are produced for movies.

**FIGURE 11.35**   Adding a frame.

Currently both frames are identical, so nothing will happen. We want to change from the image of the bridge to the image of the stars.

4. With frame 2 selected, hide the top layer as shown in Figure 11.36.

The frame will now update to show the stars (see Figure 11.37). Notice that frame 1 is still showing the bridge.

We could use that as our animation if we wanted. The images would change. There are two problems, though. The animation would run so fast that the images would just flicker, and the transitions are very abrupt.

We will fix the abrupt transition first. What we need is for the frames to fade slowly into each other. We could create some frames between frame 1 and 2 and then adjust the opacity of the top image on each frame to produce a slow blending transition. That's exactly what we are going to do, with one exception. We will let ImageReady do all the work!

5. Click the arrow at the top right of the Animation Palette, and you will see a drop-down menu. Choose Tween from the options.

**FIGURE 11.36**    Hiding a layer.

**FIGURE 11.37**    The changed frame.

Figure 11.38 shows the Tween Palette. What this tool does is create the be-*tween* frames. Choose 4 for the number of frames to add.

**FIGURE 11.38**    Tweening.

6. Click OK.

All the frames will now be added to the Animation Palette.

7. To test the animation, click on the Play button as shown in Figure 11.39.

The animation should now work, and the second problem will be come evident. The animation is running much too quickly.
We can fix it easily enough by assigning a delay time to the frames.

8. Choose frame 1. Hold the Shift key and click on the last frame. All the frames should now be highlighted.
9. Click on the words 0 Sec at the bottom of one of the thumbnails, and you will see a pop-up menu with delay times attached.
10. Choose 0.2 seconds (see Figure 11.40). Because all the frames were selected, the delay will be added to all the frames.

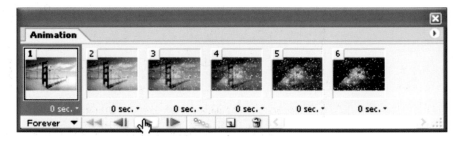

**FIGURE 11.39** Previewing the animation.

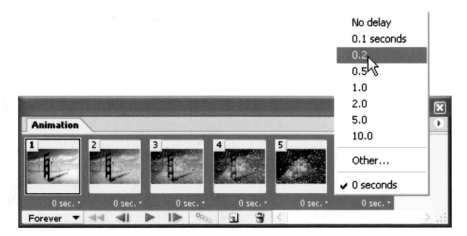

**FIGURE 11.40** Setting the overall delay.

The transition will run a bit slower now and look smoother because we want the images to be displayed longer so they can be viewed and enjoyed. To achive this, we need to assign a separate delay time to the first and last frames.

11. Click on the last frame's thumbnail. This will deselect all the frames, leaving only the last frame selected.
12. As shown in Figure 11.41, change the Delay time to 2 seconds in the same manner as we set the delay just a moment ago.
13. Add a 2-second delay to the first frame, also.
14. Test the animation again by pressing the Play button.

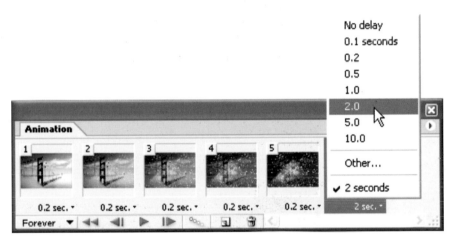

**FIGURE 11.41**   Setting Delay for frames.

It looks much better, however, the fade works only one way. When the image changes back from the stars to the bridge, it is abrupt again. We need to add another fade effect. Let's look at a quick way to create a smooth looping animation.

15. Select all the frames as shown in Figure 11.42.

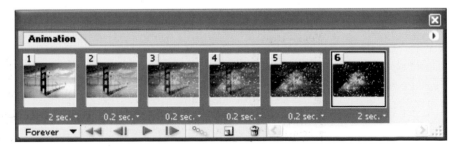

**FIGURE 11.42**   Selecting all the frames.

16. Click the upper-right arrow and choose Copy Frames from the drop-down menu.
17. Click again and choose Paste Frames.
18. You will see the dialog box in Figure 11.43. Choose Paste After Selection to paste the frames at the end of the animation.

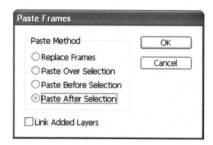

**FIGURE 11.43**    Copying and pasting frames.

You will see the frames repeated at the end of the Animation Palette as seen in Figure 11.44. Do not deselect them yet, because we need to reverse their direction.

19. Click on the top-right arrow again and choose Reverse Frames. They will now be rearranged in the reverse order. See Figure 11.45

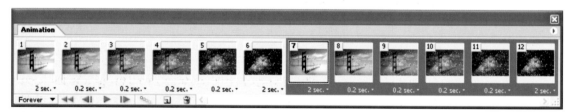

**FIGURE 11.44**    The pasted frames.

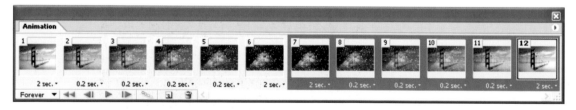

**FIGURE 11.45**    Reversed frames.

ON THE CD

20. Click on the Play button to test the animation again. It should now run smoothly. You can view the finished animation from the CD-ROM (see Figure 11.46).

It's named Animation-large.gif, and it will run from any Web browser.

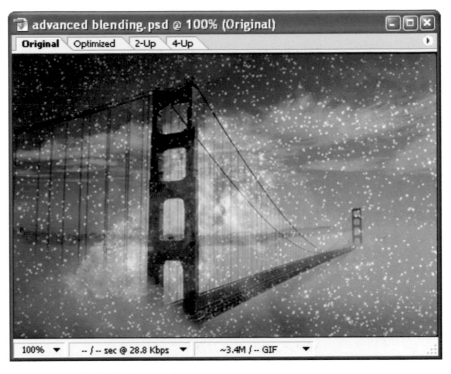

**FIGURE 11.46**    The finished animation.

In Figure 11.47, the size has been reduced to 100 pixels for faster loading in a Web page. If you click on the Optimized tab at the top of the window, you will see a preview of how the image will look after it is exported, as shown in Figure 11.47.

**FIGURE 11.47**    Smaller for fast download speed.

To save the animation, choose File > Save Optimized As. Choose a location and name for the image and click OK. The image can be embedded into a Web page in the same way that you would attach a normal image.

## OPTIMIZATION

Optimization is a word used for image compression. We can force an image's file size to be reduced by lowering the quality of the image. The reason we may want to do this is to reduce the time a viewer has to wait for the image to load on the screen. When we are dealing with an animated GIF, we are dealing with several images at a time, so optimization will have a big impact. The difficult part is balancing between acceptable image quality and acceptable file size. You cannot increase one without sacrificing the other. Go with the minimum quality image that you can possibly get by with for your needs and thus reduce the waiting time as much as possible. Generally, when you are adding animated GIFs to a Web page, you will want to keep them as small as possible in physical size. Shrinking the image will reduce the file size dramatically. Once you have reduced the image's actual size, you will want to use the optimization features in ImageReady to further reduce the file size.

## TUTORIAL

1. Open the Optimize Palette.

   GIF should be the selected option because it is the only image format that will support animation.

2. Click the little arrow by the Color Table option. The palette will now expand to display some more options.

3. Click on the Colors box. This is how you optimize a GIF file. By reducing the number of colors, you will reduce the file size. The default is 256, which is the maximum number of colors supported by the GIF format (see Figure 11.48).

4. Choose 128 and test the animation to see how it looks; try 64 colors and test again. Every image is different. What you are looking for is the lowest number of colors that looks acceptable to you. Be sure you preview in the Optimized window because the Original window will not reflect the optimization settings.

5. When you have found a satisfactory setting, choose Image > Save > Optimized As and choose a location and name.

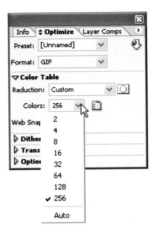

**FIGURE 11.48** Optimizing the image for faster download.

You are now ready to add animations to your Web pages to attract some attention. Be warned, though, that too many animations will not impress your visitors. In fact, they can be annoying. Imagine trying to read this book with little things spinning all over the pages. The key is moderation and good taste.

## SUMMARY AND CONCLUSION

Hopefully you have enjoyed reading this book and learned some new techniques that will help you to create new and exciting things with your photographs or perform some old tasks more efficiently. No one expects you to remember everything you read between these pages. That's why it's a good idea to keep this book handy for future reference. Nor would we think that this book has exhaustively covered everything there is to know about Photoshop and photography. You have a good start, though, and are pointed in the right direction. The next step is up to you. Go ahead and experiment and unleash your creativity. The best way to improve is through practice, and the more you perform the tasks you have learned, the faster and better you will become at them.

# ABOUT THE CD-ROM

## WHAT'S ON THE CD?

We are very happy to bring you some great bonus material on the CD-ROM, including trial versions of Adobe Photoshop CS, most of the images used in the book projects, some of the techniques on video, and some third-party plug-in demos. Here's where you'll find everything:

**Book Files:** You will find the image files used for the tutorials. These are under the Book File folder. The names of the images are listed in the tutorials. Each image is organized under the chapter number.

**Photo Gallery:** The final Photo Gallery is provided here.

**Videos:** Five video clips are included from the collection at *www.photoshopcd.com*. View the clips right off of the CD-ROM using an advanced interface.

**Software Demos:**

**Mac and Windows**

**Adobe Systems:** *www.adobe.com*

**Photoshop CS**

**Alienskin Software:** *www.alienskin.com*

**EC 4000:** Eye Candy 4000 is a collection of 23 time-saving filters that will fortify any user's creativity. Eye Candy is the only filter set on the market that combines practical effects like shadows, bevels, and glows with stunning effects like Chrome, Fire, Smoke and Wood. This easy-to-use set is consistently ranked one of the top-selling graphics plug-ins in the world.

**Image Doctor:** Image Doctor™ is an all new set of powerful image-correction filters for Photoshop®, Fireworks®, Paint Shop Pro®, and other image editors. Image Doctor magically removes blemishes and defects, quickly repairs over-compressed JPEGs, and seamlessly replaces unwanted details and objects. Professional and

amateur photographers, photo editors, archivists, graphic designers and Web designers can quickly fix their images.

**Xenofex 2:** Xenofex 2 delivers 14 more phenomenal effects for Web designers, graphic artists, digital photographers, and special effects enthusiasts.

**Andromeda:** *www.andromeda.com*

**Lens Doc:** Corrects the barreling and pin-cushioning image distortions produced by many zoom and wide angle lenses.

**Varifocus:** Lets you focus/defocus features in your image with custom control.

**Scatterlight Lenses**
- Professional digital lenses for scattering highlights
- DreamOptics lenses for glows
- SoftFocus lenses for portraiture
- SoftDiffuser lenses for mist and fog
- StarLight lenses for glints, sparks, and flares

**Auto FX:** *www.autofx.com*

**Photo/Graphic Edges 6.0:** Photo/Graphic Edges 6.0 is a suite of 14 photographic effects that enable anyone, regardless of experience, to give images a unique, artistic look. By giving your images shape and dimension, you can add interest and appeal to your work.

## Minimum System Requirements

### Windows

Intel® Pentium® III or 4 processor
Microsoft® Windows® 2000 with Service Pack 3 or Windows XP
192 MB of RAM (256 MB recommended)
280 MB of available hard-disk space
Color monitor with 16-bit color or greater video card
800 × 600 or greater monitor resolution
CD-ROM drive
Internet or phone connection required for product activation

### Macintosh

PowerPC® G3, G4, or G5 processor
Mac OS X v.10.2 through v.10.3
192 MB of RAM (256 MB recommended)
320 MB of available hard-disk space
Color monitor with 16-bit color or greater video card
800 × 600 or greater monitor resolution
CD-ROM drive

# INDEX

noise reduction with, 183–86
sharpening with, 170–73
landscape orientation, 22
Lasso tool, 202, 226, 280, 290
Layer Mask, 243–45, 322–28
Layers Palette
  Channel Mixer, 237, 239, 241
  Levels adjustment, 157
Lens, 14
Lens Blur, 245–54
Lens Doc, 356
lens vignette, 15
Levels Adjustment, 89
Levels Palette, 104–8, 157–62
  Black Point Input, 104, 158
  Midtones, 104
  White Point Input, 104, 158
light source, 308
lighting configuration, 6
Linear Gradient tool, 129, 267, 318
Liquify tool, 201, 204, 206, 218

**M**
Macromedia© Flash™, 344
Magnetic Lasso tool, 210
mapping, 111
Marquee tools, 212, 214, 222, 226, 229
masks, 127–28
Match Color, 144–47
Measure tool, 77
metadata, 29–36
  adding information to, 31
  Camera Raw, 31
  categories of, 31
  copyright information as, 32
  Edit History, 31
  Exif, 29–30, 31
  File Properties, 31
  GPS, 31

IPTC, 31
  searching with, 35–36
  templates for, 32–35
  viewing, 30–31
midtones, 90, 102, 104
Miranda, Fred, 67–68
moles, removing, 190–91
monochrome images, 239–42
multiple images, 289–320
  combining images, 308–18
  compositing two images, 305–8
  removing object from background, 290–304
Multiply mode, 274

**N**
natural media, 258–63
Nearest Neighbor interpolation, 63
New Layer Mask, 322
noise reduction, 13, 177–86
  Channels for, 180–81
  Lab Color for, 183–86
  Smart Blur for, 178
nose reduction, 206–8

**O**
offset printing, 60
optical zoom, 6
optimization, 351, 352–53
Optimize Palette, 352

**P**
Paint Daubs, 262
painting, image becoming, 261–63
panoramic images, 337–43
paper, 57
Patch tool, 196, 197
Pattern Library, 272
PDF Presentation, 43–46